Museum of Contemporary Art, Chicago, in association with D. A. P. / Distributed Art Publishers, Inc., New York

This catalogue is published in conjunction with the exhibition *Universal Experience: Art, Life, and the Tourist's Eye,* organized by the Museum of Contemporary Art, Chicago (MCA), and presented at the MCA (February 12 – June 5, 2005), Hayward Gallery, London (October 6 – December 11, 2005), and Museo d'Arte Moderna e Contemporanea di Trento e Roverto (February 10 – May 14, 2006).

The exhibition is curated by Francesco Bonami, Manilow Senior Curator, with Julie Rodrigues Widholm, Assistant Curator, for the exhibition and Tricia Van Eck, Curatorial Coordinator and Curator of Artists' Books, for this catalogue.

Major support for the exhibition is provided by the Harris Family Foundation in honor of Bette and Neison Harris.

Major support is also provided by Muriel Kallis Newman, and Donna and Howard Stone.

Major corporate support is provided by Bank One, a JPMorgan Chase company.

BANK≣ONE.
A JPMorgan Chase company

Additional support is provided by Anne and Kenneth Griffin; Nancy and Sanfred Koltun; Helen Zell; Ruth P. Horwich; the Kovler Family Foundation; Meta S. and Ronald Berger Family Foundation in memory of our beloved Ronald by Meta Berger, Jan and Robin, Louis and Robin and J.R. and Michael, Jonathan and Rebecca and Jessica and Sydney; Nancy Lauter McDougal and Alfred McDougal; the Pritzker Traubert Family Foundation; Sara Albrecht; Marilyn and Larry Fields; Wolfgang Puck Catering; Dick Lenon; Jackie and Ed Rabin; C. Bradford Smith and Donald L. Davis; Lindy Bergman; Paul and Dedrea Gray; and Jane and Gary Wilner.

Hotel accommodations are provided by the Millennium Knickerbocker Hotel, a part of Millennium Hotels and Resorts.

Support for the London exhibition is provided by Pro Helvetia, Arts Council of Switzerland.

The Museum of Contemporary Art, Chicago, is a nonprofit, tax-exempt organization. The MCA's exhibitions, programming, and operations are member supported and privately funded through contributions from individuals, corporations, and foundations. Additional support is provided through the Illinois Arts Council, a state agency. Air transportation services are provided by American Airlines, the official airline of the Museum of Contemporary Art.

PAGES 2–3
Alexander Timtschenko
Venice II, 1999
Silver-dye bleach print
31½ × 31⅜ in.
(80 × 100 cm)
Courtesy of the artist
See also page 73.

BACK COVER
Maurizio Cattelan
Felix, 2001
Oil on polyvinyl resin and fiberglass
26 × 6 × 20 ft.
(7.9 × 1.8 × 6.1 m)
Collection Museum of Contemporary Art, The Edlis/Neeson Art Purchase Fund
2001.22
See also page 94.

Published by

Museum of Contemporary Art
220 East Chicago Avenue
Chicago, Ill. 60611-2643

and

d·a·p
Distributed Art Publishers
155 Sixth Avenue
Second floor
New York, N.Y.
10013-1507
Phone: 212.627.1999
Fax: 212.627.9484

Produced by the Publications Department of the Museum of Contemporary Art, Chicago, Hal Kugeler, Director, and Kari Dahlgren, Associate Director

Edited by Kari Dahlgren, Kamilah Foreman, and Tricia Van Eck
Essays compiled and introductory texts written by Tricia Van Eck
Artwork descriptions written by Julie Rodrigues Widholm
Designed by Hal Kugeler

Printed in Belgium by Snoeck-Ducaju & Zoon

ISBN 1-933045-02-7

Library of Congress Catalog Number: 2004116600

**FRANCIS CLOSE HALL
LEARNING CENTRE**
Swindon Road, Cheltenham
Gloucestershire GL50 4AZ
Telephone: 01242 714600

CHI
UNIVERSITY OF
GLOUCESTERSHIRE
at Cheltenham and Gloucester

NORMAL LOAN

2 0 JAN 2012

WITHDRAWN

UNIVERSAL EXPERIENCE

Art, Life, and the Tourist's Eye

Curated by Francesco Bonami
with Julie Rodrigues Widholm
and Tricia Van Eck

You cannot travel on the path before you have become the Path itself.

Gautama Buddha

Urs Fischer (Swiss, b. 1973)
Untitled, 2004
Concrete, iron, steel, wax,
cement, soot, pigments,
hair, silver polyurethane,
and acrylic paint
$78\frac{3}{4} \times 78\frac{3}{4} \times 94\frac{1}{2}$ in.
($200 \times 200 \times 240$ cm)
Courtesy of Gavin Brown's
enterprise, New York

Fischer's concrete version of
the mythic sword in the stone
positions the Arthurian legend
in contemporary time. The story
of the search for the sword in
the stone, one of the most fa-
mous voyages in literary history,
endures today mostly in Holly-
wood films and Disneyland at-
tractions. Fischer's works often
examine the struggles and fail-
ures of daily life; this one seems
to question how our everyday
routines measure up to the
heroic journey of Arthur, who
broke Merlin's spell and re-
trieved the sword from the stone,
becoming the heir to the
throne of the King of Britain.

Contents

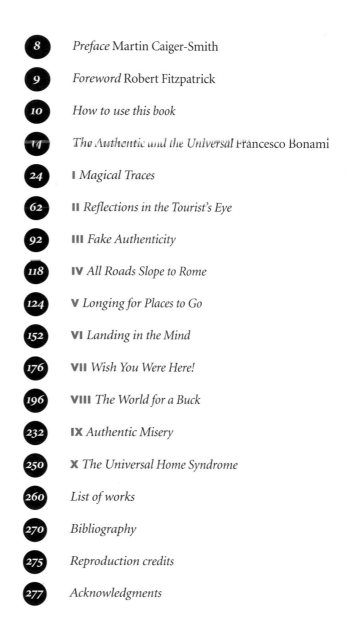

Preface

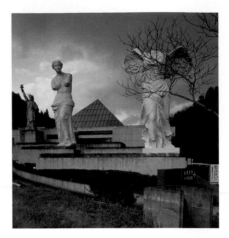

The Hayward Gallery is delighted to host the first European showing of *Universal Experience: Art, Life, and the Tourist's Eye*, a timely and provocative show that explores the phenomenon of global tourism. This catalogue, which should be read as a souvenir guidebook, vividly illuminates individual works and the exhibition's themes. The exhibition's journey from the Museum of Contemporary Art in Chicago to London provides an apt opportunity for its translation into a fresh context for a new European audience.

Our gratitude goes first to the participating artists and their representatives who have worked closely with us to present their art in our galleries. The selection of works has been necessarily reduced for the Hayward's showing; however, all the artists' works shown in Chicago, as well as some others, are illustrated in this book.

We thank the MCA staff with whom it has been a pleasure to collaborate on this ambitious project. In particular we are grateful to Robert Fitzpatrick, Pritzker Director, for his support and enthusiasm, and to Francesco Bonami, Manilow Senior Curator, for guiding the development of the London showing and for revising his essay in this book for our presentation. Their sensitivity and insight have been invaluable to the process of repositioning *Universal Experience* in its new setting. Thanks are due also to Julie Rodrigues Widholm, Assistant Curator, for her meticulous attention to the organisational needs of the show, and to Tricia Van Eck, Curatorial Coordinator and Curator of Artists' Books, for her help with this catalogue.

This exhibition would not have been possible without generous support from Pro Helvetia and The Red Mansion Foundation. We also thank The Elephant Trust, who have generously supported the screening of Andy Warhol's film *Empire*.

Finally I am grateful to my colleagues at the Hayward Gallery, in particular Exhibition Curator Clare Carolin, and Assistant Exhibition Organiser Rachel Kent. Without their dedication and skill, this project could not have been successfully realised in London.

Martin Caiger-Smith
Acting Director
Hayward Gallery

Foreword

With great pleasure the Museum of Contemporary Art, Chicago, presents *Universal Experience: Art, Life, and the Tourist's Eye*, the first major American contemporary art museum exhibition about travel and tourism. Museums are immensely popular tourist destinations, and this exhibition provides us the opportunity to reflect upon what kind of experience we provide for our visitors. For *Universal Experience* the MCA has devoted all of its galleries and outdoor spaces to one exhibition, for the first time since presenting *One Hundred Years of Architecture* in 2000. The exhibition and this book showcase more than seventy internationally renowned and emerging visual artists, many of whom have never been exhibited in Chicago. Works ranging from large-scale installations and sculptures to photographs and video, including several new works created for presentation here, incorporate a wide variety of themes — anthropology, architecture, authenticity, history, souvenirs, and spectacle — that articulate the experience of traveling throughout various countries and cultures. We hope the selected texts in this book, which provide a critical context for the ideas explored within the exhibition, encourage you to take many different paths as you travel through it.

I would like to thank Francesco Bonami, Manilow Senior Curator, whose vision and ambition brought this exhibition to the MCA, and for his illuminating essay in the catalogue. My thanks also go to Julie Rodrigues Widholm, Assistant Curator, for her commitment to the organization of the show, and to Tricia Van Eck, Curatorial Coordinator and Curator of Artists' Books, for her diligent oversight of this book. We are profoundly grateful to the Harris Family Foundation, Donna and Howard Stone, Muriel Newman, and Bank One, without whom this project would not have been possible. We thank Anne and Kenneth Griffin, Nancy and Sanfred Koltun, Helen Zell, Ruth Horwich, Sally and Jon Kovler, Meta Berger and family, Nancy Lauter McDougal and Alfred McDougal, Sara Albrecht, Marilyn and Larry Fields, Wolfgang Puck Catering, Brad Smith and Don Davis, and Lindy Bergman for their additional support. And our gratitude goes to American Airlines and the Millennium Knickerbocker Hotel for air transportation and hotel accommodations for the many artists who came to Chicago for this exhibition.

OPPOSITE
Kyoichi
Tsuzuki
The Louvre Sculpture Museum, 1993
See also page 84.

Robert Fitzpatrick
Pritzker Director
Museum of Contemporary Art, Chicago

How to use this book

Tourism, the largest industry in the world, is a significant social force in contemporary society with far-reaching international, economic, cultural, and geopolitical importance. *Universal Experience: Art, Life, and the Tourist's Eye* posits tourism as a universal experience and asks: If we are all tourists, what is the tourist gaze, and what is the tourist experience? Functioning as a reader, souvenir, and illustrated catalogue of the exhibition, this book presents the artworks within *Universal Experience* as icons and as tourist sites for exploration.

The excerpted articles and essays written by authors from a wide range of fields serve as a guide to the proliferation of research surrounding travel. These texts, juxtaposed with the artwork, are meant to help you find your way through the diverse and hybrid cultural conventions and symbols deciphered, created, and disseminated by an increasingly mobile, international group of artists who often create work in response to travel between and within multiple cultures. Complete bibliographic citations appear on pages 270–274, and a list of authors represented appears on the back cover flap.

activity, separated off from play, religion, and festivity.... Industrialists attempted to impose a rigorous discipline on their newly constructed workforce.

As work became in part rationalised so the hours of working were gradually reduced.

A complex of conditions produced the rapid growth of ... mass leisure activities and hence of these relatively specialised and unique concentrations of services ... designed to provide novel, and what were at the time utterly amazing, objects of the tourist gaze.

Orvar Löfgren *On Holiday: A History of Vacationing,* p. 247

The Butlin concept was to provide not only a holiday package, with everything included, but a holiday program as well. The morning started with the wake-up call from the Butlin camp radio: "Wakey, wakey!" He organized children's programs to give the parents time for themselves and, even more important, had girls stationed in the chalets at night to act as baby-sitters and make it possible for Mum and Dad to dance every night in the camp's ballroom, where Henry Mancini might be playing. "Every night is party night!" There were all kinds of silly games and competitions, amateur nights, and then the brilliant idea of how to get people out of the bars at the end of the evening, making the Salvation Army song "Come and Join Us" into a follow-the-leader routine, with a redcoat leading a wriggling row of guests out into the night.

Butlin and his competitors created a holiday package whose golden days were the 1950s, the days when even the working class could afford a vacation and before the south had become the new magnet.

OPPOSITE AND FOLLOWING PAGES
John Hinde Studio

Entrepreneur Billy Butlin's affordable, all-inclusive Butlin Holiday Camps debuted as a new kind of family vacation resort in the 1930s in England. The resorts provided activities ranging from tiki bars and ballroom dancing to quiet lounges and children's playrooms. In the late 1960s, John Hinde Studio and his staff of professional photographers—Edmund Nagele, David Noble, and Elmar Ludwig—began to produce meticulously crafted color postcards of the resorts, using large-format cameras and professional lighting. Hinde transformed postcards from traditional monochromes to dramatically staged tableaux, using vacationers, that promoted an idyllic spirit of the era. Hinde's technique made him one of the most successful postcard publishers in the world. British photographer Martin Parr resurrected interest in the work as significant to the history of photography, leading to their display as photographic prints.

UNIVERSAL EXPERIENCE *Art, Life, and the Tourist's Eye*

UNIVERSAL EXPERIENCE *Art, Life, and the Tourist's Eye*

Each artwork illustrated in the book is accompanied with information designed to prompt further investigation of the work. A list of artists represented appears on the front cover flap. Some of the artworks pictured are not included in the exhibition *Universal Experience: Art, Life, and the Tourist's Eye*. A list of works appears on pages 260–269.

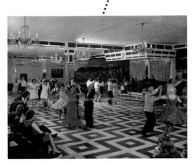

Butlin's Ayr, The Old Time Ballroom

[T]he Protestant work ethic was once pervasive in the U.S.: to work was right, moral, and satisfying. This work philosophy has largely disappeared among Americans born after World War II. The modern generation seeks instant happiness, and its work goal is to earn money with which to play. Translated into tourism, the extra money once saved for home, car, or a "rainy day" becomes the means to travel. **Valene L. Smith**
Hosts and Guests The Anthropology of Tourism

In *Echoes*, Francesco Bonami wrote, "Artistic experience at the end of the millennium is becoming more and more complex, one of difficult balance and right scale. It is walking a tightrope with no safety net of 'whys' below. . . . The true witness, the one who faces the artwork, is the ultimate beneficiary of the creative meaning of existence."

1 *Magical Traces* **51**

The artwork and images are divided into ten distinct spheres of the touristic experience. These divisions, while not representative of the physical layout of the works within the exhibition, are meant to aid and encourage you to explore multiple paths while traveling through the book and exhibition *Universal Experience: Art, Life, and the Tourist's Eye*.

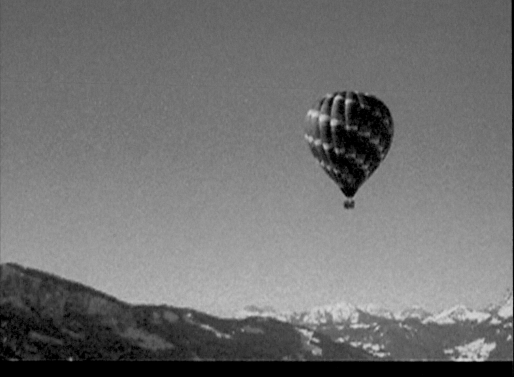

Marine Hugonnier (French, b. 1969)
The Last Tour (still), 2004

"This is about a time where natural sites are so regulated by protective laws with limited visitor access and restricted view points they are becoming almost invisible." Thus begins Marine Hugonnier's film *The Last Tour*, shot around the Swiss Alps, which takes the viewer on a fictional hot air balloon trip, the last one ever offered by Thomas Cook. Hugonnier inserts short texts between panoramic vistas of the Alps: "You proudly pretend to be the last where once you were led to believe you were the first." With clips of natural wildlife juxtaposed with a costume parade at an amusement park, the artist suggests that in the future, we will only be able to experience the Matterhorn through its replica at Disneyland. See also p. 174.

Self-discovery through a complex and sometimes arduous search for an Absolute Order is a basic theme of our civilization, a theme supporting an enormous literature: Odysseus, Aeneas, the Diaspora, Chaucer, Christopher Columbus, *Pilgrim's Progress*, Gulliver, Jules Verne, Western ethnography, Mao's Long March. This theme does not just thread its way through our literature and our history. It grows and develops, arriving at a kind of final flowering in modernity. What begins as the proper activity of a *hero* (Alexander the Great) develops into the goal of a

The Authentic and the Universal Francesco Bonami

What is *Universal Experience: Art, Life, and the Tourist's Eye?*
This exhibition is both an experience in itself and a show about experiences; it is about the ways in which global tourism is changing art, architecture, the way we look at images, and the world we inhabit. This transformation is reflected in the practice of the mobile and itinerant group of international contemporary artists whose work is included in *Universal Experience*. The works have been selected and juxtaposed so that the visitor will experience the exhibition as both an adventure and a tourist attraction.

> **Tourism has become perhaps the most popular means for individuals to give themselves the sensation that they have stepped outside the norm, while continuing to move within it.**
>
> **John Ralston Saul** *Voltaire's Bastards: The Dictatorship of Reason in the West*

We experience life through encounters, images, objects, and spaces, and our memory is composed of varied, mostly inconsequential, short experiences: new images, new flavors, new sounds, new touches, and new smells. In spite of their seeming unimportance, these sensations shape the way the world is seen and understood. Tourism — in its increasing prevalence, universality even — reduces the complexity of the world. *Universal Experience* considers these issues and suggests that, as growing numbers of people experience the world as tourists, these simple moments of seeing and consuming the same things might help counter traumatic events and balance complex cultural differences.

Universal Experience is an experience dressed as an exhibition, a gallery dressed as a work of art. First installed at the Museum of Contemporary Art in Chicago, in the heart of that city's tourist district, its London showing is at the Hayward Gallery, a building erected in the late 1960s on the South Bank of the River Thames, on the site to which millions of people flocked for the 1951 Festival of Britain. Like the World's Columbian Exposition of 1893 in Chicago, the Festival, which commemorated the Great Victorian

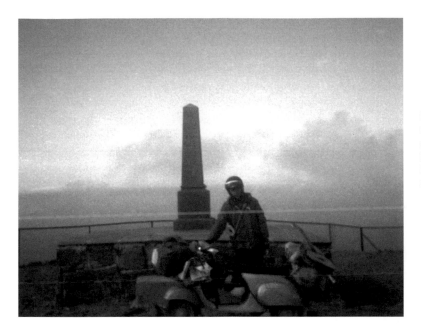

Francesco Bonami at age sixteen, with his Vespa at the North Cape, Norway, 1971.

Exhibition of 1851, was designed for broad public appeal. In the same spirit, the point of entry for *Universal Experience* is conceived to be fluid for scholars, art lovers, or tourists alike.

Whether we travel or not, the modern world increasingly forces us to conform to modes of behavior that mimic the rituals and structures of tourism and the psychology of the tourist. We are encouraged to believe and do as we are told and denied the pleasures of discovery and adventure into uncharted territory. Museums and galleries frequently show the familiar because people have been conditioned not to be attracted by curiosity or mystery, the unknown or the underground.

I remember as a kid my friends and I used to wander and wonder if we were stepping into a spot in the woods where no one had ever walked. We had this craving to discover the untouched, the unknown. I think we all still have this craving, but we cannot satisfy it for fear of making a mistake. With this in mind, *Universal Experience* has been designed to encourage the viewer to enter into a known world and to discover the commonplace and the unknown. It is my hope that this dialogue between the familiar and the alien will open and enrich the lives of visitors to the exhibition.

This show offers the opportunity to experience visions and to reflect on their meaning, but not before your gut has told you something about that experience that only you can know. A mediated world of mass-manufactured mirages, tricks, and look-alike miracles is a difficult world in which to find unique experiences and places. By endlessly reproducing and transmitting the same images around the world, the media creates the powerful impression that we all occupy the same space. *Universal Experience*, however, aims to be like the woods where you wish to find a spot where no one else has been. This discovery is of course an illusion; it is a fiction; and yet this illusion and this fantasy can — at least for a short time — satisfy a need to dream.

Can an exhibition change our lives?

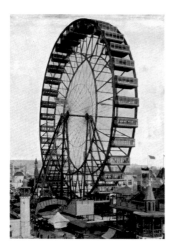

The World's Columbian Exposition of 1893 in Chicago was just this kind of fiction and illusion, and yet it deeply changed the way people experienced modernity and their lives within it. I am fascinated with how the show was organized. My first idea for *Universal Experience* was to create a historical show, but the mandate of a contemporary art curator is to look at the present. I decided to discard the historical approach to tourism, and I slowly transformed the project into an experience in itself, into a tourist attraction.

Today museums and galleries place great emphasis on imparting as much information about their exhibitions as possible in an attempt to entice crowds through their doors. We frequently anticipate criticism by answering questions before they have been asked. The tendency is to approach contemporary art viewers by saying, "Around this corner you are going to see something you probably will not like or understand, but we will help you," rather than, "You are not going to believe what is around this corner!" People often enter contemporary art museums asking, "Where is the Picasso?" Instead of saying, "We are sorry we don't have any Picassos. Would you like your money back?" we should respond, "Here you won't find a Picasso but you will have an experience that will change the way that you look at any Picasso."

The first Ferris Wheel was created for the World's Columbian Exposition.

Tourists visiting St. Peter's Basilica in Rome do not to ask what it is about. They look, they stare, and they wonder in the same way that visitors to the Louvre contemplate the *Victory of Samothrace* before asking about the sculpture's origin. One of the aims of this show is to engage viewers with contemporary art in a way that privileges emotional experiences and the desire to communicate them. To travel is to confront both the mysterious and the universal in the hope that someone at home is waiting to hear the story of our experience of a different world. In this sense, a visit to *Universal Experience* becomes a metaphor for travel into uncharted territory and finding, not the familiar, but the unknown which in our hearts we long to discover.

At the same time *Universal Experience* is a dialogue between icons and icons to be. It questions how tourist attractions, like the Eiffel Tower and the Empire State Building, become works of art, and how works of art, like Leonardo da Vinci's *Last Supper*, become tourist attractions. It explores the shift between the role of tourist, viewer, and spectator, questioning the differences between these roles. Increasingly visitors enter museums as tourists seeking spectacle, and on encountering the perceived mystery of art, are transformed into viewers. As viewers of icons such as the *Last Supper* or Andy Warhol's film *Empire*, they share an experience, becoming tourists and viewers and tourists again, making this exhibition a system of mirrors, where icons, viewers, and tourists reflect each other.

Why *Universal Experience* now?
In 366 AD Pope Damasus tried to convert all Romans to Christianity. When he realized that he would never succeed, he made the church Roman. Likewise, forces within the modern world have tried to convert everything — life, work, family, leisure — into the entertainment business, celebrity industry, and mass culture. That conversion has not been wholly successful, but much of what is widely valued today is judged within these parameters. In a mass-mediated society, the tourist, entertainment, and celebrity industries have all become preeminent.

Today a work of art cannot afford not to become famous. Fame is one of the materials with which contemporary artists work, and many works are conceived as famous before they are created. Artists such as Andy Warhol and Jeff Koons see fame as intrinsic to their role, and they create

bodies of work infused with an aura of fame. For Warhol the aura was innate in the images he used in his paintings from the logos (Coca-Cola bottles, Campbell's soup cans, dollar signs) to the personalities (Mickey Mouse, Elvis, Marilyn, Jackie) that embodied the soul of commodity fetishism. Koons's work, on the other hand, is consciously infused with the Nike syndrome — the transformation of an anonymous object into a symbol, then a universal icon.

Perhaps through this metamorphosis of the empty signifier into the universally recognized brand we discover the core of contemporary existence. The McDonald's golden arches, the shape of the Guggenheim museums in New York and Bilbao, the Nike swoosh, the Apple computer, even Warhol's Campbell's soup cans have all become familiar in their ubiquity. They form and inform the awareness of tourists who look everywhere for

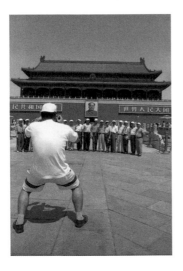

signs, assuring them that they are in the same world as everyone else — a world in which doubt and uncertainty have been eliminated because they are bad for business.

Universal Experience and Universal Truth

Universal Experience examines how truth is constituted, asking, "Which kind of truth do we want to believe when we look at something? Do we like to believe the prescribed version of what we are told, or do we want to find the untold story, the true unabridged tale behind the image?" Can you say that looking at Hiroshi Sugimoto's *Last Supper*—a photograph of a waxwork reconstruction of Leonardo da Vinci's fresco — is less true than looking at the original fresco, itself a Renaissance visualization of a biblical episode? Thanks to its copies the aura of the authentic is amplified, while the fake appears more authentic. The original becomes more familiar and so our emotions and ideas in relation to it are strengthened or weakened as we share them with the world.

People tend to think that they know everything because they believe that they have explored the woods and are wandering the world in search of a true experience. Maybe contemporary art is the ultimate true experience, because we cannot know it yet. Maybe it can lead to the last untouched corner of the woods. Providing more opportunities for people to lose themselves and revel in the unknown — to find truth lying next to fear — could be the next step for museums to create new audiences. Art allows one to question, delve into the unknown, and return unscathed from the journey.

I believe that exhibitions encounter crisis when their creators start to worry more about how their exhibition will be understood than about the experiences that they offer. *Universal Experience* is a modest attempt to make people look first and ask questions later. A work of art changes the way we look at the world when it creates an epiphany. Knowing more about the life of an artist or the technique he or she used is useful, but it rarely results in a revelation. To deprive art of its immediacy is to deprive ourselves of this chance for a possible transformation in the way we see and think.

The prospect of discovering the new and the unknown pushed millions to visit the Great Exhibition of 1851 in London and the World's Columbian Exposition of 1893 in Chicago. Curiosity and awe moved them across the country. They came to witness and to participate in these events but not necessarily to understand them. With displays of objects and people from around the world, the 1851 exhibition presented Great Britain as an unrivalled imperial power leading the world in industry, commerce, and culture. Some forty years later the aim of the Columbian exhibition was almost identical: it maintained that the nation's cultural and educational achievements rivalled those in Europe and asserted a sense of American unity and pride in the country's accomplishments. The Columbian Exposition created a new sense of awareness for the American individual as a modern subject. It lit the way to the future. Americans were encouraged to believe and to trust their nation.

The Columbian Exposition had a $27 million budget, which today would be equivalent to $600 million, and 27 million people attended. At the time it was the only destination in town, and possibly the United States. It offered the unknown — albeit a version of the unknown that aimed to confer a sense of superior identity to white Americans — for a fifty-cent ticket, roughly ten dollars now. Today the number of choices among forms of leisure, entertainment, and culture is immense. Experiences are everywhere. The unknown is lost, and the known is much more expensive.

Millions attended the World's Columbian Exposition to see the White City and other fantastic delights.

While *Universal Experience* cannot aspire to the popularity of the Columbian Exposition or the Great Exhibition of 1851, it offers a special experience to viewers willing to encounter the doubt of the future and uncertain of why they are looking at these works, images, and ideas. It aims to push galleries and their visitors through a threshold. Contemporary art can illuminate the present and the future by

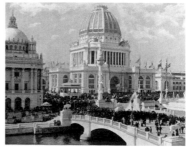

offering a new and uncharted section of the woods that can be experienced with trust, curiosity, and new expectations.

Today only fragments remain from the monumental exhibitions of the nineteenth century. At that time experience was concentrated in a physical place. We can now receive experiences through a variety of media — regardless of where we are. Museums and galleries remain the last places where the relationship between space and time has been maintained. Their physicality is essential to how the stories they tell unfold. They provide experiences lived in real time and space, no matter how virtual, entertainment-driven, and colonized by commodity culture the rest of the world has become.

Museums and galleries, arrival or departure?

The museum or gallery is a terminal where another group of contemporary tourists — the artists — stop. They tell their stories, their truths, and their lies. Audiences listen to these storytellers and image makers and share their experiences. As if in an airport for a moment they share the lives of unknown people, feel a part of the same world, and forget about the other worlds that have been left behind. And each time an artist's work is shown, these shared experiences are repeated and retold.

I have tried to make an exhibition with the potential to become an event. Yet I do not want to build expectations. I do not want to create a success story before it is even a story. Tourist attractions are built success stories — people go to see them because their fame precedes their original and historical value. Their importance within their social context has been lost in the void of popular reputation.

Success, once a result, is now a starting point. The task of the museum or gallery press office is to present the show as a success before it has happened. Journalists want to know as much as possible in advance before they will enter a show. Like tourists, they want to feel they are moving into a known territory. They do not like to be taken off guard or to leave a show with questions. Instead they simply want answers, *their* answers probably. Understanding is no longer an achievement, but a demand to be met. Again, fears and doubts have been removed from contemporary experience, because the experiences we undertake today are predetermined and mass-manufactured.

The same few architects build major museums and buildings, because their work comes prepackaged as a success story. Their projects are famous before

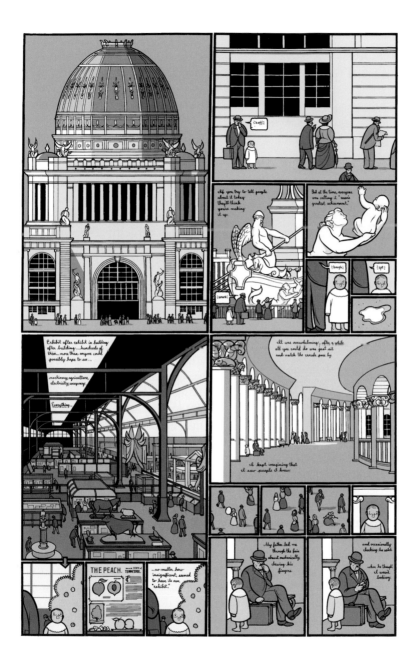

 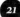

"Travel and tourism" is the largest industry in the world, accounting for 11.7 per cent of the world G.D.P.

John Urry, *The Tourist Gaze*

Number of international passenger arrivals in 1950: **25 million**

Number of international passenger arrivals each year as of 2000: **698 million**

Projected international passenger arrivals by 2010: **1 billion**
By 2020: **1.6 billion**

Number of air passengers each day in the US: **2 million**

Number of passengers in flight *above* the U.S. at any one time: **300,000**

Number of hotel rooms built annually: **500,000**

Number of refugees across the globe: **31 million**

Number of visitor attractions in 1960: **800** In 1983: **2,300**
In 2000: **6,100**

(Source: John Urry, *The Tourist Gaze,* pp. 5 and 6)

they have even been designed. The time when the French government would take a chance in giving almost unknown architects like Renzo Piano and Richard Rogers an outrageous commission for the biggest museum in Paris — the Pompidou Center — has passed.

The culture of mass-manufactured experience, instant success, entertainment, and reward is a dangerous one in which to live. It considers viewers as idiots trapped in a confusing world, deprived of curiosity, desires, and needs. Even those who work in museums and galleries admit that the general public fears these institutions and the art in them. So the result is to feed them not what they truly crave — mystery and the unexpected — but the familiar — the Impressionists, Picasso, and Warhol. The public is served a prix fixe menu of experiences, images, words, and ideas. While they hunger for a vision, they are fed an explanation, and in the process their minds are slowly closed, no longer capable of experiencing visions.

I hope that this exhibition will contain some of the raw material of experience: complications, unexpected turns, and unknown corners that we desire because they allow us to make our own discoveries. An explanation destroys this raw material. The discovery has been made by someone else and is lost to us.

When the world has become completely homogenized, we will finally say that the end has arrived. The Day of Judgement is the day when all humanity will see the same world simultaneously. Standing in front of the same tourist attractions, wearing the same clothes, and eating the same food creates the illusion of safety. When doubt, curiosity, and mystery are eradicated, it will echo the paradox of impressionism — open visual

experience freed from academic rules only to become a tool to make reality flat, academic, and predictable. The icons of impressionism, once new and radical, have been transformed into marketing tools.

At the end of the *Divine Comedy*, Dante encounters God in the form of a blinding light, not as image, just as light. All of us are searching for that light in this world through art, architecture, and brief experiences. Tourists search for artificially mediated truth and meaning. They stand in awe of an art object after "awe" has been constructed in their minds through magazines, television, and advertising. In our age, words have lost the war against images. When violence is not directly experienced or witnessed with our eyes, it seems less horrific and less real.

When two planes flew into the World Trade Center on September 11, 2001, more than 3,000 people died in full view of the world's media. The images of devastation were so potent, so visceral, that four years later the world still grapples with their effects. Hundreds of thousands died in Rwanda untelevised, and yet much of the horror was diluted in imageless newspaper articles; the lack of images mirrored the denial of the situation and the wider world's failure to intervene. Image is the medium through which truth is constructed and political action is justified.

One can travel the world and see nothing. To achieve understanding it is necessary not to see many things, but to look hard at what you do see. Giorgio Morandi quoted in Michael Kimmelman, "Looking Long and Hard"

Universal Experience began as a tourist's tale, a caravan going through the center of the earth to reappear in front of a museum in Chicago, a fantasy turned into an object, turned into an experience and an attraction. Traveling by sea and air *Universal Experience* has transformed itself to reappear in London. With the nomadic movement of its artworks, the exhibition, which was conceived as fantasy turned into reality, becomes an experience translated through the eyes of the viewer, with questions unanswered and doubts alive.

Magical Traces

The writings and artworks presented in this section explore ancient and modern travel. Since primitive times, people have marked places they believe to be sacred with altars, temples, and other structures. The first tourists — sages and pilgrims seeking meaning — set out to find, visit, and learn from these markers.

Most of us are no longer pilgrims on pilgrimages. Urban living, easy mobility, and the exchange of capital have transformed how we live, why we travel, and how we see. Recording the changes of sensibility brought on by the modern world, the nineteenth-century flaneur strolled along wide, ordered city streets lit by gas light. The contemporary tourist, often dislocated and adrift, seeks a vista of the past to understand the present. The contemporary artist can be seen as a journalist (the word comes from *journey*) who reflects on the world and creates new markers and signs.

OPPOSITE
Matthew Barney
CREMASTER 3, 2002
Production still of Fingal on the Giants' Causeway
Courtesy Gladstone Gallery

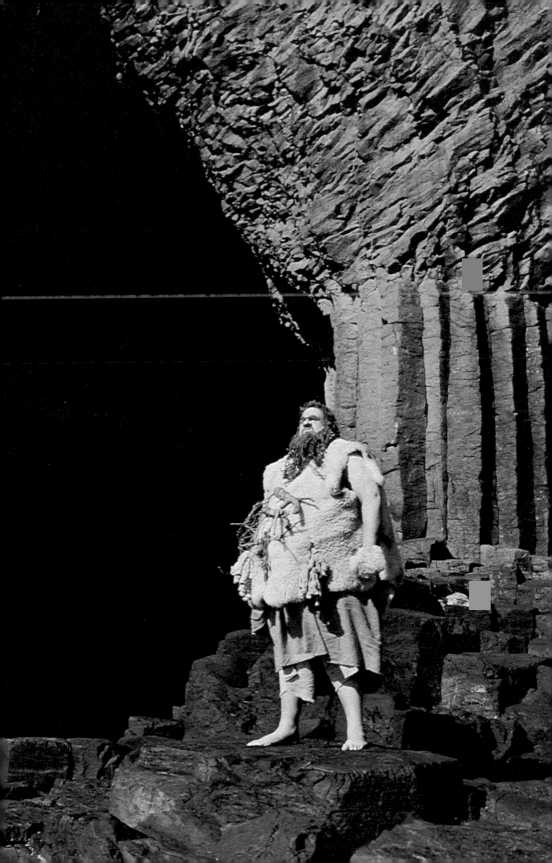

The starting point of critical elaboration is the consciousness of what one really is, and is "knowing thyself" as a product of the historical process to date, which has deposited in you an infinity of traces, without leaving an inventory. . . . Therefore it is imperative at the outset to compile such an inventory.

Antonio Gramsci
in Edward Said, *Orientalism*

Bruce Chatwin *What Am I Doing Here*,
pp. 138–39

[Werner Herzog] was . . . the only person with whom I could have a one-to-one conversation on what I would call the sacramental aspect of walking. He and I share a belief that walking is not simply therapeutic for oneself but it is a poetic activity than can cure the world of its ills. He sums up his position in a stern pronouncement: "Walking is virtue, tourism deadly sin." A striking example of this philosophy was his winter pilgrimage to see Lotte Eisner.

Lotte Eisner, film critic and associate of Fritz Lang in Berlin, had emigrated in the early 1930s to Paris, where she helped found the Cinémathèque. . . .

She was soon to become a guiding spirit of the new German cinema. . . . Werner, I'm told, was her favourite. And in 1974, when he heard she was dying, he set out walking, through ice and snow, from Munich to Paris, confident that somehow he could walk away her sickness.

Werner Herzog *Of Walking in Ice*, pp. 1 and 57

SATURDAY 11/23/74
Right after 500 metres or so I made my first stop near the Pasinger Hospital, from where I wanted to turn west. With my compass I gauged the direction of Paris, now I know it. . . .

Our Eisner must not die, she will not die, I won't permit it. She is not dying now because she is not dying. Not now, no, she is not allowed. My steps are firm. And now the earth trembles. When I move, a buffalo moves. When I rest, a mountain reposes. She wouldn't dare! She musn't. She won't. When I'm in Paris she will be alive.

SATURDAY 12/14/74
As afterthought just this: I went to Madame Eisner, she was still tired and marked by her illness. Someone must have told her on the phone that

An almost universal motif for the explanation and description of life is the journey, for journeys are marked by beginnings and ends, and by a succession of events along the way.

Nelson H. H. Graburn
"Tourism: The Sacred Journey"

A journey of a thousand miles starts with a single step. **Lao Tzu**

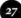

ⵏ *Magical Traces* **27**

Tourism can be a bridge to an appreciation of cultural relativity and international understanding.

Valene L. Smith *Hosts and Guests: The Anthropology of Tourism*

I had come on foot, I didn't want to mention it. I was embarrassed and placed my smarting legs up on a second armchair, which she pushed over to me. In my embarrassment, a thought passed through my head, and since the situation was strange anyway, I told it to her. Together, I said, we shall boil fire and stop fish. Then she looked at me and smiled very delicately, and since she knew that I was alone on foot and therefore unprotected, she understood me. For one splendid fleeting moment something mellow flowed through my deadly tired body. I said to her, open the window, from these last days onward I can fly.

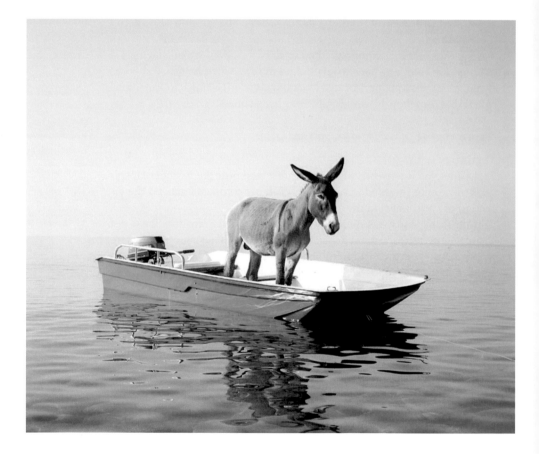

Eric J. Leed *The Mind of the Traveler:*
From Gilgamesh to Global Tourism, pp. 2–3 and 4

Travel is as familiar as the experience of the body, the wind, the earth, and this is why at all times and in all places it is a source of reference, a ground of symbols and metaphors, a resource of signification. The anthropologist and historian of religions Mircea Eliade laments the absence of genuine rituals of intiation in modern life and suggests that "modern man has lost all sense of traditional initiation."[1] But perhaps it is only that the

> In Middle English, the word *progress* meant a *journey*, particularly a *seasonal journey* or *circuit*. **Bruce Chatwin** *The Songlines*

reality of the passage has replaced the ritual, and the most important transitions we experience are written into our journeys, which make of our lives a procession and spectacle more engrossing and transforming than any ritual could possibly be. . . .

If one broadens the definition of travel to encompass all passage across significant boundaries that separate differing personas, kinds of social relations, activities, then it becomes obvious that travel is much more than common. It is an activity that weaves the fabric of contemporary lives. Very few of us eat, sleep, work, and play in the same place — this would be a definition of confinement and unfreedom. Normally our lives are segmented into places of work, play, privacy, to be joined through territorial passage along the corridors and passageways, road and rail networks of modern metropolitan areas — those extended "cities" that differ so markedly from ancient cities. . . . [I]n modern metropolitan corridors, the vast majority of human relations are relations between strangers, who are served by a variety of roads, markets, communicational networks, pathways that constitute our cities. The contrast is sufficiently powerful to draw millions of tourists out of our modernity back into those ancient cities of Mesopotamia, Egypt, ancient Europe, to experience the difference between contained lives and lives lived openly and in passage.

1 Mircea Eliade, *The Rites and Symbols of Initiation*
(New York: Harper Torchbooks, 1965), p. 134.

OPPOSITE
Paola Pivi (Italian, b. 1971)
Untitled (donkey), 2003

Originally displayed as a billboard along a canal in Venice during the 2003 Venice Biennial, Pivi's absurd and enigmatic image of two of the oldest forms of transportation challenges our abilities to discern truth and fiction. While seeming to be the result of digital manipulation, Pivi in fact photographed this and other whimsical scenes of displaced animals, such as two zebras in snowy mountains and an ostrich in the ocean, on location.

Pico Iyer *Video Night in Kathmandu:*
And Other Reports from the Not-So-Far East, p. 23

Every trip we take deposits us at the same forking of the paths: it can be a shortcut to alienation — removed from our home and distanced from our immediate surroundings, we can afford to be contemptuous of both; or it can be a voyage into renewal, as leaving our selves and pasts at home and traveling light, we recover our innocence abroad. . . . If every journey makes us wiser about the world, it also returns us to a sort of childhood. In alien parts, we speak more simply, in our own or some other language, move more freely, unencumbered by the histories that we carry around at home, and look more excitedly, with eyes of wonder. And if every trip worth taking is both a tragedy and a comedy, rich with melodrama and farce, it is also, at its heart, a love story. The romance with the foreign must certainly be leavened with a spirit of keen and unillusioned realism; but it must also be observed with a measure of faith.

Eric J. Leed *The Mind of the Traveler: From Gilgamesh to Global Tourism,* pp. 4, 105–6

Contemporary society, as many have noted, is a "mobile" society, but even more than that, it is a society of travelers. Contemporary life is perhaps unprecedented in the scale, quantity, and global organization of modern journeys, and yet it is clear that travel is not a new human experience. Mobility is the first, prehistorical human condition; sessility (attachment or fixation to one place), a later, historical condition. At the dawn of history, humans were migratory animals. Recorded history — the history of civ-

OPPOSITE
Simon Starling (British, b. 1967)
Tabernas Desert Run, 2004

"On the 9th of September 2004, I crossed the Tabernas Desert on an improvised, fuel-cell-powered, electric bicycle. The entire journey of 41 miles over undulating terrain required the use of 2 lightweight gas bottles containing 800 litres of compressed hydrogen. The only waste product from 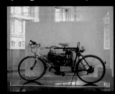 the moped's desert crossing was pure water, of which 600ml were captured in a water bottle mounted below the fuel cell — the rest escaped as water vapour. The captured water was used to produce a 'botanical' painting of an Opuntia cactus. The painting of this most 'ergonomic' of plants refers back to the site of the journey and in a way to Sergio Leone (who introduced cacti into the area as part of the film sets) while also parodying my somewhat clumsy prototype moped. The whole project is exhibited within a sealed perspex vitrine, as a kind of closed, symbiotic system, referring in part to Hans Haacke's *Condensation Cube.* The work makes a direct reference to Chris Burden's 1977 *Death Valley Run,* a desert crossing made on a bike powered with a tiny petrol engine."

— Simon Starling

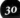

UNIVERSAL EXPERIENCE *Art, Life, and the Tourist's Eye*

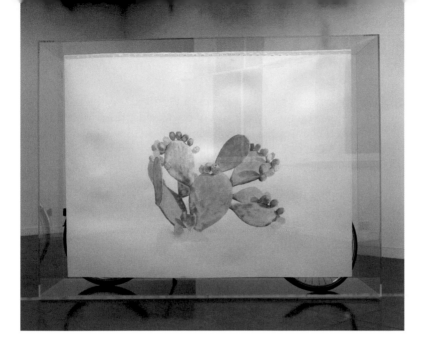

ilization — is a story of mobilities, migrations, settlements, of the adaptation of human groups to place and their integration into topography, the creation of "homes." In order to understand our present, we must understand how mobility has operated historically, in the past, as a force of change, transforming personalities, social landscapes, human topographies, creating a global civilization. . . .

Travelers — particularly before the modern era of print and electronic media — were a primary source of news and information about the outer world, and journalism begins in the journeys and journals of seventeenth-century travelers. The traveler, too, was a source of entertainment, of novelties, of comic relief, as well as of new conceits and designs. Certain species of travelers — singers of tales, bards (called *griots* in Africa), minstrels, comic actors, mountebanks — specialized in these functions and were welcome and honored guests. . . .

> ## The only true democracy, D. H. Lawrence once wrote, is Whitman's version, in which "soul meets soul on the open road."
>
> **Pico Iyer** *Video Night in Kathmandu: And Other Reports from the Not-So-Far East*

Travel is a primary source of the "new" in history. The displacements of the journey create exotica (matter out of place) and rarities, as well as generating that peculiar species of social being of unknown identity — the stranger. Travel also creates new social groups and bonds between strangers who meet in passing, and who are bound by a common motion, destination, or purpose. . . .

Those who bear the impress of many passages — professionals in the transport industries, sailors, teamsters, soldiers on expedition, missionaries and merchants, indefatigable tourists and anthropologists — are, in fact, the brokers of contacts among cultural domains, architects of a world that grows out of "external" relations, from the outside in.

Boris Groys "The City in the Age of Touristic Reproduction"
[A]bove all, it is today's artists and intellectuals that are spending most of their time in transit — rushing from one exhibition to the next, from one project to another, from one lecture to the next or from one cultural context to another. All active participants in today's cultural world are now expected to offer their productive output to a global audience, to be prepared to be constantly on the move from one venue to the next and to present their work with equal persuasion, regardless of where they are. A life spent in transit like this is bound up with equal degrees of hope and fear. On the one hand, artists are now given the possibility of evading the pressure of prevailing local tastes in a relatively painless way. Thanks to modern means of communication they can seek out like-minded associates from all over the world instead of having to adjust to the tastes and cultural orientation of their immediate surroundings. This, incidentally, also explains the somewhat depoliticized condition of contemporary art that is so frequently deplored. In former times, artists compensated for the lack of response to their work among people of their own culture by projecting their aspirations largely on the future dreaming of political changes that would one day spawn a new and future viewer of their work. . . . Rather than practising avant-garde politics based on the future, we now embrace the politics of travel, migration and nomadic life, paradoxically rekindling the utopian dimension that had ostensibly died out in the era of romantic tourism.

UNIVERSAL EXPERIENCE *Art, Life, and the Tourist's Eye*

This means that as travelers we are now observers, not so much of various local settings than of our fellow travelers, all caught up in a permanent global journey that has become identical with life in the world city. . . . We are now prepared to be attracted and persuaded particularly by artistic strategies capable of producing art that achieves the same degree of success regardless of the cultural context and conditions in which it is viewed. What fascinates us nowadays is precisely not locally defined differences and cultural identities but artistic forms that persistently manage to assert their own specific identity and integrity wherever they are presented. Since we have all become tourists capable only of observing other tourists, what especially impresses us about all things, customs, and practices is their capacity for reproduction, dissemination, self-preservation, and survival under the most diverse local conditions.

From the Middle Ages onward, master craftsmen traveled all over Europe to build cathedrals and palaces, attracted now by the wealth of one city, then by that of another. Milanese stonemasons built fortresses for Teutonic knights in Poland; Venetian architects and painters went to decorate the courts of the tsars of Russia. Even Leonardo, that paragon of creativity, kept serving one master after another depending on whether duke, pope, or king could best finance his dreams.

Mihaly Csikszentmihalyi
*Creativity: Flow and the Psychology
of Discovery and Invention*

Bernard Lewis *From Babel to Dragomans: Interpreting the Middle East,* p. 137–38

[T]he pilgrimage — more specifically the Muslim pilgrimage to Mecca and Medina — is the first really major factor of personal travel over vast distances in human history, and for long it remained the most important single factor.

There were of course pilgrimages before the advent of Islam; pilgrimage was practiced by both Jews and Christians as well as in some of the Eastern religions. But it is usually, almost invariably, what one might call in modern parlance an optional extra.

It is not optional in Islam. A Muslim is required, as one of the five pillars of his faith, on par with belief, prayer, fasting, and charity, to go at least once in a lifetime to the sacred places in Mecca and Medina where the Prophet was born and carried out his mission, and to do so at a specified time in the year, in the sacred month of communal pilgrimage. Christians and Jews could go on pilgrimage to Jerusalem at any time, whenever convenient. . . .

Every year, great numbers of Muslims, from many countries and from different races and social strata, leave their homes and travel, often over vast distances, to take part in a common act of worship. These journeys, unlike the mindless collective migrations familiar in ancient and medieval times, are voluntary and individual. Each is a personal act, following a personal decision, and resulting in a wide range of significant personal experience.

This degree of physical mobility, without parallel in pre-modern societies, involves important social, intellectual, and economic consequences

In general, the ancients most valued the journey as a revelation of those forces that sustain and shape, alter, and govern human destinies. **Eric J. Leed**
The Mind of the Traveler: From Gilgamesh to Global Tourism

UNIVERSAL EXPERIENCE *Art, Life, and the Tourist's Eye*

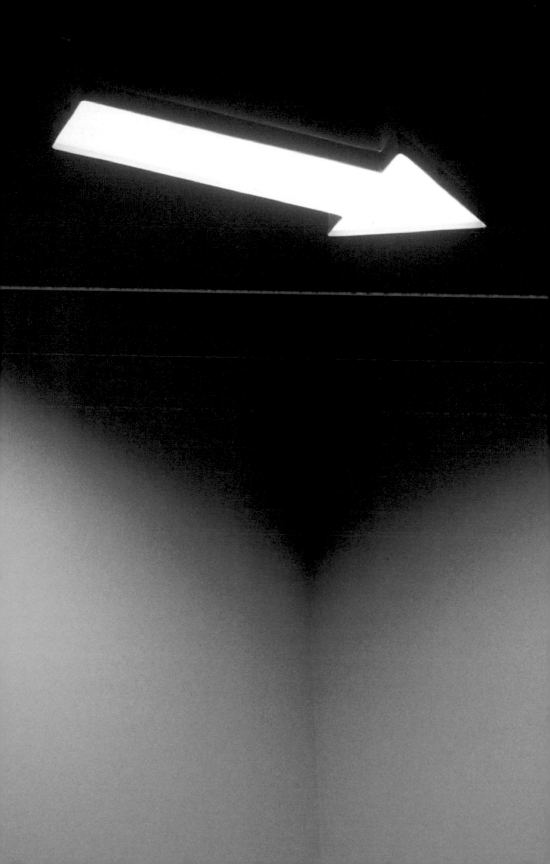

> # Pilgrimage is the ... formalization of the notion that travel purifies, cleanses, removes the wanderer from the site of transgressions.
>
> **Eric J. Leed** *The Mind of the Traveler: From Gilgamesh to Global Tourism*

The needs of the pilgrimage — the demands of the faith reinforcing the requirements of government and commerce — help to maintain a network of communications between the far-flung Muslim lands; the experience of the pilgrimage gives rise to a rich literature of travel, bringing information about distant places, and a heightened awareness of belonging to a larger whole. This awareness is reinforced by participation in the common rituals and ceremonies of the pilgrimage in Mecca and Medina, and the communion with fellow Muslims of other lands and peoples. The physical mobility of important groups of people entails a measure of social and cultural mobility, and a corresponding evolution of institutions.

Islamic history offers many examples of the impact of the pilgrimage; the biographies of learned and holy men are full of accounts of formative meetings and studies in the Holy Cities, on the way there, and on the way back. The wandering scholar is a familiar feature of medieval societies: the pilgrimage ensured that the wanderers met, at a determined time and place. It provided the Islamic world as a whole with a centre and a forum, which already in medieval times contributed greatly to the formation and maintenance of an Islamic consensus — almost, one might say, an Islamic public opinion.

Carol Becker "Pilgrimage to My Lai: Social Memory and the Making of Art," p. 57–61

In January 2002 Carol Becker, accompanied by her colleagues Jeffrey Skoller and Stanley Murashige, took a group of students from the School of the Art Institute of Chicago to Vietnam to study the Vietnam War. Of all the sites they visited none had as powerful and profound an effect as their visit to My Lai. The following is an excerpt from the essay she wrote on her return from that trip.

THE NATURE OF PILGRIMAGE

Various conditions are associated with the notion of pilgrimage. The most primary is the simple movement away from and toward place. Peter Harbison, in *Pilgrimage in Ireland*, writes: "What sparked the first Christian pilgrimage was the desire felt by St. Paul to stand on the same ground the Savior had trodden."[1]

One needs to leave the mundaneity of one's life and become a seeker of that which is sacred: in oneself, in the world, and in those metaphysical realms that cannot be known in this world. In order to set out on a pilgrimage, space must metamorphose into metaphor. Once the journey has begun, the ground one walks on, the distance one travels, becomes a mirror for the evolution of one's own spirituality. This is an important element of pilgrimage — while walking, journeying, traveling to a designated place, the act of getting there is as important as the arrival. During that time of travel, it is assumed that one will undergo a certain transformation of consciousness that cannot be achieved when one is immersed in daily life. Harbison continues, "The act of going on pilgrimage is common to many religions, not only Christianity but Islam, Hinduism, and Buddhism as well. Nomadic people feel no need for it, as they are on the move anyway. It is a phenomenon found only among settled communities, usually those which have a considerable cultural development behind them."[2]

The act of going on pilgrimage may derive from a desire to seek absolution, but it might also be an expression of pain and compassion. It might come from needing or wanting something for oneself or one's loved ones, or, as in the case of our visit to My Lai, it might be a symbolic gesture, not only for oneself, but also for one's country; an attempt to resolve what remains unresolved. Whatever the motivation, there is a purposefulness about such a journey that separates it from the randomness and pleasure-seeking of mundane travel. The intention of this type of journey is not to change the world, but to change oneself: to achieve a consciousness and spiritual transformation while connecting with the history of others who have trodden the same path.

The time of the journey (which for the pilgrims of the Middle Ages might have extended over years) becomes mythic. It moves us into another, more informal way of measuring time that is much more internal and upon which one places a great deal of symbolic meaning. If this meaning is shared by a large group of people, as it often is when connected to famous sites of pilgrimage such as Croagh Patrick in Ireland or Santiago de Compostela in Spain — then the journey takes place in mythic time and mythic space. In *Roads to Santiago,* Cees Nooteboom writes:

> It is impossible to prove and yet I believe it: there are some places in the world where one is mysteriously magnified on arrival or departure by the emotions of all those who have arrived and departed before. . . .

1 Peter Harbison, *Pilgrimage in Ireland: The Monuments and the People* (London: Rarrie and Jenkins, 1997), p. 23.

2 Ibid.

At the entrance of the cathedral in Santiago de Compostela there is a marble column with deep impressions of fingers, an emotional, expressionistic claw created by millions of hands. . . . by laying my hand in the hollow one I was participating in a collective work of art. An idea becomes visible in matter. . . . The power of an idea impelled kings, peasants, monks to lay their hands on exactly that spot on the column, each successive hand removed the minutest particle of marble so that, precisely where the marble had been erased, a negative hand became visible.[3]

This is the symbolic made manifest through gesture. You can only participate in this collective act by physically standing in the exact place others have stood: St. Paul's motivation to stand where Christ had stood.

One can speak of sites that have seen pilgrims for centuries, like Santiago de Compostela, but one can also speak of places that have become sacred overnight, like the former World Trade Center. At first the World Trade Center was a site of horrific devastation, but it quickly became a place of visitation and mourning for New Yorkers, and then for those who traveled to the city. Now there is a viewing platform from which people can observe the site of the buildings' collapse. There is no longer anything physical to see — just a gigantic absence — but nonetheless, people come to pay homage. And to see with their own eyes, to feel in their own bodies the tremendous emptiness that remains. At least for now, until there is new construction, this deep pit will be considered hallowed ground that memorializes the thousands who died there.

The authors of *Image and Pilgrimage in Christian Culture* write that "a tourist is half a pilgrim, if a pilgrim is half a tourist."[4] We might say that one difference between pilgrims and tourists is that for pilgrims, the road to the site, the process of getting there, is as important as the arrival. It is filled with the anticipation of some spiritual event that will occur as they travel, when they arrive, and while they are there. This of course can be true of tourism as well: one can anticipate the cathedral at Cologne, the Pyramids, or even the Acropolis as did Freud, with a sense that after having experienced these phenomena, one will never be the same. The difference is that a great deal of tourism is about consumption and acquisition of culture, the natural landscape, or both. One seeks out certain places because it is believed that to be a cultured or worldly person, one must have the experience of visiting them: Venice, Paris, Istanbul, the Grand Canyon, Niagara Falls, the Nile. One visits, just to have seen them, just to know, in a

sense, what all the fuss is about. In this acquisitive mode, all will photograph, and some will physically take something from the site: stones from the foundation of the Parthenon, pieces of the Berlin Wall, magazine cutouts of movie stars from the wall of Anne Frank's bedroom in the Annex; maybe fake, maybe stolen, ancient ceramic turtles, sold at the site of Monte Albán. Others would be horrified to remove anything from such sites and will want to alchemize the experience psychically. Pilgrims, in particular, journey for the spirit, seeking purification or the granting of a wish or a prayer, while most others who travel are attracted by the external phenomena they might encounter. Some even want to circumvent the *going* entirely. I was quite taken aback when my mother suggested, only a bit tongue-in-cheek, that my trip to and time spent in Bellagio, Italy, could have been avoided by simply visiting Bellagio, Las Vegas. "You don't really need to travel anymore. You have it all in Las Vegas," she said. Some will be satisfied with simulacra. Others will always have to go.

But why? What does one want from such experiences? For those who have studied art history, the thought of actually seeing the paintings of Fra Angelico in Florence in the cells and niches of the Dominican priory for which they were painted is comparable to a religious experience; not because of the content of the paintings per se, but because one is transformed by what Walter Benjamin refers to as "aura," the experience of the art, as it was meant to be had in its intended actual location. No matter how many replicas of the Acropolis we might find in Nashville, Tennessee, there is nothing like standing on the actual site: the air, the light, the position of the rock over the city embracing its totality from 360 degrees, and its arched posture looking down at the Agora, the place in which it has stood since antiquity, are transformative. The experience links the traveler, pilgrim, tourist with history and, in this case, with the evolution of Western Civilization. It makes the past present, transforms the present into the past. Walking up to the Acropolis or down from it, one imagines that the cicadas one hears have been there for centuries. Nothing you can read, no simulations you may see, can give you that experience. And why is that? Because the experience takes place only through the sensation of the flesh. It is the physical knowing that links us to the body of collective memory.

There is a moveable wall called *The Wall that Heals* that simulates the permanent Vietnam Veterans Memorial designed by Maya Lin. The portable wall, which is a half-scale replica made of powder-coated aluminum, can never embody the physical and spiritual gravity of the actual

3 Cees Nooteboom, *Roads to Santiago: A Modern Day Pilgrimage through Spain*, trans. Ina Rilke (New York: Harcourt, 1997), p. 3.

4 Victor Turner and Edith Turner, *Image and Pilgrimage in Christian Culture: Anthropological Perspectives* (New York: Columbia University Press, 1978), 20.

granite wall. It has not absorbed the pain of the millions who have come to the actual wall as mourners and supplicants for twenty years now, praying on behalf of those who died. And although many viewers find the portable wall powerful, it cannot hold the weight of the 58,000 Americans and all the Vietnamese who died or the faith in the United States that died for many with the pain and shame that accompanied the war. At the actual wall in Washington D. C., one doesn't even need to see the wall to feel its presence. Walking towards it, one begins to internalize the palpable sadness of the thousands who have come before. The memorial has become a repository for all the complex emotions associated with the war. For many Vietnam veterans it has become a destination for pilgrimage.

Such space is the opposite of nonspace, mall-space, suburban space, cor-porate, generic, or interchangeable space — the spaces of postmodernity. The Vietnam Veterans Memorial is well-designed and conceptualized space that has become ritualized through the spontaneity of the masses. As the artist/architect of this project, Maya Lin could never have imagined how her design would be transformed.

The Vietnam Veterans Memorial was also immediately turned into a site of offering by all the visitors who brought things to it. Soon a museum will be built to house the collection of objects left at the wall. Similarly, hand-made altars immediately marked the perimeter of Ground Zero: candles, flowers, photos, offerings.

Pilgrimages have always been democratic in just this way. For the Greeks, the long journey to Delphi was about locating the future, the travel to Eleusis about finding the Mysteries — the fate that would befall them after death. In Christianity such pilgrimages existed outside the hierarchy of the church and the domain of priests and clerics. They arose spontaneously. Their perpetuation built community. Seekers of all kinds became equal as they undertook the journey. Because every pilgrim who comes must walk up the very difficult mountain of shale to get to the top of Croagh Patrick, the journey becomes about the community that is formed each time by those making it. They all find, in turn, their own internal peace through the process. Historically, when seekers could not physically go on such journeys, there were simulated pilgrimages close to home, such as that designed for the cathedral of Chartres. One could walk the length of the pilgrimage "in time" in the cathedral's eleven-circuit stone labyrinth set in the nave. This could serve as a substitute for the actual pilgrimage to Jerusalem and as a result came to be known as Chemin de Jerusalem or Road to Jerusalem. But

UNIVERSAL EXPERIENCE *Art, Life, and the Tourist's Eye*

in the actual journeys, the going is far different than the return, or as Victor and Edith Turner write: "Indeed, even when pilgrims return by the way they came, the total journey may still be represented, not unfittingly, by an ellipse, if psychological factors are taken into account. For the return road is, psychologically, different from the approach road."[5] The purposefulness and focus of the *going* may be over, while the *returning* to one's own life is full of a new expectation — that one will somehow return transformed.

Dinh Q. Lê and Moira Roth "Cuoc Trao Doi Giua / Of Memory and History: An [E-Mail] Exchange between Dinh Q. Lê and Moira Roth, June 1999 – April 2003," pp. 11 and 17

June 15, 1999, Ho Chi Minh City
DL: Every trip back to Vietnam, I would bring a handful of American soil to Vietnam. I would mix the soil in the heavily silted water of the Mekong River as a way to spread this handful of soil throughout Vietnam. By doing this I hoped to help the wandering souls of all American MIAs lost in the jungle of Vietnam to have some sense of home. I hope this will help them rest in peace. I feel that in order for Vietnam to heal from the war, we need to help all the *oan hon* (lost souls) from the war find some peace.

MR: *What does the site of My Lai look like now? . . . Do people speak about My Lai in Vietnam? How do you as an artist (as well as a person) decide which memories to preserve?*

August 7, 1999, Ho Chi Minh City
DL: I have never been to My Lai but I plan to do so on August 12. People here don't talk at all about My Lai. The older people remember but know very little about it. I think that nature definitely has a hand in the way we slowly forget things. Nature designed our brains to remember but also to forget. Nature never intended for us to remember everything.

In the My Lai case, as an artist and as a person, I feel that the victims are one of its most overlooked aspects. Our memory of the incident is only of the massacre. I do not want to remember the victims only at the most horrific moment of their lives. What were their lives like before they were taken from them, and what would they be like today if they had not died? What gives them hope, keeps their dreams and happiness? . . . Who were these people that have become a symbol of guilt in America's conscience? These are the memories that have been completely forgotten, and these are the memories I want people to start remembering.

August 25, 1999, Ho Chi Minh City
I have just gotten back from My Lai. It was nothing
like what I had expected or heard. It is an unpreten-
tious little park, which from the outside looks like a lit-
tle school with two little buildings on the property.
The second is the exhibition hall where the pho-
tographs of the incident are on display — gruesome,
but I felt they were necessary. There is a list of all the
victims and their ages, and in a display case are house-
hold objects belonging to them, ranging from hats to
pots. . . . I do not feel it was a "theme" park or full of
propaganda — which makes me quite curious about
the reactions of American friends and some American
Vietnam vets who see the place as full of propaganda.

March 15, 2003, Los Angeles
I think my work over the years has always been very
much about everyday Vietnamese people in ex-
traordinary situations. In a profound way I have always

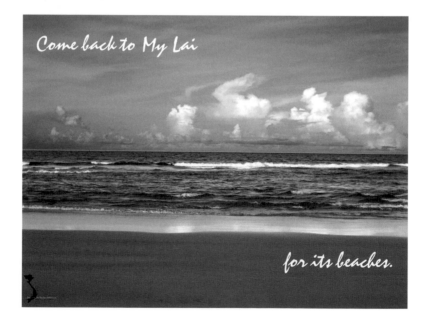

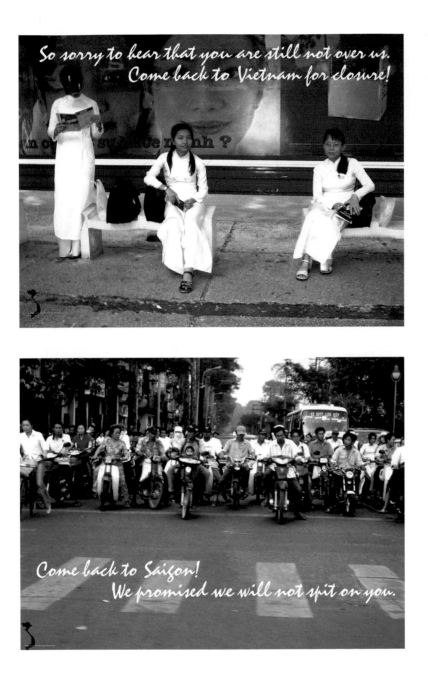

So sorry to hear that you are still not over us.
Come back to Vietnam for closure!

Come back to Saigon!
We promised we will not spit on you.

Hein's sculptures and installations are physically engaging investigations of cubes and grids. As viewers walk through *Mirror Labyrinth*, they become disoriented within the infinite reflections of themselves and their surroundings. The installation recalls both the ancient Labyrinth of Hawara in Egypt, a famous site for ancient tourists who 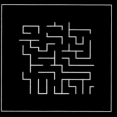 thought it was a prototype for the Cretan version inhabited by the mythic Minotaur, and Robert Smithson's *Mirror Displacements*, in which the artist placed small square mirrors into natural landscapes as ephemeral installations. The idea of the maze also has roots in English landscape architecture (the oldest hedge maze is from 1690 in Hampton Court in London). Although it was not realized, Hein appropriately envisioned *Mirror Labyrinth* in the MCA sculpture garden for *Universal Experience*.

focused on them and tried to give them a voice because they are always the ones who have been forgotten.... And, yes, I definitely want to focus now even more emphatically on the "Vietnamese" side because the history of the Vietnam War has pretty much been written by the West. I think it is time that our forgotten voices speak up and be heard.

MR: *How are you affected by living so much of the year in Vietnam?*

DL: A good friend of mine just pointed out that whenever I speak of Vietnam, I use "we" instead of "them." These days, I see myself as Vietnamese, no longer as Vietnamese-American. Unfortunately, the Vietnamese government still sees me as a foreigner....

MR: *Do you talk with friends, with strangers there about their memories of the war?*

DL: I do talk to friends and strangers about the war once in a while. It is like an old wound that has never properly healed. For the men, anger always surfaces when we talk of the war. The women always end up in sadness from remembering the loss of their loved ones. But what I have found overall is that although it is very difficult for them, there is indeed a desire to talk about their experiences of the war.

After the war, we were left with a country in ruins, so our first priorities were to survive, to rebuild, and to move forward....

Now the country is doing pretty well. Enough time has passed to give us a psychological distance from the war, so more and more people are starting to deal with it.

Mention of the mythical is unavoidable in discussions of travel and tourism.

Chris Rojek "Indexing, Dragging, and the Social Construction of Tourist Sights"

Mircea Eliade *Myth and Reality*, pp. 139 and 141

Myths are the most general and effective means of awakening and maintaining consciousness of another world, a beyond, whether it be the divine world or the world of the Ancestors. This "other world" represents a superhuman, "transcendent" plane, the place of absolute realities. It is the experience of the sacred — that is, an encounter with a transhuman reality — which gives birth to the idea that something really exists, that hence these are absolute values capable of guiding man and giving a meaning to human existence. . . .

Myth assures man that what he is about to do has already been done; in other words, it helps him to overcome doubts as to the result of his undertaking. There is no reason to hesitate before setting out on a sea voyage, because the mythical Hero has already made it in a fabulous Time. All that is needed is to follow his example.

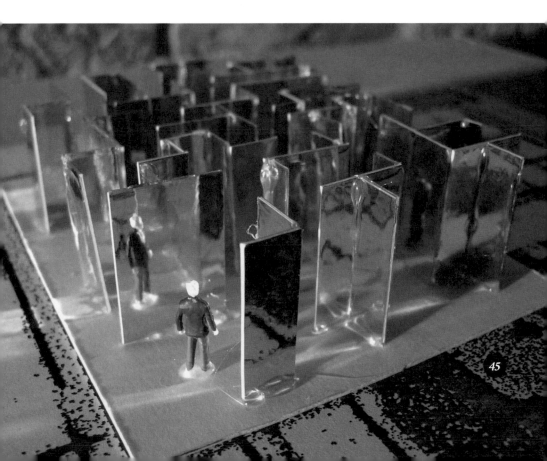

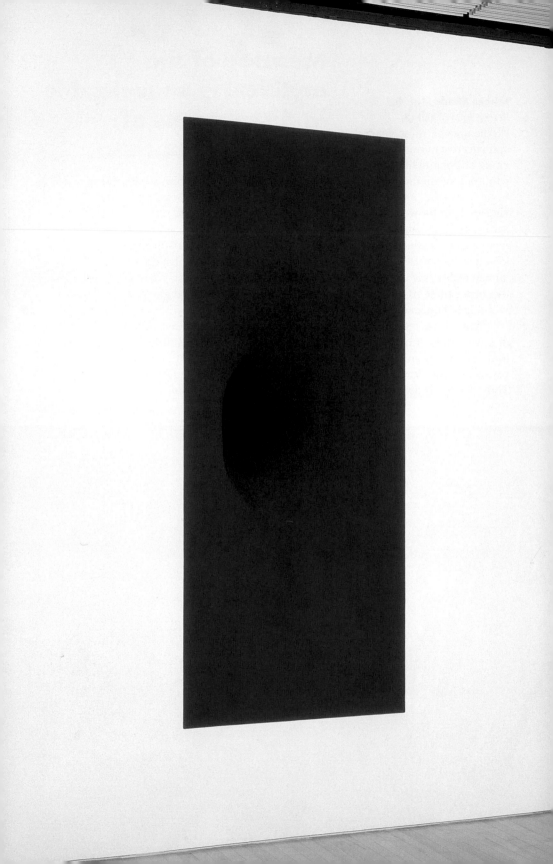

Things tend toward the center.

Strabo

Eric J. Leed *The Mind of the Traveler: From Gilgamesh to Global Tourism*, pp. 133, 136, 137–38, and 142

Philosophical travel is travel in time, a journey to the sites of the beginnings of one's cultural order. As a search for roots and beginnings, it might equally be called "historical travel," for in this sort of journey the traveler often attempts to retrace the paths of ancestors and founders in all their circuits and returns.

Beginnings are always constructed retrospectively; something needs to exist before its "beginnings" can be discovered. The manufacture of beginnings and traditions is thus an ongoing process within history and a crucial means by which individuals within a present define, legitimate, become conscious of the external "order" that defines them. . . .

To the ancient Greeks and Romans, the origins of civilization lay in Egypt. . . . Egypt was the first center of philosophical pilgrimage. . . . In a pattern repeated continually in the history of travel, the philosophical travelers to Egypt were followed by pilgrims and then by tourists. Egypt remained a place of lasting power and significance within Western civilization, a significance perpetuated in literature, photography, souvenirs, histories, and tales.

Wandering re-establishes the original harmony which once existed between man and the universe.

Anatole France

Here, in the cultural reproduction of a significant cultural site, we may find the source of the magic of place sought by the philosophical traveler. The icons of place, like the Pyramids, furnish a store of unconscious images of the long ago and far away, which may be triggered and become conscious upon the traveler's arrival at that site. . . .

The frisson of the tourist, often reported by travelers encountering an emplaced cultural icon for the first time, might be seen as an experience of meaning, a sudden coherence felt between the fictive and the real, the imagined and the actual. Marking the conjuncture of dreamed, unconscious landscapes with an observed reality in a present time, it is an experience of the continuities of time and space that underlie the contiguities of eras and constructed boundaries.

All tourists . . . embody a quest for authenticity, and this quest is a modern version of the universal human concern with the sacred. The tourist is a kind of contemporary pilgrim, seeking authenticity in other "times" and other "places" away from that person's everyday life.

John Urry *The Tourist Gaze*

Nelson H. H. Graburn "Tourism: The Sacred Journey," pp. 25 and 28
Vacations involving travel, i.e., tourism . . . are the modern equivalent for secular societies to the annual and lifelong sequences of festivals for more traditional God-fearing societies. Fundamental is the contrast between the ordinary/compulsory work state spent "at home" and the nonordinary/voluntary "away from home" sacred state. The stream of alternating contrasts provides the meaningful events that measure the passage of time. . . .

Because the touristic journey lies in the non-ordinary sphere of existence, the goal is symbolically sacred and morally on a higher plane than the regards of the ordinary workaday world.

Mihaly Csikszentmihalyi "Leisure and Socialization," p. 41
As a person matures, the most rewarding experiences still tend to occur in expressive leisure contexts such as games, sports, intimate interactions, artistic and religious activities. These experiences provide a criterion for fulfill-

UNIVERSAL EXPERIENCE *Art, Life, and the Tourist's Eye*

> **The modern individual, if he is to appear to be human, is forced to forge his own synthesis between his work and his culture.**
>
> **Dean MacCannell** *The Tourist: A New Theory of the Leisure Class*

ment that can and often does serve as a critical standard for the rest of life....Thus it could be argued that the most basic meaning of work and other instrumental activities is naturally determined by reference to meanings developed in leisure settings rather than vice versa.

Dennison Nash "Tourism as a Form of Imperialism," p. 40

[T]he origins of tourism are to be found in conditions of higher productivity, especially in industrial society. It is questionable if there is tourism among hunters and gatherers, and there is only a slight amount in agricultural societies. Higher productivity, associated with technological advances, has made possible the development of leisure classes as well as an improved material apparatus for travel. Tourism arises when people use the available means of travel for leisure-time pursuits. At the point in the industrial cycle where significant tourism appears, people are beginning to live in a society where productivity is great enough, the horizons broad enough, and the social mobility significant enough to nourish the touristic impulse.

John Urry *The Tourist Gaze*, pp. 18 and 19

The real national income per head quadrupled over the nineteenth century.[1] This enabled sections of the working class to accumulate savings from one holiday to the next, given that at the time few holidays with pay were sought, let alone provided.[2]

In addition there was a rapid urbanisation, with many towns growing incredibly rapidly. . . . This produced extremely high levels of poverty and overcrowding. Moreover, these urban areas possessed almost no public spaces, such as parks or squares. . . .

The growth of a more organised and routinised pattern of work led to attempts to develop a corresponding rationalisation of leisure: "To a large extent this regularisation of the days of leisure came about because of a change in the daily hours of work and in the nature of work."[3]

Particularly in the newly emerging industrial workplaces and cities, work came to be organised as a relatively time-bound and space-bound

1 Phyllis Deane and W. A. Cole, *British Economic Growth*, 1688–1959 (Cambridge: Cambridge University Press, 1962), p. 282.

2 J. Walton, "The Demand for Working Class Seaside Holidays in Victorian England," *Economic History Review* 34 (1981), p. 252.

3 Hugh Cunningham, *Leisure in the Industrial Revolution* (London: Croom Helm, 1980), p. 147.

I *Magical Traces*

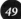 49

activity, separated off from play, religion, and festivity. . . . Industrialists attempted to impose a rigorous discipline on their newly constructed workforce.

As work became in part rationalised so the hours of working were gradually reduced.

A complex of conditions produced the rapid growth of . . . mass leisure activities and hence of these relatively specialised and unique concentrations of services . . . designed to provide novel, and what were at the time utterly amazing, objects of the tourist gaze.

Orvar Löfgren *On Holiday: A History of Vacationing*, p. 247

The Butlin concept was to provide not only a holiday package, with everything included, but a holiday program as well. The morning started with the wake-up call from the Butlin camp radio: "Wakey, wakey!" He organized children's programs to give the parents time for themselves and, even more important, had girls stationed in the chalets at night to act as baby-sitters and make it possible for Mum and Dad to dance every night in the camp's ballroom, where Henry Mancini might be playing. "Every night is party night!" There were all kinds of silly games and competitions, amateur nights, and then the brilliant idea of how to get people out of the bars at the end of the evening, making the Salvation Army song "Come and Join Us" into a follow-the-leader routine, with a redcoat leading a wriggling row of guests out into the night.

Butlin and his competitors created a holiday package whose golden days were the 1950s, the days when even the working class could afford a vacation and before the south had become the new magnet.

OPPOSITE AND FOLLOWING PAGES
John Hinde Studio
1968–1975 / 2002

Entrepreneur Billy Butlin's affordable, all-inclusive Butlin Holiday Camps debuted as a new kind of family vacation resort in the 1930s in England. The resorts provided activities ranging from tiki bars and ballroom dancing to quiet lounges and children's playrooms. In the late 1960s, John Hinde Studio and his staff of professional photographers — Edmund Nagele, David Noble, and Elmar Ludwig — began to produce meticulously crafted color postcards of the resorts, using large-format cameras and professional lighting. Using vacationers as models, Hinde transformed postcards from traditional monochromes to dramatically staged tableaux that promoted an idyllic spirit of the era. Hinde's technique made him one of the most successful postcard publishers in the world. British photographer Martin Parr resurrected interest in the work as significant to the history of photography, leading to their display as photographic prints.

The Old Time Ballroom (Butlin's Ayr)

[T]he Protestant work ethic was once pervasive in the U.S.: to work was right, moral, and satisfying. This work philosophy has largely disappeared among Americans born after World War II. The modern generation seeks instant happiness, and its work goal is to earn money with which to play. Translated into tourism, the extra money once saved for home, car, or a "rainy day" becomes the means to travel. **Valene L. Smith**

Hosts and Guests: The Anthropology of Tourism

 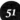

Children's Play Area (Butlin's Bognor Regis)

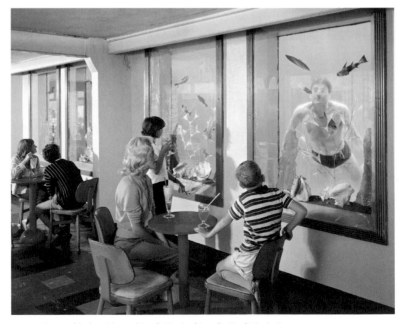

Lounge Bar and Indoor Heated Pool (Ground Level) (Butlin's Ayr)

UNIVERSAL EXPERIENCE *Art, Life, and the Tourist's Eye*

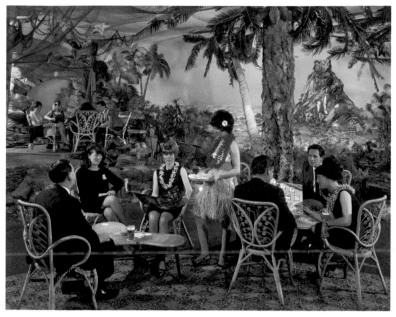

A Corner of the Beachcomber Bar (Butlin's Bognor Regis)

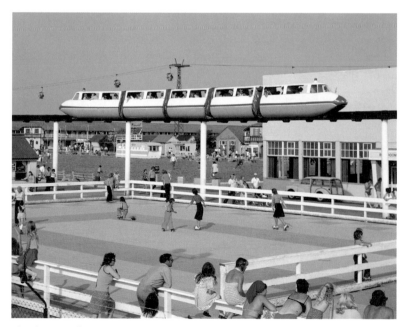

The Skating Rink and Monorail (Butlin's Skegness)

Dean MacCannell
The Tourist: A New Theory of the Leisure Class, p. 15

It is a source of anxiety that our kind of society has the capacity to develop beyond the point where individuals can continue to have a meaningful place in it. If this development were to progress without a corresponding reconstitution of a place for man in society, modernity would simply collapse at the moment of its greatest expansion. But this collapse is not happening in fact. Tourism and participation in the other modern alternatives to everyday life makes a place for unattached individuals in modern society. The act of sightseeing is a kind of involvement with social appearances that helps the person to construct totalities from his disparate experiences. Thus, his life and his society can appear to him as an orderly series of formal representations, like snapshots in a family album.

Modernity transcends older social boundaries, appearing first in urban industrial centers and spreading rapidly to underdeveloped areas. There is no other complex of reflexive behaviors and ideas that follows this development so quickly as tourism and sightseeing . . . there is no other widespread movement universally regarded as essentially modern.

OPPOSITE
Pascale Marthine Tayou
(Cameroonian, b. 1967)
Traditions, 2002

Symbols of Catholicism and local African traditions collide in *Traditions,* Tayou's photograph of a portrait of Pope John Paul II surrounded by African masks in a market in Cameroon. In addition to referring to the religious tourism of Catholic missionaries in Africa, this work suggests the pope as a symbol of a global traveling figure who is himself one of the world's greatest tourist attractions.

Our first apprehension of modern civilization . . . emerges in the mind of the tourist.
Dean MacCannell
The Tourist: A New Theory of the Leisure Class

Claude Lévi-Strauss *Tristes Tropiques: An Anthropological Study of Primitive Societies in Brazil,* pp. 132–33

I should have liked to live in the age of *real* travel, when the spectacle on offer had not yet been blemished, contaminated, and confounded; then I could have seen Lahore not as I saw it, but as it appeared to Bernier,

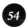

Tavernier, Manucci. . . . There's no end, of course, to such conjectures. When was the right moment to see India? At what period would the study of the Brazilian savage have yielded the purest satisfaction and the savage himself been at his peak? Would it have been better to arrive at Rio in the eighteenth century, with Bougainville, or in the sixteenth, with Léry and Thevet? With every decade we traveled further back in time, I could have saved another costume, witnessed another festivity, and come to understand another system of belief. But I'm too familiar with texts not to know that this backward movement would also deprive me of such information, many curious facts and objects, that would enrich my meditations. The paradox is irresoluble: the less one culture communicates with another, the less likely they are to be corrupted, one by the other; but, on the other hand, the less likely it is, in such conditions, that the respective emissaries of these cultures will be able to seize the richness and significance of their diversity. The alternative is inescapable; either I am a traveler in ancient times, and faced with a prodigious spectacle which would be almost entirely unintelligible to me and might, indeed, provoke me to mockery or disgust; or I am a traveler of our own day, hastening in search of a vanished reality. In either case I am the loser — and more heavily than one might suppose; for today, as I go groaning among the shadows, I miss, inevitably, the spectacle that is now taking shape. My eyes, or perhaps my degree of humanity, do not equip me to witness that spectacle; and in the centuries to come, when another traveler revisits this same place, he too may groan aloud at the disappearance of much that I should have set down, but cannot. I am the victim of a double infirmity: what I see is an affliction to me; and what I do not see, a reproach.

Alain de Botton *The Art of Travel,* pp. 110–11
Entitling his essay, "On the Uses and Disadvantages of History for Life," Nietzsche began with the extraordinary assertion that collecting facts in a quasi-scientific way was a sterile pursuit. The real challenge, he suggested, was to use facts to enhance "life.". . .

What would it mean to seek knowledge "for life" in one's travels? Nietzsche offered suggestions. . . . This tourist would learn to seek in other cultures "that which in the past was able to expand the concept 'man' and make it more beautiful," thus joining the ranks of those, "who, gaining strength through reflecting on past greatness, are inspired by the feeling that the life of man is a glorious thing."

UNIVERSAL EXPERIENCE *Art, Life, and the Tourist's Eye*

[Tourism] is a kind of collective striving for a transcendence of the modern totality, a way of attempting to overcome the discontinuity of modernity, of incorporating its fragments into unified experience.

Dean MacCannell *The Tourist: A New Theory of the Leisure Class*

Nietzsche...proposed a kind of tourism whereby we may learn how our societies and identities have been formed by the past and so acquire a sense of continuity and belonging. The person practicing this kind of tourism "looks beyond his own individual transitory existence and feels himself to be the spirit of his house, his race, his city." He can gaze at old buildings and feel "the happiness of knowing that he is not wholly accidental and arbitrary but grown out of a past as its heir, flower, and fruit, and that his existence is thus excused and indeed justified."...

Instead of bringing back sixteen thousand new plant species, we might return from our journeys with a collection of small, unfeted but life-enhancing thoughts.

Anke Gleber *The Art of Taking a Walk: Flanerie, Literature, and Film in Weimar Culture,* pp. 16, 23, and 29

George Simmel's treatise "The Metropolis and Mental Life" (1903), one of the first studies to approach the city in order to scrutinize its new living conditions ... touches closely on some of the premises and rhetoric of flanerie. ... As Simmel explains, "The psychological foundation upon which the metropolitan individuality is erected is the *intensification* of emotional life (*Nervenleben*) due to the swift and continuous shift of external and internal *stimuli*."...

A virtual arsenal of visual signs competes for the attention of passengers, pedestrians, and passersby: the street's signals serve as miniaturized icons for the level of modern rationality that governs the public sphere, with traffic lights that display red, yellow, and green flashes of ordering stimuli, significant markers on the surface of the streets that regulate moving vehicles and reserve crossings for passing pedestrians.

Faced with this very new terrain of complex and conflicting stimuli, more than ever the eye becomes the prevailing medium of attention and orientation. It not only imparts a sense of spatial perception but it also

While the traveler encounters descriptions of tourist attractions such as Versailles, the Louvre, and the Tuileries, the flaneur balances them with equal care and attention for the nuances of the city. His collection of the details of gossip, statements, and facts forms a kind of journalistic *recherché* in the street.

Anke Gleber *The Art of Taking a Walk: Flanerie, Literature, and Film in Weimar Culture*

determines the life of the city via the sheer multiplication of what can now be seen. This quantitative increase in perceptible moments in fact enhances the very quality of perception. The proliferation of visual phenomena is variously affected by the developments of modernity emerging from the conditions that determine its traffic: as Simmel explains, never "before the formation of buses, trains, and streetcars, were [humans] able or obliged to look at each other for minutes or hours without talking to each other."[1] Public transportation encourages the increased use and observation of the visual as a medium in everyday life. . . . Simmel suggests that this immense multiplication of visual stimulation is . . . "characterized by a markedly greater emphasis on the use of the eyes than on that of the ears."[2] This shift from the acoustic to the visual is crucial not

1 Georg Simmel, "Exkurs über die Soziologie der Sinne," in *Soziologie. Untersuchungen über die Formen der Vergesellschaftung* (Berlin: Duncker and Humblot, 1968), p. 486.

2 Ibid.

OPPOSITE
Matthew Buckingham (American, b. 1963)
A Man of the Crowd, 2003

Based on Edgar Allan Poe's story *The Man of the Crowd,* Buckingham's film shows a young man as he follows an older man through a city. It is projected through a hole in a wall onto a two-way mirror, which creates a double-sided projection. Viewers' shadows become part of the urban crowds depicted in the film. Although the original story is set in London, Buckingham filmed in Vienna because he sees it as characteristic of the nineteenth century, when the division between private and public life became less defined and the concept of the voyeuristic flaneur developed. According to Buckingham, "One of the most layered sites I used is the nineteenth-century style shopping passage, or arcade. . . . Poe's urban wanderers greatly influenced Baudelaire's concept of the flaneur — the well-to-do meandering observer of complex city life. Walter Benjamin, in turn, also used the figure of the flaneur as a tool for understanding modernity. . . . The flaneur, the consummate 'consumer' of the modern city, could easily fulfill his goal of being an observed observer in this type of arcade or passage."

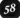
UNIVERSAL EXPERIENCE *Art, Life, and the Tourist's Eye*

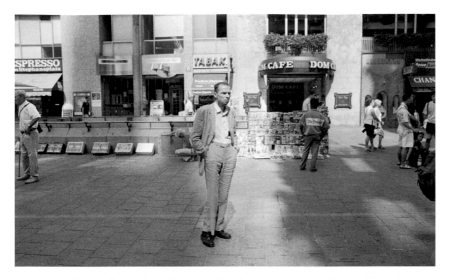

only to Simmel's reading of modernity, but also to an understanding of the flaneur as the modern type to be conjured and defined by this visual shift.

Poe's stories . . . bear witness to the altered nature of experience in the city, ranging from "The Man in the Crowd" to "The Murders in the Rue Morgue." "The crowd" and

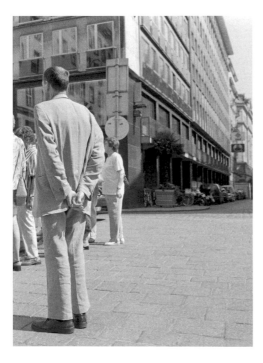

"the street" name the formative sites where modernity is constructed and its secrets wait to be investigated, to become illuminated by a sense of simultaneous curiosity, wonder, and terror. As Poe's tales describe activities that are commonly ascribed to the detective, they also focus on what [Walter] Benjamin calls the x-ray image of both prototypes of the detective story and patterns of modernity

that figure in the process of flanerie: the pursuer, the crowd, the stranger. Strolling and observing, the flaneur is therefore a kind of detective of the streets who, by his association with the suspicious circumstances of the public sphere, comes to be regarded as a conspicuous presence in the crowd himself. The detective approaches the streets of the city from a double, and often ambivalent, perspective that circumscribes the flaneur's existence as well: moving in the streets as an active, observing camera, he becomes a screen on which he projects himself, as an observed medium of modernity.

Charles Baudelaire "The Painter of Modern Life," pp. 212–214

For ten whole years I wanted to make the acquaintance of M. G., who is by nature a great traveller and very cosmopolitan . . . the man of the world . . . the spiritual citizen of the universe. . . .

Do you remember a picture (for indeed it is a picture!) written by the most powerful pen of this age [Edgar Allen Poe] and entitled *The Man of the Crowd*? Sitting in a cafe, and looking through the shop window, a convalescent is enjoying the sight of the passing crowd, and identifying himself in thought with all the thoughts that are moving around him. He has only recently come back from the shades of death and breathes in with delight all the spores and odours of life; as he has been on the point of forgetting everything, he remembers and passionately wants to remember everything. In the end he rushes out into the crowd in search of a man unknown to him whose face, which he had caught sight of, had in a flash fascinated him. Curiosity had become a compelling, irresistible passion.

Now imagine an artist perpetually in the spiritual condition of the convalescent, and you will have the key to the character of M. G.

But convalescence is like a return to childhood. The convalescent, like the child, enjoys to the highest degree the faculty of taking a lively interest in things, even the most trivial in appearance. . . .

The crowd is his domain, just as the air is the bird's, and water that of the fish. His passion and his profession is to merge with the crowd. For the perfect idler, for the passionate observer it becomes an immense source of

enjoyment to establish his dwelling in the throng, in the ebb and flow, the bustle, the fleeting and the infinite. To be away from home and yet to feel at home anywhere; to see the world, to be at the very centre of the world, and yet be unseen of the world, such are some of the minor pleasures of those independent, intense and impartial spirits, who do not lend themselves easily to linguistic definitions. The observer is a prince enjoying his incognito wherever he goes. The lover of life makes the whole world into his family, just as lover of the fair sex creates his from all the lovely women he has found, from those that could be found, and those who are impossible to find, just as the picture-lover lies in an enchanted world of dreams painted on canvas. Thus the lover of the universal life moves into the crowd as though into an enormous reservoir of electricity. He, the lover of life, may also be compared to a mirror as vast as this crowd; to a kaleidoscope endowed with consciousness, which with every one of its movements presents a pattern of life, in all its multiplicity, and the flowing grace of all the elements that go to compose life. It is an ego athirst for the non-ego, and reflecting it at every moment in energies more vivid than life itself, always inconsistent and fleeting. . . .

When, as he wakes up, M. G. opens his eyes and sees the sun beating vibrantly at his window-panes, he says to himself with remorse and regret: "What an imperative command! What a fanfare of light! Light everywhere for several hours past! Light I have lost in sleep! and endless numbers of things bathed in light that I could have seen and have failed to!" And off he goes! And he watches the flow of life move by, majestic and dazzling. He admires the eternal beauty and the astonishing harmony of life in the capital cities, a harmony so providentially maintained in the tumult of human liberty. He gazes at the landscape of the great city, landscape of stone, now swathed in the mist, now struck in full face by the sun. He enjoys handsome equipages, proud horses, the spit and polish of the grooms, the skillful handling by the page boys, the smooth rhythmical gait of the women, the beauty of the children, full of joy of life and proud as peacocks of their pretty clothes; in short, life universal.

II *Reflections in the*

With the contemporary explosion of visual information and instantaneous, simultaneous communication, along with the democratization of travel, we have all become tourists. Away from home, removed from the familiar, tourists have a heightened awareness of images,

Tourist's Eye

Andy Warhol
(American, 1928–1987)
Empire (still), 1964

Like the icons of Warhol's
paintings — Marilyn Monroe,
Elizabeth Taylor, Jacqueline
Kennedy, and the Mona Lisa —
the Empire State Building is
the star of his silent film
Empire. Warhol believed that
images of celebrities were
more captivating than their
actions; thus *Empire*, an
eight-hour endurance piece,
depicts only the building,
with the sun setting behind it.
The film captures an era in
which the Empire State Build-
ing was the tallest building
in the world (the following
year the World Trade Center
took this title) and the first
to be floodlit, its flashy appear-
ance dominating the New
York skyline. See also p. 78.

places, and information, perceiving them as extraordinary, even when familiar. Everything tourists encounter is a potential spectacle for transformation, consumption, and meaning. To experience this intensified receptivity, however, we no longer need to be traveling, within the presence of the object, nor does the object need to remain in its original location.

The writings and artworks in this section explore the gaze of tourists — what they see and how they observe — and draw parallels between how tourists see the world and how artists see the world. By re-presenting images and assigning to them new meanings, both artists and tourists re-circulate and re-interpret views of their world.

Roland Barthes *The Eiffel Tower and Other Mythologies,* pp. 3–17

Maupassant often lunched at the restaurant in the tower, though he didn't care much for the food: *It's the only place in Paris,* he used to say, *where I don't have to see it.* And it's true that you must take endless precautions, in Paris, not to see the Eiffel Tower; whatever the season, through mist and cloud, on overcast days or in sunshine, in rain — wherever you are, whatever the landscape of roofs, domes, or branches separating you from it, *the Tower is there;* incorporated into daily life until you can no longer grant it any specific attribute, determined merely to persist, like a rock on the river, it is as literal as a phenomenon of nature whose meaning can be questioned to infinity but whose existence is incontestable. There is virtually no Parisian glance it fails to *touch* at some time of day; at the moment I begin writing these lines about it, the Tower is there, in front of me, framed by my window; and at the very moment the January night blurs it, apparently trying to make it invisible, to deny its presence, two little lights come on, winking gently as they revolve at its very tip: all this night, too, it will be there, connecting me above Paris to each of my friends that I know are seeing it: with it we all compromise a shifting figure of which it is the steady center: the Tower is friendly.

The project of "reading" the city as an unfolding book becomes an ever-present factor in all daily walks of life and one that can no longer be overlooked. Commercial posters transmit the first signs of a semiotics of the street that calls attention to itself as a visual "language" in its own right.... The shocks of modernity unfold into a scream in the street, a call for attention that can be "overheard," so to speak, in visual terms. **Anke Gleber** *The Art of Taking a Walk: Flanerie, Literature, and Film in Weimar Culture*

The Tower is also present to the entire world. First of all as a universal symbol of Paris, it is everywhere on the globe where Paris is to be stated as an image; from the Midwest to Australia, there is no journey to France which isn't made, somehow in the Tower's name, no schoolbook, poster, or film about France which fails to propose it as the major sign of a people and

of a place: it belongs to the universal language of travel. Further: beyond its strictly Parisian statement, it touches the most general human image-repertoire: its simple, primary shape confers upon it the vocation of an infinite cipher: in turn and according to the appeals of our imagination, the symbol of Paris, of modernity, of communication, of science or of the nineteenth century, rocket, stem, derrick, phallus, lightning rod or insect, confronting the great itineraries of our dreams, it is the inevitable sign; just as there is no Parisian glance which is not compelled to encounter it, there is no fantasy which fails, sooner or later, to acknowledge its form and to be nourished by it; pick up a pencil and let your hand, in other words your thoughts, wander, and it is often the Tower which will appear, reduced to that simple line whose sole mythic function is to join, as the poet says, *base and summit,* or again, *earth and heaven.*

This pure — virtually empty — sign — is ineluctable, *because it means everything.* In order to negate the Eiffel Tower (though the temptation to do so is rare, for this symbol offends nothing in us), you must, like Maupassant, get up on it and, so to speak, identify yourself with it. Like man himself, who is the only one not to know his own glance, the Tower is the only blind point of the total optical system of which it is the center and Paris the circumference. But in this movement which seems to limit it, the Tower acquires a new power: an object when we look at it, it becomes a lookout in its turn when we visit it, and now constitutes as an object, simultaneously extended and collected beneath it, that Paris which just now was looking at it. The Tower is an object which sees, a glance which is seen; it is a complete verb, both active and passive, in which no function, no *voice* (as we say in grammar, with a piquant ambiguity) is defective. This dialectic is not in the least banal, it makes the Tower a singular monument; for the world ordinarily produces either purely functional organisms (camera or eye) intended to see things but which then afford nothing to sight, what *sees* being mythically linked to what remains *hidden* (this is the theme of the voyeur), or else spectacles which themselves are blind and are left in the pure passivity of the visible. The Tower (and this is one of its mythic powers) transgresses this separation, this habitual divorce of *seeing* and *being seen;* it achieves a sovereign circulation between the two functions; it is a complete object which has, if one may say so, both sexes of sight. This radiant position in the order of perception gives it a prodigious propensity to

meaning: the Tower attracts meaning, the way a lightning rod attracts thunderbolts; for all lovers of signification, it plays a glamorous part, that of a pure signifier, i.e., of a form in which men unceasingly put *meaning* (which they extract at will from their knowledge, their dreams, their history), without this meaning thereby ever being finite and fixed: who can say what the Tower will be for humanity tomorrow? But there can be no doubt it will always be something, and something of humanity itself. Glance, object, symbol, such is the infinite circuit of functions which permits it always to be something other and something much more than the Eiffel Tower.

In order to satisfy this great oneiric function, which makes it into a kind of total monument, the Tower must escape reason. The first condition of this victorious flight is that the Tower be an utterly *useless* monument. The Tower's inutility has always been obscurely felt to be a scandal, i.e., a truth, one that is precious and inadmissible. Even before it was built, it was blamed for being useless, which, it was believed at the time, was sufficient to condemn it; it was not in the spirit of a period commonly dedicated to rationality and to the empiricism of great bourgeois enterprises to endure the notion of a useless object (unless it was declaratively an *objet d'art,* which was also unthinkable in relation to the Tower); hence Gustave Eiffel, in his own defense of his project in reply to the Artists' Petition, scrupulously lists all the future uses of the Tower: they are all, as we might expect of an engineer, scientific uses: aerodynamic measurements, studies of the resistance of substances, physiology of the climber, radio-electric research, problems of telecommunication, meteorological observations, etc. These uses are doubtless incontestable, but they seem quite ridiculous alongside the overwhelming myth of the Tower, of the human meaning which it has assumed throughout the world. This is because here the utilitarian excuses, however ennobled they may be by the myth of Science, are nothing in comparison to the great imaginary function which enables men to be strictly human. Yet, as always, the gratuitous meaning of the work is never avowed directly: it is rationalized under the rubric of *use*: Eiffel saw his Tower in the form of a serious object, rational, useful; men return it to him in the form of a great baroque dream which quite naturally touches on the borders of the irrational.

This double movement is a profound one: architecture is always dream and function, expression of a utopia and instrument of a convenience. Even before the Tower's birth, the nineteenth century (especially in America and

UNIVERSAL EXPERIENCE *Art, Life, and the Tourist's Eye*

in England) had often dreamed of structures whose height would be astonishing, for the century was given to technological feats, and the conquest of the sky once again preyed upon humanity. In 1881, shortly before the Tower, a French architect had elaborated the project of a sun tower; now this project, quite mad technologically, since it relied on masonry and not on steel, also put itself under the warrant of a thoroughly empirical utility; on the one hand, a bonfire placed on top of the structure was to illuminate the darkness of every nook and cranny in Paris by a system of mirrors (a system that was undoubtedly a complex one!), and on the other, the last story of this sun tower (about 1,000 feet, like the Eiffel Tower) was to be reserved for a kind of sunroom, in which invalids would benefit from an air "as pure as in the mountains." And yet, here as in the case of the Tower, the naive utilitarianism of the enterprise is not separate from the oneiric, infinitely powerful function which actually inspires its creation: use never does anything but shelter meaning. Hence we might speak, among men, of a true Babel complex: Babel was supposed to *serve* to communicate with God, and yet Babel is a dream which touches much greater depths than that of the theological project; and just as this great ascensional dream, released from its utilitarian prop, is finally what remains in the countless Babels represented by the painters, as if the function of art were to reveal the profound uselessness of objects, just so the Tower, almost immediately disengaged from the scientific considerations which had authorized its birth (it matters very little here that the Tower should be in fact useful), has arisen from a great human dream in which moveable and infinite meanings are mingled: it has reconquered the basic uselessness which makes it live in men's imagination. At first, it was sought — so paradoxical is the notion of an empty monument — to make it into a "temple of Science"; but this is only a metaphor; as a matter of fact, the Tower is *nothing*, it achieves a kind of zero degree of the monument; it participates in no rite, in no cult, not even in Art; you cannot visit the Tower as a museum: there is nothing to see *inside* the Tower. This empty monument nevertheless receives each year twice as many visitors as the Louvre and considerably more than the largest movie house in Paris.

Then why do we visit the Eiffel Tower? No doubt in order to participate in a dream of which it is (and this is its originality) much more the crystallizer than the true object. The Tower is not a usual spectacle; to enter the

 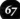

Hans-Peter Feldmann
(German, b. 1941)
Untitled (Eiffel Tower), 1990

The ubiquitous picture postcard has
its roots in late nineteenth-century
German holiday attractions. Alpine
scenes were popular before the Eiffel
Tower was built in 1889 and took over
as the most popular postcard between
1890 and 1914, before telephone
communications were widely available.
One of Feldmann's numerous arch-
ives and collections, his group of post-
cards of the Eiffel Tower and sunsets
reveal the idyllic conventions of post-
card imagery: a broad, elevated view
with no people in sight, so that the
viewers can imagine themselves there
without the intrusion of other tourists.
See also p. 179.

Tower, to scale it, to run around its courses, is, in a manner both more elementary and more profound, to accede to a *view* and to explore the interior of an object (though an openwork one), to transform the touristic rite into an adventure of sight and of the intelligence. It is this double function I should like to speak of briefly, before passing in conclusion to the major symbolic function of the Tower, which is its final meaning.

The Tower looks at Paris. To visit the Tower is to get oneself up onto the balcony in order to perceive, comprehend, and savor a certain essence of Paris. And here again, the Tower is an original monument. Habitually, belvederes are outlooks upon nature, whose elements — waters, valleys, forests — they assemble beneath them, so that the tourism of the "fine view" infallibly implies a naturist mythology. Whereas the Tower overlooks not nature but the city; and yet, by its very position of a visited outlook, the Tower makes the city into a kind of nature; it constitutes the swarming of men into a landscape, it adds to the frequently grim urban myth a romantic dimension, a harmony, a mitigation; by it, starting from it, the city joins up with the great natural themes which are offered to the curiosity of men: the ocean, the storm, the mountains, the snow, the rivers. To visit the Tower, then, is to enter into contact not with a historical Sacred, as is the case for the majority of monuments, but rather with a new nature, that of human space: the Tower is not a trace, a souvenir, in short a culture; but rather an immediate consumption of a humanity made natural by that glance which transforms it into space.

One might say that for this reason the Tower materializes an imagination which has had its first expression in literature (it is frequently the function of the great books to achieve in advance what technology will merely put into execution). The nineteenth century, fifty years before the Tower, produced indeed two works in which the (perhaps very old) fantasy of a panoramic vision received the guarantee of a major poetic writing *(écriture):* these are, on one hand, the chapter of *Notre-Dame de Paris (The Hunchback of Notre Dame)* devoted to a bird's-eye view of Paris, and on the other, Michelet's *Tableau chronologique.* Now, what is admirable in these two great inclusive visions, one of Paris, the other of France, is that Hugo and Michelet clearly understood that to the marvelous mitigation of altitude the panoramic vision added an incomparable power of *intellection:* the bird's-eye view, which each visitor to the tower can assume in an instant for his own, gives us the world to *read* and not only to perceive; this is why it corresponds to a new sensibility of vision; in the past, to travel (we may recall certain — admirable, moreover — promenades of Rousseau) was to be thrust into the midst of sensation, to perceive only a kind of tidal wave of things; the bird's-eye view, on the contrary, represented by our romantic writers as if they had anticipated both the construction of the Tower and the birth of aviation, permits us to transcend sensation and to see things *in their structure.* Hence it is the advent of a new perception, of an intellectualist mode, which these literatures and these architectures of vision mark out (born in the same century and probably from the same history): Paris and France become under Hugo's pen and Michelet's (and under the glance of the Tower) intelligible objects, yet without — and this is what is new — losing anything of their materiality; a new category appears, that of concrete abstraction; this, moreover, is the meaning which we can give today to the word *structure:* a corpus of intelligent forms. . . .

What, in fact, is a panorama? An image we attempt to decipher, in which we try to recognize known sites, to identify landmarks. Take some view of Paris taken from the Eiffel Tower; here you make out the hill sloping down from Chaillot, there the Bois de Boulogne; but where is the Arc de Triomphe? You don't see it, and this absence compels you to inspect the panorama once again, to look for this point which is missing in your structure; your knowledge (the knowledge you may have of Parisian topography) struggles with your perception, and in a sense, that is what intelligence is: to *reconsti-*

UNIVERSAL EXPERIENCE *Art, Life, and the Tourist's Eye*

tute, to make memory and sensation cooperate so as to produce in your mind a simulacrum of Paris, of which the elements are in front of you, real, ancestral, but nonetheless disoriented by the total space in which they are given to you, for this space was unknown to you . . . on the one hand, it is a euphoric vision, for it can slide slowly, lightly the entire length of a continuous image of Paris, . . . but, on the other hand, this very continuity engages the mind in a certain struggle, it seeks to be deciphered, we must find *signs* within it, a familiarity proceeding from history and from myth; this is why a panorama can never be consumed as a work of art, the aesthetic interest of a painting ceasing once we try to *recognize* in it particular points derived from our knowledge; to say that there is a beauty to Paris stretched out at the feet of the Tower is doubtless to acknowledge this euphoria of aerial vision which recognizes nothing other than a nicely connected space; but it is also to mask the quite intellectual effort of the eye before an object which requires to be divided up, identified, reattached to memory; for the bliss of sensation (nothing happier than a lofty outlook) does not suffice to elude the questioning nature of the mind before any image. . . .

[B]y rising above Paris, the visitor to the Tower has the illusion of raising the enormous lid which covers the private life of millions of human beings; . . . the Tower is merely the witness, the gaze which discreetly fixes, with its slender signal, the whole structure — geographical, historical, and social — of Paris space. This deciphering of Paris, performed by the Tower's gaze, is not only an act of the mind, it is also an initiation. To climb the Tower in order to contemplate Paris from it is the equivalent of that first journey, by which the young man from the provinces went up to Paris, in order to conquer the city. At the age of twelve, young Eiffel himself took the diligence from Dijon with his mother and discovered the "magic" of Paris. The city, a kind of superlative capital, summons up that movement of accession to a superior order of pleasures, of values, of arts and luxuries; it is a kind of precious world of which knowledge makes the man, marks an entrance into a true life of passions and responsibilities; it is this myth — no doubt a very old one — which the trip to the Tower still allows us to suggest; for the tourist who climbs the Tower, however mild he may be, Paris laid out before his eyes by an individual and deliberate act of contemplation is still something of the Paris confronted, defied, possessed by Rastignac. Hence,

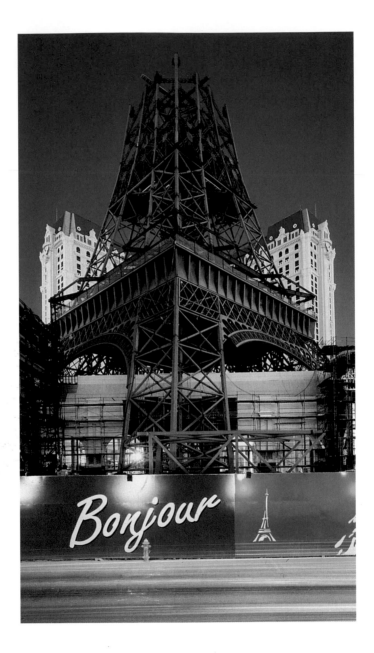

UNIVERSAL EXPERIENCE *Art, Life, and the Tourist's Eye*

of all the sites visited by the foreigner or the provincial, the Tower is the first obligatory monument; it is a Gateway, it marks the transition to a knowledge: one must sacrifice to the Tower by a rite of inclusion from which, precisely, the Parisian alone can excuse himself; the Tower is indeed the site which allows one to be incorporated into a race, and when it regards Paris, it is the very essence of the capital it gathers up and proffers to the foreigner who has paid to it his initiational tribute.

From Paris contemplated, we must now work our way back toward the Tower itself: the Tower which will live its life as an object (before being mobilized as a symbol). Ordinarily, for the tourist, every object is first of all an *inside,* for there is no visit without the exploration of an enclosed space: to visit a church, a museum, a palace is first of all to shut oneself up, to "make the rounds" of an interior, a little in the manner of an owner: every exploration is an appropriation; this tour of the *inside* corresponds, moreover, to the question raised by the *outside:* the monument is a riddle, to enter it is to solve, to posses it; here we recognize in the tourist visit that the initiational function we have just invoked apropos of the trip to the Tower; the cohort of visitors which is enclosed by a monument and processionally follows its internal meanders before coming back outside is quite like the neophyte who, in order to accede to the initiate's status, is obliged to traverse a dark and unfamiliar route within the initiatory edifice. In the religious protocol as in the tourist enterprise, being enclosed is therefore a function of the rite. Here, too, the Tower is paradoxical object: one cannot be shut up within it since what defines the Tower is its longilineal form and its open structure: How can you be enclosed within emptiness, how can you visit a line? Yet incontestably the Tower is visited: we linger within it, before using it as an observatory. What

Alexander Timtschenko (German, b. 1965)
Paris, 1999, OPPOSITE
Paris I, 1999, OVERLEAF

Las Vegas is the paramount example of the artificial city: within the last ten years copies of Venice, Greece, New York, Paris, Egypt, and even a pirate ship have sprouted in Sin City. Timtschenko's large glossy photos of culturally specific hotels highlight the seductive beauty and plasticity of the buildings, slowly revealing themselves as reproductions with synthetic colors and unreal juxtapositions that recall the artificiality of Hollywood stage sets. See also pp. 2, 103, and 225.

 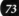

is happening? What becomes of the great exploratory function of the *inside* when it is applied to this empty and depthless monument which might be said to consist entirely of an exterior substance?

In order to understand how the modern visitor adapts himself to the paradoxical monument which is offered to his imagination, we need merely observe what the Tower gives him, insofar as one sees in it an object and no longer a lookout. On this point, the Tower's provisions are of two kinds. The first is of a technical order; the Tower offers for consumption a certain number of performances, or, if one prefers, of paradoxes, and the visitor then becomes an engineer by proxy; these are, first of all, the four bases, and especially (for enormity does not astonish) the exaggeratedly oblique insertion of the metal pillars in the mineral mass; this obliquity is curious insofar as it gives birth to an upright form, whose very verticality absorbs its depar-

UNIVERSAL EXPERIENCE *Art, Life, and the Tourist's Eye*

Souvenirs are collected by *individuals*, by tourists, while *sights* are "collected" by entire societies.

Dean MacCannell
The Tourist: A New Theory of the Leisure Class

ture in slanting forms, and here there is a kind of agreeable challenge for the visitor; then come the elevators, quite surprising by their obliquity, for the ordinary imagination requires that what rises mechanically slide along a vertical axis; and for anyone who takes the stairs, there is the enlarged spectacle of all the details, plates, beams, bolts, and which *make* the Tower, the surprise of seeing how this rectilinear form, which is consumed in every corner of Paris as a pure line, is composed of countless segments, interlinked, crossed, divergent: an operation of reducing an appearance (the straight line) to its contrary reality (a lacework of broken substances), a kind of demystification provided by simple enlargement of the level of perception, as in those photographs in which the curve of a face, by enlargement, appears to be formed of a thousand tiny squares variously illuminated. Thus the Tower-as-object furnishes its observer, provided he insinuates himself into it, a whole series of paradoxes, the delectable contraction of an appearance and of its contrary reality.

The Tower's second provision, as an object, is that, despite its technical singularity, it constitutes a familiar "little world"; from the ground level, a whole humble commerce accompanies its departure: vendors of postcards, souvenirs, knickknacks, balloons, toys, sunglasses herald a commercial life which we rediscover thoroughly installed on the first platform. Now any commerce has a space-taming function; selling, buying, exchanging — it is by these simple gestures that men truly dominate the wildest sites, the most-sacred constructions. The myth of the moneylenders driven out of the Temple is actually an ambiguous one, for such commerce testifies to a kind of

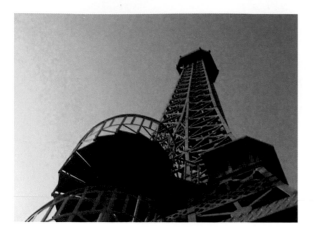

affectionate familiarity with regard to a monument whose singularity no longer intimidates, and it is by a Christian sentiment (hence to a certain degree a special one) that the spiritual excludes the familiar; in Antiquity, a great religious festival as well as a theatrical representation, a veritable sacred ceremony, in no way prevented the revelation of the most everyday gestures, such as eating or drinking: all pleasures proceeded simultaneously, not by some heedless permissiveness but because the ceremonial was never savage and certainly offered no contradiction to the quotidian. The Tower is not a sacred monument, and no taboo can forbid a commonplace life to develop there, but there can be no question, nonetheless, of a trivial phenomenon here; the installation of a restaurant on the Tower, for instance (food being the object of the most symbolic of trades), is a phenomenon corresponding to a whole meaning of leisure; man always seems disposed — if no constraints appear to stand in his way — to seek out a kind of counterpoint in his pleasures: this is what is called comfort. The Eiffel Tower is a comfortable object, and moreover, it is in this that it is an object either very old (analogous, for instance, to the ancient Circus) or very modern (analogous to certain American institutions such as the

drive-in-movie, in which one can simultaneously enjoy the film, the car, the food, and the freshness of the night air). Further, by affording its visitor a whole polyphony of pleasures, from technological wonder to haute cuisine, including the panorama, the Tower ultimately reunites with the essential function of all major human sites: autarchy; the Tower can live on itself: one can dream there, eat

UNIVERSAL EXPERIENCE *Art, Life, and the Tourist's Eye*

there, observe there, understand there, marvel there, shop there; as on an ocean liner (another mythic object that sets children dreaming), one can feel oneself cut off from the world and yet the owner of a world.

Chris Rojek "Indexing, Dragging, and the Social Construction of Tourist Sights," pp. 57–60

[Walter] Benjamin repeatedly characterises the culture of capitalism as a "phantasmagoria." Although never rigorously defined, this term loosely refers to the dreamworld of commodity capitalism.... The market is not only the showplace for commodities, it is also the material register of our inner fantasies and dreams....

At the heart of Benjamin's discussion of the phantasmagoria of consumer culture is the concept of aura. The closest he comes to a definition is his remark that aura is "the unique manifestation of distance."[1] However, from his general discussion we can see that the term "distance" carries a dual meaning.

In the first place it refers to physical distance. The aura of an object is manifest by its magnetic power to attract us to leave our homes to see it for ourselves.... [M]ost tourists feel that they have not fully absorbed a sight until they stand before it, see it and take a photograph to record the moment.

The second sense of distance is more esoteric. It refers to Benjamin's belief that auratic objects compel us to make an inner journey, a journey which peels away our ordinary layers of consciousness to reach a deeper level of realisation. ... In other words, the

1 Walter Benjamin, *Charles Baudelaire or the Lyric Priest of High Capitalism* (London: New Left Books, 1969), p. 148.

ABOVE AND OPPOSITE
Mircea Cantor
(Romanian, b. 1977)
Tribute (stills), 2004

Cantor's short video *Tribute* documents an uncanny reproduction of the Eiffel Tower in Slobozia, Romania, built by Romanian billionaire Ilie Alexandru, who also erected on the same site a version of Southfork mansion from the 1980s television show *Dallas*. Only one tenth the size of the original, the tower subverts the idea of public ownership of civic (or fictional) monuments, and Cantor's video questions what it means to own privately what is in the public trust.

The work becomes "authentic" only after the first copy of it is produced. The reproductions are the aura, and the ritual, far from being a point of origin, derives from the relationship between the original object and its socially constructed importance.

Dean MacCannell *The Tourist: A New Theory of the Leisure Class*

"inner journey" reveals something about the self and the place of the self in the wider cultural order. . . . Benjamin's discussion of the decline of aura suggests that auratic objects inevitably become disembedded. . . .

First, mass reproduction increases the accessibility of the object. Why should we want to travel thousands of miles to see something that we can view in the comfort of our living room on television? The evaporation of physical distance eliminates the sense of remoteness, which is the essential requirement in perpetuating the authority of the auratic object. . . .

The second point is that duplication denies the principle of unique manifestation upon which the object's authority is ultimately founded. . . . By encrusting the original object with secondary images, values and associations, these processes make us lose sight of the original meaning of the object. . . .

The third point is that the technology of mass reproduction acts upon the original object to extend or treat its meaning in various ways. Distorted representations of auratic objects such as the Statue of Liberty, the Crown Jewels or the Taj Mahal, participate in the general corruption of . . . the object. . . . Mass culture makes the representation closer to everyday life than the original object. *Ipso facto* the object's place as a talisman of paramount reality is problematised.

OPPOSITE
Andy Warhol (American, 1928–1987)
Double Mona Lisa, 1963

Warhol's *Double Mona Lisa* refers to this icon of the Italian Renaissance, the most famous artwork in the world, commenting upon its incessant reproduction and how reproduced images, especially of celebrities, often take precedence over the original in contemporary life. Warhol's reproduction poses the question: was he elevating celebrities to the status of art or likening the subjects of art to modern celebrities? See also p. 63.

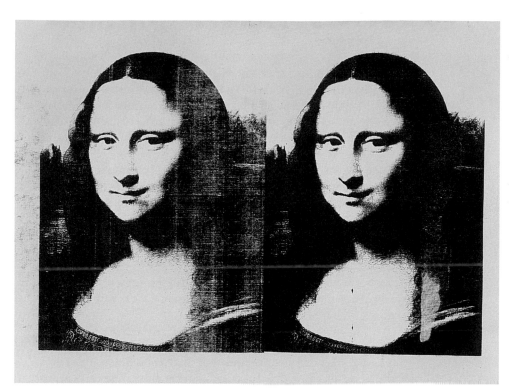

Benjamin's sociology, then, depicts a culture in crisis.... [M]ass culture reduces the ordinary consumer to the position of an addicted consumer of reproduced objects, packaged events, ... and other manipulated stimulants.

Benjamin's ... discussion of the waning of aura helps to contextualise the feelings of scepticism or indifference that we have in much tourist experience. In particular, it sheds light on that feeling of "so what?" that sight-seeing often produces in the tourist.... With respect to tourism, Benjamin's work implies that "being there" no longer involves actually visiting a sight.

In the Louvre, the attraction is the Mona Lisa. The rest is undifferentiated art in the abstract.

Dean MacCannell *The Tourist: A New Theory of the Leisure Class*

John Frow "Tourism and the Semiotics of Nostalgia," pp. 125–26
Early in [Don DeLillo's] *White Noise* Jack and Murray visit the most pho-
tographed barn in America. They pass five signs advertising it before reach-
ing the site, and when they arrive they find forty cars and a tour bus in the
carpark and a number of people taking pictures. Murray delivers a com-
mentary: "No one sees the barn," he says.

"Once you've seen the signs about the barn, it becomes impossible to
see the barn. . . . We're not here to capture an image, we're here to maintain
one. Every photograph reinforces the aura . . . We've agreed to be part of a
collective perception. This literally colors our vision. A religious experience
in a way, like all tourism. . . .They are taking pictures of taking pictures. . .
What was the barn like before it was photographed?. . .What did it look like,
how was it different from other barns, how was it similar to other barns? We
can't answer these questions because we've read the signs, seen the people
snapping the pictures. We can't get outside the aura. We're part of the aura.
We're here, we're now."[1]

Dean MacCannell *The Tourist: A New Theory of the Leisure Class,* pp. 44–45
Sights have markers. Sometimes an act of Congress is necessary, as in the
official designation of a national park or historical shrine. This first stage can
be called the *naming phase* of sight sacralization. Often, before the naming

1 Don DeLillo, *White Noise* (New York: Viking Penguin, 1985), pp. 12–13.

Society does not produce art: artists do. Society, for its part, can only produce the importance, "reality" or "originality" of a work of art by piling up repre-sentations of it alongside.

Dean MacCannell *The Tourist: A New
Theory of the Leisure Class*

phase, a great deal of work goes into the authentication of the candidate for sacralization. Objects are x-rayed, baked, photographed with special equipment and examined by experts. Reports are filed testifying to the object's aesthetic, historical, monetary, recreational and social values.

Second is the *framing and elevation* phase.... When the framing material that is used has itself entered the first stage of sacralization (marking), a third stage has been entered. This stage can be called *enshrinement.* ...

The next stage of sacralization is *mechanical reproduction* of the sacred object: the creation of prints, photographs, models or effigies of the object which are themselves valued and displayed. It is the mechanical reproduction phase of sacralization that is most responsible for setting the tourist in motion on his journey to find the true object. And he is not disappointed. Alongside of the copies of it, it has to be The Real Thing.

The final stage of sight sacralization is *social reproduction*, as occurs when groups, cities, and regions begin to name themselves after famous attractions.

Like the pilgrim the tourist moves from a familiar place to a far place ... both the pilgrim and the tourist engage in "worship" of shrines which are sacred, albeit in different ways, and as a result gain some kind of uplifting experience.

John Urry *The Tourist Gaze*

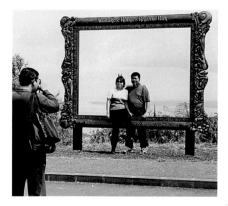

These "Natural Masterpieces Frames" were designed to increase the public's awareness of the beauty of New Zealand's Waitakere Ranges Regional Park. While some park visitors objected to the intrusion of the frames, which were sponsored by corporations, others used them as a site for taking "the perfect shot."

The final destination of any journey is ... some understanding, however simple or provisional, of what one has seen.

Pico Iyer *Video Night in Kathmandu: And Other Reports from the Not-So-Far East*

Pico Iyer *Video Night in Kathmandu: And Other Reports form the Not-So-Far East*, pp. 74–76

Yet the greatest of all of the sights in the Holy City, according to the wisdom of the Banak Shol, was the sacred rite known as the Celestial Burial. Each morning, at dawn, on a hillside five miles out of town, the bodies of the newly dead were placed on a huge, flat rock. There a sturdy local man, dressed in a white apron and armed with a large cleaver, would set about hacking them into small pieces. Assistants would grind the bones. When at last the corpses had been reduced to strips of bloody flesh, they were left on the Promethean stone for the vultures.

For Tibbetan Buddhists, the ritual was a sacrament, a way of sending corpses back into the cycle of Nature, of removing all traces of the departed. For the visitors who had begun to congregate in larger and still larger numbers to watch the man they called "the Butcher," the rite was the last word in picturesque exoticism. . . .

By the time I arrived on the sacrificial rock, three Westerners were already seated, cross-legged, around a fire, murmuring Buddhist chants and fingering their rosaries. Twenty others stood around them on the darkened hillside, faces lit up by the flames. . . .

One of the Tibetans tied an apron around his waist, picked up an ax and set about his work. As he did so, a gaggle of onlookers — most of them Chinese tourists from Hong Kong — started to inch closer to the sacred ground, chattering as they went. The man muttered something to himself, but continued about his task. Still, however, the visitors edged closer, giggling and whispering at the sight. The Tibetan stopped what he was doing, the gossip continued. And then, all of a sudden, with a bloodcurdling shriek, the man whirled around and shouted again and, waving a piece of reddened flesh, he came after the visitors like a demon, slicing the air with his knife and screaming curses at their blasphemy. The tourists turned on their heels; still the Tibetan gave the chase, reviling them for their irreverence. Terrified, the Chinese retreated to a safe position. The man stood before them, glowering.

After a long silence, the Tibetan turned around slowly and trudged back to his task. Chastened, we gathered on a hillside above the rock, a safe dis-

tance away. Before long, however, we were edging forward again, jostling to get a better glimpse of the dissection, urgently asking one another for binoculars and zoom lenses to get a close-up of the blood.

"Sometimes I think we are the vultures," said a Yugoslav girl who had come to Tibet in search of an image glimpsed in a dream a decade before.

"Oh no," said the Danish girl. "It's always wild on Mondays. The butcher takes Sundays off, so Monday's always the best day to come here." She turned around with a smile. "On Mondays, it's great: there are always plenty of corpses."

John Urry *The Tourist Gaze*, pp. 12–13 and 117
There has to be something distinctive to gaze upon, otherwise a particular experience will not function as a tourist experience. There has to be something extraordinary about the gaze.

On the face of it this seems a relatively straightforward thesis. But it is not, because of the complex nature of visual perception. We do not literally "see" things. Particularly as tourists we see objects constituted as signs. They stand for something else. When we gaze as tourists what we see are various signs or tourist clichés. Some such signs function metaphorically. A pretty English village can be read as representing the continuities and traditions of England from the Middle Ages to the present day. By contrast the use of the term "fun" in the advertising for a Club-Med holiday is a metaphor for sex. Other signs, such as lovers in Paris, function metonymically....

It is necessary to consider just what it is that produces a distinctive tourist gaze. Minimally there must be certain aspects of the place to be visited which distinguish it from what is conventionally encountered in everyday life....

"It's extraordinary how we go through life with eyes half shut," writes Joseph Conrad in *Lord Jim*. Commenting on that phrase, Conrad scholar Cedric Watts declares how "habitual perception kills." The trick, suggests Watts, is to observe things fresh, in all their unfamiliarity. This is only possible during the first few moments and hours in a place, before familiarity sets in.

Robert D. Kaplan *The Ends of the Earth: From Togo to Turkmenistan, From Iran to Cambodia — A Journey to the Frontiers of Anarchy*

 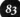

First, there is seeing a unique object, such as the Eiffel Tower, the Empire State Building, Buckingham Palace, the Grand Canyon, or even the very spot in Dallas where President Kennedy was shot. These are absolutely distinct objects to be gazed upon which everyone knows about. They are famous for being famous, although such places may have lost the basis of their fame (such as the Empire State Building, which still attracts two million people per year). Most people living in the "west" would hope to see some of these objects during their lifetime. They entail a kind of pilgrimage to a sacred centre, which is often a capital city, a major city or the site of a unique mega-event.

Then there is the seeing of particular signs, such as the typical English village, the typical American skyscraper, the typical German beer-garden, the typical French chateau, and so on. This mode of gazing shows how tourists are in a way semioticians, reading the landscape for signifiers of certain pre-established notions or signs derived from various discourses of travel and tourism.[1]

Third, there is the seeing of unfamiliar aspects of what had previously been thought of as familiar. One example is visiting museums which show representations of lives of ordinary people, revealing particularly their cultural artefacts. Often these are set out in a "realistic" setting to demon-

Kyoichi Tsuzuki (Japanese, b. 1956)
Fruit Bus Stop, 1994, ABOVE
Hanibe Gankutsu In, 1994, OPPOSITE, TOP
Sun Messe Nichonan, 1996, OPPOSITE, BOTTOM

Tsuzuki's *Roadside Japan* photographs depict humorous and bizarre public places including a museum of science-fiction erotica, a strawberry-shaped bus-stop, reproductions of the mysterious monolithic figures known as *Moai*, from Easter Island, and sculptures of frog musicians that welcome visitors to a Shinto shrine. Tsuzuki says about his photographs, "Here you find neither the beautiful scenes typical of Japan nor the simple and elegant kind of spaces that leave foreigners speechless. Rather I have included only those spots that would incur such epithets as 'gaudy' and 'frivolous,' and that would even be slighted by people living in the neighborhood. But present-day Japan has precisely this kind of unpainted, messy face. It is not beautiful, but has its own charms depending on how you look at it." See also pp. 8 and 247.

1 Jonathan Culler, "Semiotics of Tourism," *American Journal of Semiotics* 1 (1981), p. 128.

strate what their houses, workshops, and factories were roughly like. Visitors thus see unfamiliar elements of other people's lives which had been presumed familiar.

Then there is the seeing of ordinary aspects of social life being undertaken by people in unusual contexts. . . .

Also, there is the carrying out of familiar tasks or activities within an unusual visual environment. Swimming and other sports, shopping, eating and drinking all have particular significance if they take place against a distinctive visual backcloth. The visual gaze renders extraordinary, activities that otherwise would be mundane and everyday.

> ## Throughout the world, churches, cathedrals, mosques, and temples are being converted from religious to touristic functions.
>
> **Dean MacCannell** *The Tourist: A New Theory of the Leisure Class*

Finally, there is the seeing of particular signs that indicate that a certain other object is indeed extraordinary, even though it does not seem to be so. . . The attraction is not the object itself but the sign referring to it that marks it out as distinctive. Thus the marker becomes the distinctive sight.[2] A similar seeing occurs in art galleries when part of what is gazed at is the name of the artist, "Rembrandt" say, as much as the painting itself, which may be difficult to distinguish from many others in the same gallery.

2 Ibid., p. 139.

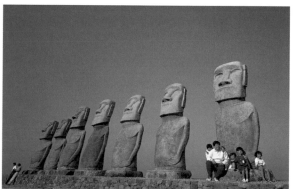

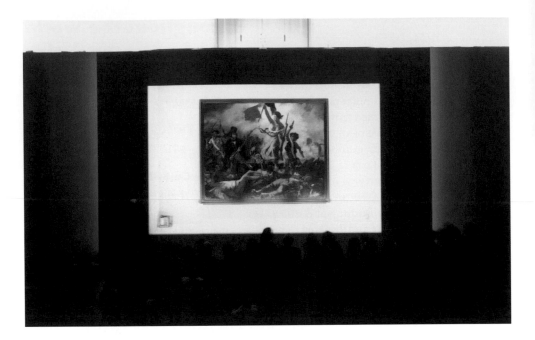

John Urry *The Tourist Gaze,* pp. 149–50

Although the tourist gaze emerges in this general sense, it is clear that there have been rather different kinds of visual gaze that have been authorised by various discourses. These different discourses include *education,* as with the eighteenth-century European Grand Tour and with many current study tour programmes; *health* ... designed to "restore" the individual to healthy functioning; ... *group solidarity.* ..; *pleasure and play; heritage and memory,* ... and *nation.* ...

Moreover, these different discourses imply different socialities [such as] the *romantic* gaze, solitude, privacy and a personal, semi-spiritual relationship with the object of the gaze are emphasized. In such cases tourists expect to look at the object privately or at least only with "significant others." Large numbers of strangers visiting, as at the Taj Mahal, intrude upon and spoil that lonely contemplation desired by western visitors ... The romantic gaze involves further quests for new objects of the solitary gaze, the deserted beach, the empty hilltop, the uninhabited forest, the uncontaminated mountain stream and so on. Notions of the romantic gaze are endlessly used in marketing and advertising tourist sites especially within the "west."

UNIVERSAL EXPERIENCE *Art, Life, and the Tourist's Eye*

By contrast . . . the collective tourist gaze involves conviviality. Other people also viewing the site are necessary to give liveliness or a sense of carnival or movement. Large numbers of people that are present can indicate that this is the place to be. These moving, viewing others are obligatory for the collective consumption of place, as with central London, Ibiza, Las Vegas, the Sydney Olympics, Hong Kong and so on. . . .

However . . . there are other gazes, other ways in which places get visually consumed, both while people are stationary and through movement. . . . [T]here is the *spectatorial* gaze that involves the collective glancing at and collecting of different signs that have been very briefly seen in passing. . . . Then there is the notion of the *reverential* gaze. . . .

Somewhat related is the *environmental* gaze . . . of scanning various tourist practices for their footprint upon the "environment.". . . And finally, there is the *mediatised* gaze. This is a collective gaze where particular sites famous for their "mediated" nature are viewed. Those gazing on the scene relive elements or aspects of the media event.

Thomas Struth (German, b. 1954)
OPPOSITE *National Museum of Art, Tokyo,* 1999
BELOW *Kunsthistorisches Museum III, Vienna,* 1989

In his large-scale museum photographs, Struth examines temporal and spatial relationships between viewers and exhibited artworks. *National Museum of Art, Tokyo* depicts a crowd gathered in front of *La Liberté guidant le peuple (28 juillet 1830),* a nineteenth-century French painting by Eugene Delacroix on loan from the Louvre. The elaborate display of the painting behind glass suggests its priceless value, yet the relationship between the Japanese audience and this symbol of Western art history remains ambiguous. Conversely, *Kunsthistorisches Museum III, Vienna,* captures a solitary viewer adopting a typical museum stance.

Anything that is remarked, even little flowers or leaves picked up off the ground and shown a child, even a shoeshine or a gravel pit, anything, is potentially an attraction.

Dean MacCannell *The Tourist: A New Theory of the Leisure Class*

Peter D. Osborne *Travelling Light: Photography, Travel, and Visual Culture,* p. 84
In Michel Tournier's fable *The Legend of Painting,* a caliph holds a competition to establish the better of the two paintings commissioned to cover opposing walls in his palace. The first painting, by an artist who'd never left home before, is unveiled to show the beautiful picture of a Chinese garden. A week later the second, widely traveled, painter pulls back the curtain to uncover a vast mirror in which the first painting is brilliantly reflected. He hadn't lifted a brush but was immediately declared the winner as not only did his secondary image contain the beauty of the first, but its garden was also alive populated by those viewing it.

All visual documenting devices mediate the gaze. The more automatic the operation and the more decisions that are consciously delegated to the camera's computers and program, the more mediated the gaze becomes.
Claudia Bell and John Lyall
The Accelerated Sublime:
Landscape, Tourism, and Identity

Guy Debord *The Society of the Spectacle,*
chapter 1, section 18
When the real world is transformed into mere images, mere images become real beings — dynamic figments that provide the direct motivations for a hypnotic behavior. Since the spectacle's job is to use various specialized mediations in order to *show* us a world that can no longer be directly grasped, it naturally elevates the sense of sight to the special preeminence once occupied by touch; the most abstract and easily deceived sense is the most readily adaptable to the generalized abstraction of present-day society. But the spectacle is not merely a matter of images, nor even of images plus sounds. It is whatever escapes people's activity, whatever eludes their practical reconsideration and correction. It is the opposite of dialogue. Wherever *representation* becomes independent, the spectacle regenerates itself.

Johannes Birringer *Media and Performance: Along the Border,* p. 5
Television (the prototype for the computer screen-human interface) has become our continuous, uninterrupted history; an endless flow of images, sounds, stories, and news events in living color. The technology that produces this flow, which in turn promotes itself, signals the future present in which electronic communication simultaneously channels knowledge, information, and expression on a global scale, ignoring national borders or differences of time and space.

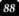

Jeff Koons
(American, b. 1955)
Rabbit, 1986

Rabbit, part of Koons's *Statuary* series, is a stainless-steel cast taken from an inflatable toy rabbit. Transformed into an expensive, highly finished art object, *Rabbit* ironically draws our attention to the boundaries between popular taste and "higher" forms of art and has become an icon of the concerns of late twentieth-century culture. Koons was interested in the narcissism and consumerism of 1980s, the so-called "me decade." He questions the value of art objects while involving viewers in the excessive and seductive qualities of the piece through their reflections in the mirror-like surface. See also p. 93.

II Reflections in the Tourist's Eye

Information superhighways and computer networks, as well as corporate mergers and satellite linkups indicate the vectors of an economic logic of freely circulating media products and services. In this shift from an older industrial culture to a media-information technoculture, the economics of technology constitutes the principles of transformation that affect all ideologies, political orders, and everyday practices as they reshape audiovisual perceptions and the relations between cognition and consumption.

Edmund Carpenter "The Tribal Terror of Self-Awareness," pp. 481–83, 485, and 487–88

Several years ago the Territory of Papua and New Guinea hired me as a communications consultant. They sought advice on the use of radio, film, even television. They wanted to use these media to reach not only townspeople but those isolated in swamps and mountain valleys and outer islands.

I accepted the invitation because it gave me an unparalleled opportunity to step in and out of 10,000 years of media history, observing, probing, testing. I wanted to observe, for example, what happens when a person — for the first time — sees himself in a mirror, in a photograph, on a screen; hears his voice; sees his name. Everywhere tribesmen responded alike to those experiences: they ducked their heads and covered their mouths.

When a shy or embarrassed person in our society ducks his head and covers his mouth, we say he is "self-conscious." But why does consciousness of self produce THIS response? Does the acute anxiety of sudden self-awareness lead man everywhere to conceal his powers of speech-thought (his breath, his soul) behind his hand, the way an awakened Adam concealed his sexual powers behind a fig leaf?...

It was important to us to film the reactions of people totally innocent of mirrors, cameras, recorders, etc. Such people exist in New Guinea, though they number only a handful and are disappearing like the morning mist. . . .

Certainly their initial reaction to large mirrors suggested this was a wholly new experience for them. They were paralyzed: after their first startled response — covering their mouths and ducking their heads — they stood transfixed, staring at their images, only their stomach muscles betraying great tension. Like Narcissus, they were left numb, totally fascinated by their own reflections; indeed, the myth of Narcissus may refer to just this phenomenon.

In a matter of days, however, they groomed themselves openly before mirrors.

You can observe a lot just by watching.

Yogi Berra

The notion that man possesses, in addition to his physical self, a symbolic self, is widespread, perhaps universal. A mirror corroborates this. It does more: it reveals that symbolic self OUTSIDE the physical self. The symbolic self is suddenly explicit, public, vulnerable. Man's initial response to this is probably always traumatic. . . .

When people know themselves only from how others respond to them and then suddenly, for the first time, by means of some new technology, see themselves clearly, in some totally new way, they often are so frightened, so exhilarated, that they cover their mouths and duck their heads.

I think they do so to prevent loss of identity. New Guineans call it loss of soul, but it's the same phenomenon. It's their response to any sudden embarrassment, any sudden self-consciousness. When they first see pictures of themselves or hear recordings of their voices, this response is greatly intensified. It's as if they had vomited up an organ: they cover their mouths and duck their heads, almost as a delayed reflex, trying to prevent this. . . .

It's a serious mistake to underestimate the trauma any new technology produces, especially any new communication technology. When people first encounter writing, they seem always to suffer great psychic dislocation. With speech, they hear consciousness, but with writing, they see it. They suddenly experience a new way of being in relation to reality. "How do I know what to think," asks Alice, "till I see what I say?"

And how do I know who I am, until I see myself as others see me? "Of course in this you fellows see more than I could see," writes Conrad in *The Heart of Darkness*. "You see me."

A camera holds the potential for SELF-viewing, SELF-awareness, and where such awareness is fresh, it can be traumatic. . . .

A still photograph moves us toward the isolated moment. It arrests time. It exists in pure space. It emphasizes individualism, private identity, and confers an element of permanence on that image.

A photographic portrait, when new and privately possessed, promotes identity, individualism: it offers opportunities for self-recognition, self-study. It provides the extra sensation of objectivizing the self. It makes the self more real, more dramatic. For the subject it's no longer enough to be: now HE KNOWS HE IS. He is conscious of himself.

III *Fake Authenticity*

As travel has become possible for a wider segment of the population, remote places previously known only to adventurers are now well traveled by tourists. Distances are more easily traversed and once-inaccessible objects and sites have been either reproduced or relocated, leading to a conflation of past and present.

Some tourists find the reproduction of an object or re-creation of a place or event to be even more satisfying than the original. Others seek an unmediated experience of objects, places, or built environments. The artworks and writings presented in this section explore these notions and the questions they raise: What defines authenticity? What is an authentic place? Is it possible for a tourist to have an authentic experience?

Jeff Koons (American, b. 1955)
Kiepenkerl, 1987

In Münster, Germany, a small statue of a Kiepenkerl, a peddler of fruits and vegetables, survived WWII and was replaced in 1954 with a larger bronze reproduction in the town square. It became an unofficial totem of the town, and miniature replicas of Kiepenkerl are popular souvenirs. As a project for the 1987 Sculpture Project in Münster, Koons recast the statue in stainless steel, which he considers the material of the masses, and temporarily replaced the original, presenting it as a symbol of individual entrepreneurship and consumerism. The peddler also symbolizes the traveling businessman as another kind of tourist. See also p. 89.

Lisa C. Roberts *From Knowledge to
Narrative: Educators and the Changing
Museum*, pp. 90, 94, 97, 99, 100, and 101
The nineteenth century was a "culture
of imitation," producing imitations
and illusions of every sort: furniture
modeled after European aristocratic
styles; . . . photographs that reported,
literally and exactly, places and events;
. . . chromolithographs that repro-
duced great paintings; . . . cylindrical
panoramas that recreated illustrious
landscapes and historic events. . . .

By the early twentieth century . . .
cheap imitations came gradually to
represent people's enslavement to the
machine . . . Basic life activities such
as . . . transportation . . . and commu-
nication were now mediated by machines
that effectively distanced the body from the physicality of the "real world.". . .

Mass media like movies and newspapers became more widespread and
thus more influential mediators of experience. Circumstances such as these
provided the groundwork for America's shift from a culture of imitation to
a culture of authenticity. . . .

[T]he essence of modernity has to do with the split between authentic
and inauthentic elements of human life, and it is this split that heralded the
rise of institutionalized forms of experience that culminated in tourism. . . .

It is no longer simply a matter of contrasting imitation to actual,
fake to real. The truth now lies somewhere in between. . . .

This confusion is manifest in the proliferation of cultural facsimiles whose apparent appeal is based on their "authentic" simulation of some place or time, yet whose fabrication fails to undermine their appeal. . . .

[I]f one can neither "accurately" represent what one experiences or knows . . . in any unadulterated way, signs become more important than that which they represent. Ultimately, signs are what shape not only one's encounters with the world but also the meanings one makes of those encounters. . . .

The experience of authenticity, in other words, is based less on an inherent quality than on a sign imposed from without. . . .

It is thus possible to search for and even to satisfy a quest for the "real," because it continues to exist as signs and markers. . . . No longer is reality some immutable, transcendent thing; it is subject to the conditions of its representation, so that encountering "reality" becomes a matter of encountering the signs that define what it is.

The tension between imitation and authenticity is a primary category in American civilization, pervading layers of our culture that are usually thought to be separate.

Lisa C. Roberts *From Knowledge to Narrative: Educators and the Changing Museum*

Umberto Eco *Travels in Hyperreality,* pp. 7–8 and 16–18
There is another, more secret America (or rather, just as public, but snubbed by the European visitor and also by the American intellectual); and it creates somehow a network of references and influences that finally spread also to the products of high culture and the entertainment industry. It has to be discovered.

This is the reason for this journey into hyperreality, in search of instances where the American imagination demands the real thing and, to attain it, must fabricate the absolute fake; where the boundaries between game and illusion are blurred, the art museum is contaminated by the freak show, and falsehood is enjoyed in a situation of "fullness," of *horror vacui*. . . .

[T]he masterpiece of the reconstructive mania (and of giving more, and better) is found when this industry of absolute iconoclasm has to deal with the problem of art.

Between San Francisco and Los Angeles I was able to visit seven wax versions of Leonardo's *Last Supper....* Each is displayed next to a version of the original. And you would naturally — but naively — suppose that this reference image, given the development of color photo reproduction, would be a copy of the original. Wrong: because, if compared to the original, the three-dimensional creation might come off second-best. So, in one museum after the other, the

One of the characteristics of modernity, according to Jonathan Culler, is the belief that authenticity has somehow been lost, and that it can be recuperated in other cultures and in the past.

Elizabeth Diller and Ricardo Scofidio
"Suit Case Studies: The Production of a National Past"

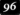

wax-work scene is compared to a reduced reproduction carved in wood, a nineteenth-century engraving, a modern tapestry, or a bronze, as the commenting voice insistently urges us to note the resemblance of the waxwork, and against such insufficient models, the waxwork, of course, wins. The falsehood has a certain justification, since the criterion of likeness, amply described and analyzed, never applies to the formal execution, but rather to the subject: "Observe how Judas is in the same position, and how Saint Matthew . . ." etc., etc.

As a rule the Last Supper is displayed in the final room, with symphonic background music and *son et lumière* atmosphere. Not infrequently you are admitted to a room where the waxwork Supper is behind a curtain that slowly parts, as the taped voice, in deep and emotional tones, simultaneously informs you that you are having the most extraordinary spiritual experience of your life, and that you must tell your friends and acquaintances about it. Then comes some information about the redeeming mission of Christ and the exceptional character of the great event portrayed, summarized in evangelical phrases. Finally, information about Leonardo, all permeated with the intense emotion inspired by the

ABOVE

Hiroshi Sugimoto
(Japanese, b. 1948)
The Last Supper, 1999

Sugimoto's photograph of a re-creation of the biblical Last Supper in a Japanese wax museum reflects many ideas related to *Universal Experience*, including the ubiquitous reproductions of Leonardo da Vinci's *Last Supper* and the wax museum as a classic tourist attraction. More importantly, this work — a twenty-first century photograph of a twentieth-century wax sculpture of da Vinci's Renaissance fresco — compels us to consider how displacement in time and space add new dimensions to a tourist icon.

Cologne Karnival No. 1

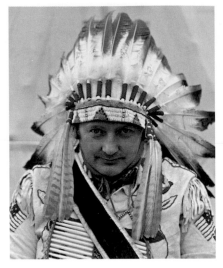

German Indians: Chief

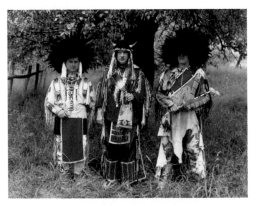

German Indians: Three Men

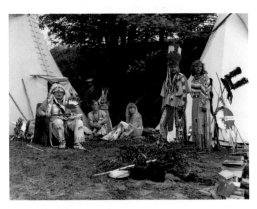

German Indians: Campfire

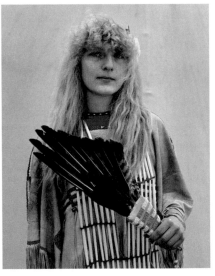

German Indians: Blonde

UNIVERSAL EXPERIENCE *Art, Life, and the Tourist's Eye*

mystery of art. . . . [Y]ou have been touched by the thrill of artistic greatness, you have had the most stirring spiritual emotion of your life and seen the most artistic work of art in the world. It is far away, in Milan, which is a place, like Florence, all Renaissance; you may never get there, but the voice has warned you that the original fresco is by now ruined, almost invisible, unable to give you the emotion you have received from the three-dimensional wax, which is more real, and there is more of it.

Elizabeth Diller and Ricardo Scofidio "Suit Case Studies: The Production of a National Past," pp. 34, 35, 38, 40, 41, 42, 43, and 44

The tourist certainly yearns for the authentic — and tourism fuels that desire. In sights of the national past, for example, travel promotions lure tourists with the temptation to "stand on the *very* spot the general fell," "witness the *actual* sights, sounds, and smells of the clashing troops," "see the *original* manuscript later drafted into law," "observe the *genuine* skills the early settlers used in making soap," etc. In the rhetoric of authenticity, italicized adjectives certify the real.

American tourism produces the *authentic* past with a fictive latitude in which literature, mythology and popular fantasy are blended together into the interpretation process called *heritage*. . . .

The construction of the sanitized past is called *living history*. It is a past in which the tourist can go back in time as a passive observer without any effect on the outcome of the future — a classic dilemma of science-fiction time travel. In the *space* of the re-enactment of *time*, the tourist unproblematically accepts the role of voyeur within a virtual world of cowboys, pioneers, and pilgrims — a world safeguarded from the vicissitudes of daily life in the past. . . .

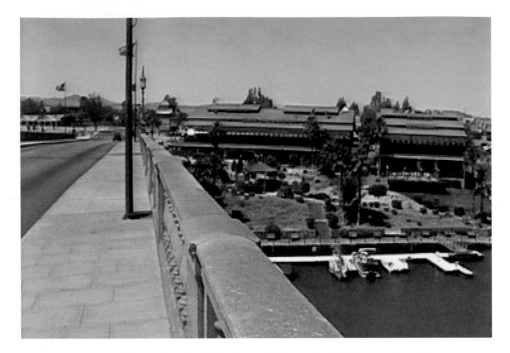

Bypassing the limitations of chronological time and contiguous space, touristic time is reversible and touristic space is elastic. Consequently, correspondences between time and space — between histories and geographies — become negotiable. . . . The [London Bridge] was dismantled stone by stone, transported from England and reassembled on the dry, relentless desert landscape of the Mojave. Once rebuilt, the town retroactively constructed a natural obstacle for the bridge to cross. A mile-long channel was excavated

beneath it and flooded. "Today," the travel literature reads, "the bridge, with its granite scoured clean of London grime and its bright flags snapping in the breeze, is more at home on the desert than it was on the Thames."

If a sight cannot be transplanted, it can be replicated. . . . Replication, like reenactment, allows tourism to perfect the very thing after which it is modeled. . . .

 UNIVERSAL EXPERIENCE *Art, Life, and the Tourist's Eye*

The substitution of originals with facsimiles presents no anxiety for the tourist so long as the expected narrative is sustained.

Presuming that all histories are constructs anyway, what is at stake in rethinking authenticity is the question, whose authenticity? It is not the *authentic* but the *authentication*, that needs to be interrogated. . . .

The home (of the public figure), one of tourism's most "auratic" attractions, foregrounds this play of authenticity/authentication best. It performs a double role of representation — housing the resident's artifacts of self-representation as well as those added later, by others, for their representational merit in the production of the narrative about that figure. Every prosaic detail offered before the voyeuristic gaze of the tourist is, in fact, a museological artifact, curatorially managed and nuanced for display. . . .

The tourist, attracted by the home of the luminary — typically, by their humble beginnings of flamboyant ends, trades homes. Ironically, travel is a mechanism of escape from the home. According to Freud, "A great part of the pleasure of travel lies in the fulfillment of early wishes to escape the family and especially the father." Being sick of home may lead to travel which may, in turn, lead to homesickness, which will

OPPOSITE AND ABOVE
Daniel Jewesbury (British, b. 1972)
Mirage (stills), 2000

Jewesbury's video installation *Mirage* locates the London Bridge in what the artist calls a hybrid "third space" that belongs to neither London nor Lake Havasu, Arizona, where it was transported and reconstructed in 1968. The three-monitor video installation combines interviews with people who were involved with re-building the bridge and those who work in the Lake Havasu tourist bureau, references to *Oliver Twist* and T. S. Eliot, and fictionalized first-person stories told by the artist. Interspersed throughout are abstract shots of light on the bridge and panoramas of the surrounding desert. A mirage suggests a hallucination or delusion, which Jewesbury relates to the appearance of the displaced bridge, but also to the history of its site. While the region has ignored Native American history, the head of Lake Havasu's tourist office proclaimed that the bridge "brings meaning and history to a community with a lack of history."

surely lead back home. This circular structure is the basis of travel. Tourism interrupts this circuit by eliminating the menace of the unfamiliar: that which produces homesickness. It domesticates the space of travel — the space between departure from home and return to it. The comfort of familiarity is the guarantee of chain hotels and restaurants. "*You'll feel right at home*" is the reassuring advertising slogan of Caravan Tours. If video technology offers the traveler infinite destinations in total inertia, the paradox of *going without leaving,* then tourism reverses the logic — a sophisticated technology with invisible hardware which offers the traveler the continuity of home with uninterrupted mobility, the paradox of *leaving without going....*

The theme of home is repeated throughout tourism; however, the *actual* home of the traveler is the only certainty in touristic geography, a fixed point of reference. It is the site in which the trip itself must be authenticated. The tourist's accountability resides in the snapshot or videotape — portable evidence of the sight having been seen.

The camera, the ultimate authenticating agent, is but one point in the nexus between tourism and vision. Tourism is dominated by *sight;* the *sightseer* travels to *see sights.* As tourism domesticates space, it also domesticates vision. Attractions can be understood as optical devices, which frame the *sight* within a safe, purified visual domain while displacing the *unsightly* into a blind zone.

When you are everywhere, you are nowhere. When you are somewhere, you are everywhere.

Rumi

Scopic control operates at a grand scale in sites of nature, "nature" being a favorite tourist attraction.... A photo opportunity can be thought of as a prescribed location in which the sight corresponds with its expected image and is thus offered to the affirmative camera of the tourist.

Often a sight must struggle to resemble its expected image.... [T]he postcard has become the fixed referent after which the mutable sight models itself....

The touristic construction puts into motion an exchange of references between a sight and its indispensable components—the postcard, the plaque, the marker, the brochure, the guided tour, the souvenir, the snapshot, and further, the replica, the reenactment, etc. Given the extensive production of contemporary tourism, a tourist sight can be considered to be only *one* among its many representations, thus eliminating the "dialectics of authenticity" altogether.

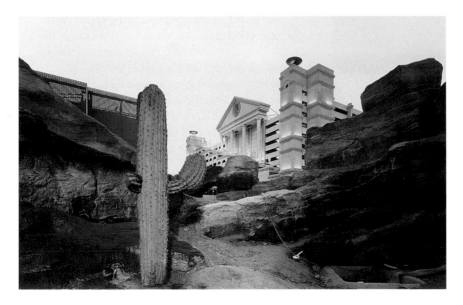

Alexander Timtschenko
(German, b. 1965)
OPPOSITE *Wild, Wild, West I*, 1999
ABOVE *Wild, Wild, West*, 1997
See also p. 73.

 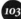

Robert Smithson
(American, 1938–1973)
The Spiral Jetty (stills), 1970

The documentary film *Spiral Jetty*, narrated by Smithson, represents a period in the 1960s when artists were making interventions in the landscape known as earthworks. The primordial spiral form refers to the ancient geological history of the site and the entropic effects of time; in 2003 the water levels receded so that *The Spiral Jetty* was visible for the first time in twenty-three years. Tourists can travel to Rozel Point, Great Salt Lake, Utah, to see and experience the work, made as an alternative to art displayed in museums and galleries. For art aficionados, such a trek is like a pilgrimage to a venerated, mythic place — Smithson's career ended abruptly when he died in a plane crash in 1973. See also p. 111.

Golden Spike National Historic Site
Directions to *The Spiral Jetty*

Note: Odometer readings vary with each vehicle. The distances given below are only approximations.

1. Go to Golden Spike National Historic Site (GSNHS), 30 miles west of Brigham City, Utah. The Spiral Jetty is 15.5 dirt road miles southwest of Golden Spike's visitor center.

To get there (from Salt Lake City) take I-15 north approximately 65 miles to the Corinne exit (exit 368), just west of Brigham City, Utah. Exit and proceed through Corinne, paying close attention to the signs, and drive another 17.7 miles west, still on Highway 83, turn left and follow signs, another 7.7 miles up the east side of Promontory Pass to Golden Spike National Historic Site.

2. From the visitor center, drive 5.6 miles west on the main gravel road.

3. Five point six miles should bring you to an intersection. From this vantage point you can see the lake. Looking southwest, you can see the low foothills that make up Rozel Point, 9.9 miles distant.

4. At this intersection the road forks. One road continues west, the other goes south. Take the south (left) fork. Both forks are Box Elder County Class D (maintained) roads.

5. Immediately you cross a cattle guard. Call this cattle guard #1. Including this one, you should cross four cattle guards before you reach Rozel Point and the Spiral Jetty.

6. Drive 1.3 miles south. Here you should see a corral on the west side of the road. Here too, the road again forks. One fork continues south along the west side of the Promontory Mountains. This road leads to a locked gate. The other fork goes southwest toward the bottom of the valley and Rozel Point.

UNIVERSAL EXPERIENCE *Art, Life, and the Tourist's Eye*

Turn right onto the southwest fork, just north of the corral. This is also a Box Elder County Class D road.

7. After you turn southwest, go 1.7 miles to cattle guard #2. Here, besides the cattle guard, you should find a fence but no gate.

8. Continue southeast 1.2 miles to cattle guard #3, a fence, and gate.

9. Another .5 miles should bring you to a fence but no cattle guard and no gate.

10. Continue 2.3 miles south-southwest to a combination fence, cattle guard #4, iron-pipe gate — and a sign declaring the property behind the fence to be that of the "Rafter S. Ranch". Here too, is a "No Trespassing" sign.

11. At this gate the Class D road designation ends. If you choose to continue south for another 2.3 miles, and around the east side of Rozel Point, you should see the Lake and a jetty (not the Spiral Jetty) left by oil drilling exploration in the 1920s through the 1980s. As you approach the Lake, you should see an abandoned, pink and white trailer (mostly white), an old amphibious landing craft, an old Dodge truck . . . and other assorted trash.

Tacita Dean (British, b. 1965)
Trying to Find the Spiral Jetty, 1997

Trying to Find the Spiral Jetty is a sound installation of Dean's attempt to see Robert Smithson's earthwork in a remote area of Utah using the directions reproduced on pages 104–6. In a meditation on the journey itself and failed expectations, Dean and her friend narrate getting lost in the car, asking for directions, and what they find or do not find when they arrive. As in many of her films and sound works, Dean crafts an account that is part truth and part fiction — she has edited together conversations from the road trip with scripted texts and sound effects — since memories are often a blending of both.

From this location, the trailer is the key to finding the road to the Spiral Jetty. As you drive slowly past the trailer, turn immediately from the southwest to the west (right), passing on the south side of the Dodge, and

The earth to me isn't nature, but a museum.

Robert Smithson

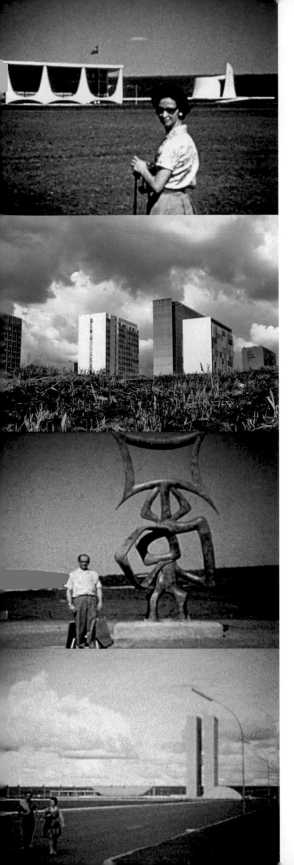

onto a two-track trail that contours above the oil-drilling debris below. This is not much of a road! Only high clearance vehicles should advance beyond the trailer. Go slowly! The road is narrow, brush might scratch your vehicle, and the rocks, if not properly negotiated, could high center your vehicle. Don't hesitate to park and walk. The Jetty is just around the corner.

12. Drive or walk 6/10th of a mile west-northwest around Rozel Point and look toward the Lake. The Spiral Jetty should be in sight. The lake level varies several feet from year-to-year and from season to season, so the Spiral Jetty is not always visible above the water line.

Malcolm McCullough

Digital Ground: Architecture, Pervasive Computing, and Environmental Knowing, p. 47–48

The built environment organizes flows of people, resources, and ideas. . . . Architecture frames intentions. Interactivity, at its very roots, connects those mental states to available opportunities for participation. . . .

For much as the body imposes a schema on space, architecture imposes a schema on the body.[1] The proportions, image, and embellishments of the body are reflected in the proportions, image, and embellishments of buildings. Similarly, cities reflect the form of their buildings, cultural landscapes reflect the structure of their cities and towns, and mythologies orient all of these in the world. . . .

Wherever goods, people, or electronic communications flow, spaces form around them. This emergence has been particularly evident in the case of disembodied electronic channels.

BELOW
Angelina Gualdoni (American, b. 1975)
The Reflecting Skin, 2004

Gualdoni's paintings have a disaffecting, almost apocalyptic quality that is formally balanced by lush textures, colors, and shapes of modernist architecture. Gualdoni's interest lies in the entropic decay and destruction of these buildings, which often reflected utopian designs for the future. Taking the city of Brasilia as a case study, she depicts government buildings and monuments located in the Praça dos Tres Poderes (Square of the Three Powers) to see how mid-century building designs and urban plans function today.

Peter Osborne

The Politics of Time: Modernity and Avant-Garde, p. 15

It has become commonplace to assume that whilst modernity is about new forms of experience of time, "postmodernity" marks a revolution in spatial relations. But this is too simple. The two dimensions are inextricably bound together. Changes in the experience of space always also involve changes in the experience of time and vice versa.

1 Yi-Fu Tuan, *Space and Place: The Perspective of Experience* (Minneapolis: University of Minnesota Press, 1976), p. 36.

Saskia Sassen "Whose City Is It? Globalisation and The Formation of New Claims," pp. 60–61

Cities are the terrain where people from many different countries are most likely to meet and a multiplicity of cultures come together. The international character of major cities lies not only in their telecommunication infrastructure and international firms, but also in the many different cultural environments they contain. . . .

It is true that throughout history people have moved and through these movements constituted places. But today the articulation of territory and people is being constituted in a radically different way at least in one regard, and that is the speed with which that articulation can change. One consequence of this speed is the expansion of the space within which actual and possible linkages can occur. The shrinking of distance and the speed of movement that characterise the current era find one of its most extreme forms in electronically based communities of individuals or organisations from all around the globe interacting in real time and simultaneously, as is possible through the Internet and kindred electronic networks. . . .

[A]nother radical form assumed today by the linkage of people to territory is the unmooring of identities from what have been traditional sources of identity, such as the nation or the village. This unmooring in the process of identity formation engenders new notions of community, of membership, and of entitlement.

All the science in the world cannot explain what it is like to wake up in a great city.

See **Malcolm McCullough**
Digital Ground

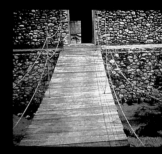
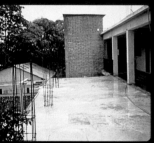

The space constituted by the global grid of cities, a space with new economic and political potentialities, is perhaps one of the most strategic spaces for the formation of transnational identities and communities. This is a space that is both place-centred in that it is embedded in particular and strategic locations; and it is transterritorial because it connects sites that are not geographically proximate yet are intensely connected to each other. . . . It is not only the transmigration of capital that takes place in this global grid, but also that of people, both rich, i.e., the new transnational professional workforce, and poor, i.e., most migrant workers; and it is a space for the transmigration of cultural forms, for the territorialisation of "local" subcultures. An important question is whether it is also a space for a new politics, one going beyond the politics of culture and identity, though at least partly likely to be embedded on it.

Robert Smithson "See the Monuments of Passaic New Jersey," p. 356
What can you find in Passaic that you can not find in Paris, London, or Rome? Find out for yourself. Discover (if you dare) the breathtaking Passaic River and the eternal monuments on its enchanted banks. Ride in Rent-a-Car comfort to the land that time forgot. Only minutes from N.Y.C. Robert Smithson will guide you through this fabled series of sites . . . and don't forget your camera. Special maps come with each tour. For more information visit Dwan Gallery, 29 West 57th Street.

OPPOSITE
Robert Smithson (American, 1938–1973)
Hotel Palenque, 1969

In 1969, while traveling in Mexico's Yucutan Peninsula, an area rich with Mayan architecture and monuments, Smithson became interested in modern structures such as the dilapidated Hotel Palenque. In 1972, he presented the slides of architectural details in a lecture to a group of architecture students at the University of Utah. A recording of the artist's voice accompanies the slide show in *Universal Experience*. As expressed in his seminal text *The Monuments of Passaic New Jersey*, *Hotel Palenque* is an example of Smithson's examination of peripheral sites and the effects of entropy and decay in cities and suburbs. See also p. 104.

Saskia Sassen "A Global City," pp. 18, 28, and 34
Many people think that modern communications remove the need for . . . conventional infrastructure. But the "production" process in modern industries requires face-to-face contact. Business travel and electronic links have grown together, and neither replaces the other. The virtual office sounds more complete than it is. Certain types of work can indeed be done

from a virtual office located anywhere. But work that requires specialized knowledge, considerable innovation, and risk-taking needs direct meetings and environments that bring together many diverse, highly specialized professionals with experience in different parts of the world. . . .

Many of the functions needed to make all of this work are not mobile at all but happen in certain places. Indeed, they are dependent on these certain places, which we call global cities. . . .

Cities are organic things, with life-cycles, constantly changing. Many, like Paris or London have reinvented themselves many times over the centuries in response to historical and economic changes. Others, like Chicago, are relatively young, products of the Industrial Revolution, manufacturing giants that grew from raw labor pools to places of power and sophistication in little more than a century. These cities are reinventing themselves now for the first time.

Global cities do not spring fresh from virgin soil. Instead, the global cities of today and tomorrow are mostly the great cities of the past.

Saskia Sassen "A Global City"

UNIVERSAL EXPERIENCE *Art, Life, and the Tourist's Eye*

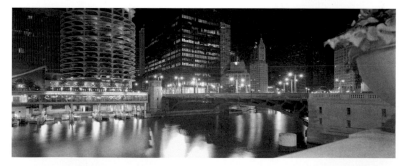

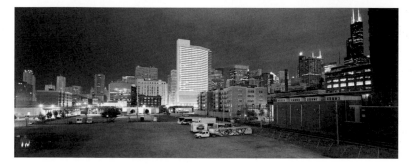

Globalization refers to fundamental changes in the spatial and temporal contours of social existence. Geographical distance is typically measured in time. As the time necessary to connect distinct geographical locations is reduced, distance or space undergoes compression or "annihilation." The human experience of space is intimately connected to the temporal structure of [how] we experience space. Changes in the temporality of human activity inevitably generate altered experiences of space or territory. **William E. Scheuerman** "Globalization"

Zhan Wang (Chinese, b. 1962)
Urban Landscape, 2003

Zhan Wang's sublime landscape made with hundreds of stainless steel pots and pans represents the struggle between tradition and progress. New building materials are changing the landscape and way of life in China; sturdy stainless steel kitchen utensils, for example, have replaced fragile porcelain. For Wang, stainless steel, which never rusts, represents a desire for luxurious materialism and immortality. At the same time, *Urban Landscape* reflects his fantasy of walking into a traditional Chinese landscape painting; viewers can walk around the misty peaks and valleys of the stainless steel mountains.

Malcolm McCullough *Digital Ground: Architecture, Pervasive Computing, and Environmental Knowing,* pp. 41–42 and 48

"Space," like embodiment, has occupied philosophers from the ancients to the latest wave of cyberpunks.[1] Because it allows motion, space has been intrinsic to modernity. Space is a means, and not a mere setting. . . . It is the form of external experience as distinguished from the things encountered within that experience. . . .

Quite often a people forgets that it has a particular environmental orientation. . . . A culture may not always acknowledge that even the most mundane environmental configurations are far from inevitable: choices have been made. Recollecting this is what makes travel so interesting. . . .

As each culture develops its own environmental ordering as a foil to the world's indifference, settlement patterns not only reflect but then also shape beliefs. As cultures become identified with their peculiar spatial customs, landscape tends to serve as the best framework for narrative memory. Thus Cicero could write: *"Quacunque enim ingredimur, in aliqua historia uestigium ponomius;*[2] "For walk where we will, we tread upon some story."

1 See Steven Hawking and Roger Penrose, *The Nature of Space and Time* (Princeton, N.J.: Princeton University Press, 2000).

2 Cicero, *de Finibus,* vol. 5. Cited in H. J. Rose, *A Handbook of Greek Mythology* (New York: E. P. Dutton, 1959), p. 254.

OPPOSITE
Olivo Barbieri (Italian, b. 1954)
site specific_roma 04, 2004

Barbieri has photographed cities in China, Tibet, India, Italy, and the United States, among others, portraying them as miniature scale models. His images allow viewers to envision themselves as part of a larger urban network of roads, buildings, and monuments. In *site specific_roma 04,* Barbieri filmed Rome from a helicopter. The aerial view and soundtrack of moving helicopter blades create a feeling of expectation, as if we are looking for something to happen in the scenes below. What we find is daily life in a city of temporal and technological contrasts; tourists visit the Colosseum while locals drive to work along Rome's historic roadways and ancient ruins coexist with shopping centers. Barbieri's Rome acknowledges the Eternal City's role as a model for the development of the modern city.

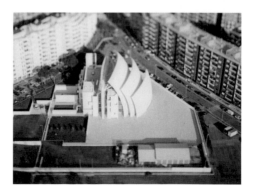

I borrow the phrase "spatial practice" from Michel de Certeau's book *The Practice of Everyday Life* (1984). For de Certeau, "space" is never ontologically given. It is discursively mapped and corporeally practiced. An urban neighborhood, for example, may be laid out physically according to a street plan. But it is not a space until it is practiced by people's active occupation, their movements through and around it.

James Clifford *Routes: Travel and Translation in the Late Twentieth Century*

IV *All Roads Slope to*

About the sea the continents lie "vast and vastly spread," ever supplying you with products from those regions. Here is brought from every land and sea all the crops of the seasons and the produce of each land, river, lake, as well as the arts of the Greeks and barbarians, so that if someone should wish to view all these things, he must either see them by traveling over the whole world or be in this city. **Aelius Aristides** *The Complete Works*

UNIVERSAL EXPERIENCE *Art, Life, and the Tourist's Eye*

Rome

To tourists, Rome represents almost 3,000 years of cultural history. To military historians, Rome was the epicenter of an empire that brought much of the world under its rule. To architects and engineers, ancient Rome is a model for study and experimentation.

Rather than serving kings or gods, Roman republican society served its citizens. For this reason, ancient Rome is considered the first modern city. This section explores ancient Rome through the lenses of the military, architecture, and film with a new essay by Robert Somol.

PAGES 118–123
Rem Koolhaas, Robert Somol, and Jeffrey Inaba
(Dutch, b. 1944; American, b. 1961 and 1962)
Roman Operating System, Project on the City (R/OS), 2004

As part of the Harvard Design School Project on the City's extensive research on urban planning, *R/OS* posits Rome as the principle operating system for building, activating, and networking all cities. This compilation of text, maps, charts, film stills, and images, taken from the recent publication *R/OS_MM: A Users Manual*, standardizes elements of this ancient city and illustrates how they function as universal prototypes. Installed in the MCA atrium, *R/OS* reflects Rome as a franchise for the modern metropolis, adaptable to any location.

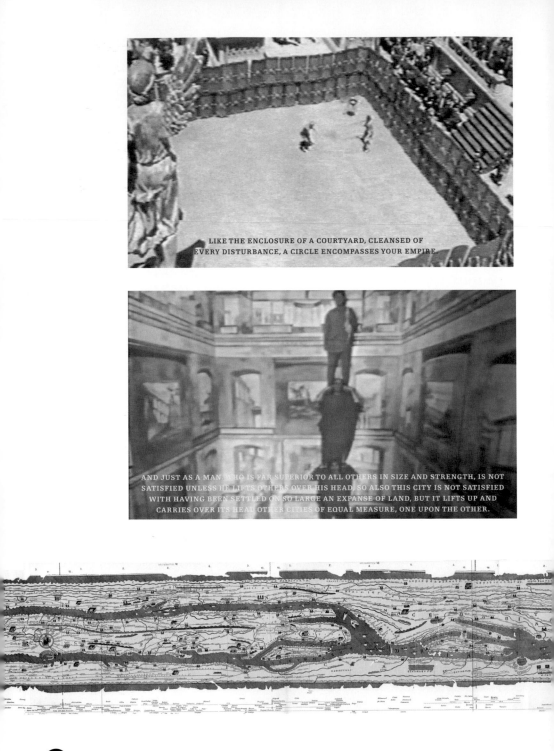

LIKE THE ENCLOSURE OF A COURTYARD, CLEANSED OF
EVERY DISTURBANCE, A CIRCLE ENCOMPASSES YOUR EMPIRE.

AND JUST AS A MAN, WHO IS FAR SUPERIOR TO ALL OTHERS IN SIZE AND STRENGTH, IS NOT
SATISFIED UNLESS HE LIFTS OTHERS OVER HIS HEAD, SO ALSO THIS CITY IS NOT SATISFIED
WITH HAVING BEEN SETTLED ON SO LARGE AN EXPANSE OF LAND, BUT IT LIFTS UP AND
CARRIES OVER ITS HEAD OTHER CITIES OF EQUAL MEASURE, ONE UPON THE OTHER.

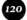

UNIVERSAL EXPERIENCE *Art, Life, and the Tourist's Eye*

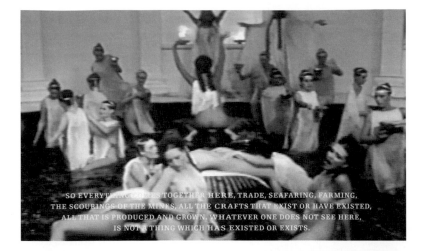

SO EVERYTHING COMES TOGETHER HERE, TRADE, SEAFARING, FARMING,
THE SCOURINGS OF THE MINES, ALL THE CRAFTS THAT EXIST OR HAVE EXISTED,
ALL THAT IS PRODUCED AND GROWN. WHATEVER ONE DOES NOT SEE HERE,
IS NOT A THING WHICH HAS EXISTED OR EXISTS.

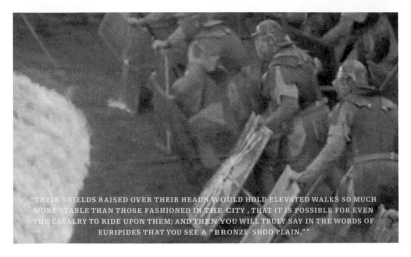

"THEIR SHIELDS RAISED OVER THEIR HEADS WOULD HOLD ELEVATED WALKS SO MUCH
MORE STABLE THAN THOSE FASHIONED IN THE CITY, THAT IT IS POSSIBLE FOR EVEN
THE CAVALRY TO RIDE UPON THEM; AND THEN YOU WILL TRULY SAY IN THE WORDS OF
EURIPIDES THAT YOU SEE A "BRONZE-SHOD PLAIN.""

IV *All Roads Slope to Rome*

Robert Somol *All Roads Slope to Rome (A Tourist's Guide to the Roman System)*
Tourists are the first performers of the Roman System. Unlike generations
of historians and planners who represent Rome as a singular and monu-
mental object, the act of
the tourist recognizes the
Roman Empire as a city-
making machine, the
first instance of global-
ization and moderniza-
tion. The typical deni-
gration of the tourist-
effect — rendering all
places the same — actu-
ally enacts the procedure
of the Roman System itself, the proliferation of *roman cities*, urbanism now
rendered generic and plural. We come not to praise Rome, but to use it.

Examples of genericities you will be able to build using the R/OS

As a primary document of this Roman System, the so-called Peutinger
Table (at the bottom of this section), initially dating from the second cen-
tury AD, is a pictorial itinerary. Despite a high visual distortion in the E-W
axis, producing the Empire as a distended sausage, the Peutinger denotes
precise distances between various sites, stations, and amenities. In fact, its
stretched projection is required to make it more useful as a guide on the
road for both the military and citizens, a portable scroll just over a foot high

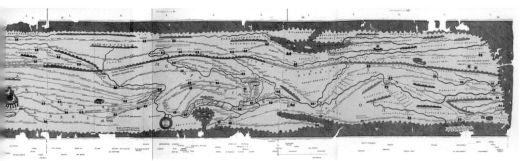

UNIVERSAL EXPERIENCE *Art, Life, and the Tourist's Eye*

and twenty-two feet long that can be rolled around a stick for the convenient navigation of the empire. Seemingly floating in a surrounding aqueous medium, the Empire emerges as an island, or a dynamic system caught in a temporal snapshot. The Peutinger thus exposes the Roman System as a network of flows where materials, products, and populations are in a continuous state of movement. With its material themodynamics, the *slope* of the system reveals that gravity (and the real tilt of the section) has overcome geometry (or the ideal extrusion of plan).

The state-sanctioned tourism of the military and the privately motivated itineraries of the nobility find their perverse corollary in generations of designers and thinkers who return to "Rome" to bring back souvenir lessons for architecture and urbanism. From Piranesi to Burnham, Lewis Mumford to Le Corbusier, "disciplined" tourists have systematically misread Rome for their own purposes; yet, through their "failures," have nonetheless demonstrated the secret survival of the Roman System. Whereas earlier grand tourists have used Rome to justify or explain situations such as Las Vegas, a more energetic understanding of the Roman System can now employ urbanisms like Las Vegas (and other tourist traps) to diagnose and project the system, with its manipulated landscapes, fluid infrastructures, endlessly reversible interiors, and saturated graphic fields.

In the running failure of the Roman System, tourism begins with war and ends in architectural history.

The Men Who Invented White-Out

Clearly, following the eloquent oratory of Cato the Elder, everyone knew that Carthage just *had* to be destroyed. But how? There were several good options on the table: fire, water, invasion, someone even mentioned another Trojan Horse. But there was one idea that Cato just could not get out of his head, *sow the fields around Carthage with salt*. Such a simple plan but so effective. Carthage would never rise again.

Cato had a reason to be mad. He was old-school and, moreover, he had been there himself. He had fought in the 2nd Punic War, and he remembered how Hannibal had made the Romans look bad. *Elephants? In Europe?* It just wasn't right.

So with the support of Scipio Aemilianus, Cato invented white-out, relying on just salt and a dream. Scipio sacked Carthage, forced Hannibal into suicide, and then with his army tilled the land and salted it over. Later the Roman's built a new city there, over-writing the white out. Cato himself later commited suicide. He couldn't take the success.

V Longing for Places

Travel is often considered a time to dream, to wander in wonder — when we travel, we have a new set of eyes and a new frame of mind. While the tourist often leaves home in search of the unknown and the unfamiliar, the physical and metaphysical changes that result from the act of traveling often generate within the tourist a novel reception to possibilities and opportunities. Perhaps the true reason for travel is to return home not only with memories, but with this newly discovered receptivity intact and operable.

The writings and artworks in this section examine the acts of traveling — departure and a range of increasingly accelerated modes of movement — while exploring our longing for travel. Although the desire for recreational travel may be universal, millions of people travel for survival rather than for stimulation.

In its most specific meaning, the Latin word *limen*, from which liminality is derived, referred not to a threshold but to the outermost *road* of the Roman Empire. The extreme limit of the imperial domain was a pathway, and thus a world in itself with its own logic, sequences, liberties, and constraints, not simply a boundary between inner and outer space. **Eric J. Leed** *The Mind of the Traveler: From Gilgamesh to Global Tourism*

Illinois Institute of Technology
Chicago Transit Authority
(CTA) Station, designed by
Rem Koolhaas
(Dutch, b. 1944), 2002
See also p. 119.

o Go

The motel, like the airport transit lounge or the coach station, represents neither arrival nor departure. It represents the "pause" before tourists move on to the next stopping-point along the extraordinary routeways of a "liquid modernity."

John Urry *The Tourist Gaze*

Mark Gottdiener *Life in the Air: Surviving the New Culture of Air Travel*, pp. 9–10

Airports might be considered liminal spaces *par excellence* because of their function as thresholds. . . . When standing at the portal of a themed restaurant or park, especially one that offers some totalizing fantasy environment, such as Disney World or the Rainforest Cafe, you are poised at a spot that functions as a space of *transition*. It is precisely this alteration in the way you experience space that is distinctive of these new environments. Entering the space triggers new feelings of self, new identities that are set off by stimulators engineered within the new consumer fantasy domains. Hence, the term "transition space" is used to describe the new forms of architectural commercialism because they connect with the altered ways that people experience themselves. In this sense, the airport is the definitive transition space. Trips are nothing if they are not existential.

RIGHT
Elizabeth Diller + Ricardo Scofidio (American, b. 1954 and 1935)
Interclone Hotel, 1997

Originally installed among other advertisements at Attatürk Airport during the 1997 Istanbul Biennial, *Interclone Hotel* is an advertising campaign for a fictional international hotel chain located in cities such as Ho Chi Minh City, Vietnam; Kampala, Uganda; and Tijuana, Mexico. Alluding to the tenuous balance between economic development and preserving cultural specificity, the images suggest the homogenizing effect of multinational corporations, especially international hotel chains, with each room containing the same basic furniture and layout. Yet, in order to satisfy tourists' desire for a "local" experience, the rooms are decorated in a manner that often reflects a stereotypical view of the native culture. A chart at the bottom of each picture depicts "useful" information such as the local color palette, symbolic cultural motifs, distance from the nearest airport, and safety advisories. See also p. 233.

UNIVERSAL EXPERIENCE *Art, Life, and the Tourist's Eye*

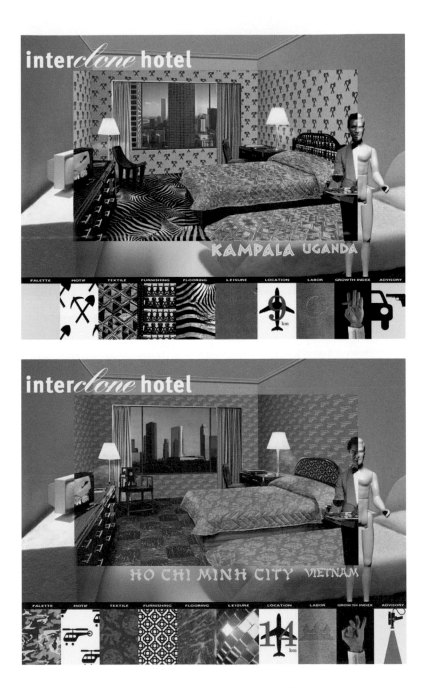

Doug Aitken (American, b. 1968)
The Moment (stills), 2004

In *The Moment*, an eleven-screen video installation, Aitken captures the feeling of displacement associated with traveling, a feeling that is heightened upon waking in an unfamiliar place. Each video depicts someone asleep and waking in transitional places such as hotels, parking lots, and terminals. Mirrors behind each hanging flat screen create multiple reflections of the other videos, creating a kaleidoscope of movement.

▾ *Longing for Places to Go*

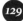

Mark Gottdiener *Life in the Air: Surviving the New Culture of Air Travel*, p. 11

Airports are the gateway to the "other," i.e., another staging area of action outside the ordinary bonds of existence. A trip, any trip, provides us with the freedom to escape our daily routine. Even if the purpose of travel is business, the trip is a kind of vacation. . . . "The holiday trip is a setting in which constraints can be relaxed if not rejected, identities slip if not disappear, a place where lives are rejuvenated if not changed. The holiday is the archetypal free area, the institutionalized setting for temporary excursions away from the domain of paramount reality. More than any other everyday escape, the holiday is a small-scale replica of the great escape messages of our culture. Reverberating right through religion, folklore, artistic expression and mass culture are powerful symbolic and allegorical messages around the theme of a move to a new land. Pilgrims and seekers after spiritual enlightenment must move to new landscapes: somewhere outside the walls of the prison is the Holy Grail, El Dorado, Shangri-La."[1]

Because they represent the transcendence of space and time, airports function as gateways and as transition spaces; they personify the "great escape." Precisely for this reason, air transportation possesses the aura of romance and exoticism, of possibility, difference, and a new chance for daily living. Early in its history, this romantic element of escape to some fantasy location was the strongest aspect of commercial aviation's appeal.

1 Stanley Cohen and Laurie Taylor, *Escape Attempts* (New York: Routledge, 1992).

The airport is a place where we have passed through but never really *been.*

Mark Gottdiener
Life in the Air: Surviving the New Culture of Air Travel

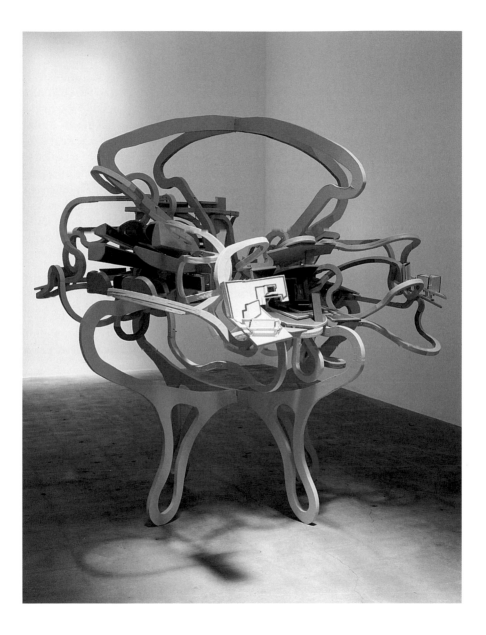

 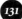

Alain de Botton *The Art of Travel*, pp. 239–49

1.

I returned to London from Barbados to find that the city had stubbornly refused to change. I had seen azure skies and giant sea anemones, I had slept in a raffia bungalow and eaten a kingfish, I had swum beside baby turtles and read in the shade of coconut trees. But my hometown was unimpressed. It was still raining. The park was still a pond; the skies were still funereal. When we are in a good mood and it is sunny, we may be tempted to impute a connection between what happens inside and outside of us, but the appearance of London on my return was a reminder of the indifference of the world to any of the events unfolding in the lives of its inhabitants. I felt despair at being home. I felt there could be few worse places on Earth than the one I had been fated to spend my existence in.

2.

"The sole cause of man's unhappiness is that he does not know how to stay quietly in his room" — Pascal, *Pensées*, 136.

3.

From 1799 to 1804, Alexander von Humboldt undertook a journey around South America, later entitling the account of what he had seen *Journey to the Equinoctial Regions of the New Continent.*

Nine years before Humboldt set out, in the spring of 1790, a twenty-seven-year-old Frenchman named Xavier de Maistre had undertaken a journey around his bedroom, an account of which he would later entitle *Journey around My Bedroom.* Gratified by his experiences, de Maistre in 1798 embarked upon a second journey. This time he travelled by night and ventured out as far as the window ledge; the literary result would be titled *Nocturnal Expedition around My Bedroom.*

Two approaches to travel: *Journey to the Equinoctial Regions of the New Continent; Journey around my Bedroom.* The first required ten mules, thirty pieces of luggage, four interpreters, a chronometer, a sextant, two telescopes, a Borda theodolite, a barometer, a compass, a hygrometer, letters of introduction from the king of Spain and a gun; the latter, a pair of pink-and-blue cotton pyjamas.

Xavier de Maistre was born in 1763, in the picturesque town of Chambéry, at the foot of the French Alps. He was of an intense, romantic nature

Paul Theroux … comments that many people travel for the purpose of "home plus" — Spain is home plus sunshine … Africa is home plus elephants and lions. And for some, of course, travel is ideally home plus more and better business. **Ulf Hannerz**

Transnational Connections:
Culture, People, Places

and was fond of books, especially by Montaigne, Pascal and Rousseau, and of paintings, above all Dutch and French domestic scenes. At the age of twenty-three, de Maistre became fascinated by aeronautics. Etienne Mont-golfier had, three years before, achieved international renown by con-structing a balloon that flew for eight minutes above the royal palace at Ver-sailles, bearing as passengers a sheep named Montauciel ("Climb-to-the-sky"), a duck and a rooster. De Maistre and a friend fashioned a pair of giant wings out of paper and wire and planned to fly to America. They did not succeed. Two years later de Maistre secured himself a place in a hot-air balloon and spent a few moments floating above Chambéry before the ma-chine crashed into a pine forest.

Then, in 1790, while he was living in a modest room at the top of an apartment building in Turin, de Maistre pioneered a mode of travel that was to make his name: room travel.

Introducing *Journey around my Bedroom*, Xavier's brother, the political theorist Joseph de Maistre, emphasised that it was not Xavier's intention to cast aspersions on the heroic deeds of the great travellers of the past — namely, "Magellan, Drake, Anson and Cook." Magellan had discovered a western route to the Spice Islands around the southern tip of South America, Drake had circumnavigated the globe, Anson had produced ac-curate sea charts of the Philippines and Cook had confirmed the existence of a southern continent. "They were no doubt remarkable men," wrote Joseph. It was just that his brother had discovered a way of travelling that might be infinitely more practical for those neither as brave nor as wealthy as those explorers.

"Millions of people who, until now, have never dared to travel, others who have not been able to travel and still more who have not even thought of travelling will be able to follow my example," explained Xavier as he prepared for his journey. "The most indolent beings will no longer have any reason to hesitate before setting off to find pleasures that will cost them neither money nor effort." He particularly recommended room travel to the poor and to those afraid of storms, robbers, and high cliffs.

4.

Unfortunately, de Maistre's own pioneering journey, rather like his flying machine, did not get very far.

The story begins well: de Maistre locks his door and changes into his pink-and-blue pyjamas. With no need of luggage, he travels to the sofa, the largest piece of furniture in the room. His journey having shaken him from his usual lethargy, he looks at it through fresh eyes and rediscovers some of its qualities. He admires the elegance of its feet and remembers the pleasant hours he has spent cradled in its cushions, dreaming of love and advancement in his career. From his sofa, de Maistre spies his bed. Once again, from a traveller's vantage point, he learns to appreciate this complex piece of furniture. He feels grateful for the nights he has spent in it and takes pride in the fact that his sheets almost match his pyjamas. "I advise any man who can do so to get himself pink and white bedlinen," he writes, "for these are colours to induce calm and pleasant reveries in the fragile sleeper."

But thereafter de Maistre may be accused of losing sight of the overall purpose of his endeavour. He becomes mired in long and wearing digressions about his dog, Rosinne, his sweetheart, Jenny, and his faithful servant, Joannetti. Prospective travellers in search of specific guidance on room travel risk coming away from reading *Journey around My Bedroom* feeling a little betrayed.

And yet de Maistre's work sprang from a profound and suggestive insight: the notion that the pleasure we derive from a journey may be dependent more on the mindset we travel *with* than on the destination we travel *to*. If only we could apply a travelling mindset to our own locales, we might find these places becoming no less interesting than, say, the high mountain passes and butterfly-filled jungles of Humboldt's South America.

What, then, is a travelling mindset? Receptivity might be said to be its chief characteristic. Receptive, we approach new places with humility. We

carry with us no rigid ideas about what is or is not interesting. We irritate locals because we stand in traffic islands and narrow streets and admire what they take to be unremarkable small details. We risk getting run over because we are intrigued by the roof of a government building or an inscription on a wall. We find a supermarket or a hairdresser's shop unusually fascinating. We dwell at length on the layout of a menu or the clothes of the presenters on the evening news. We are alive to the layers of history beneath the present and take notes and photographs.

Home, by contrast, finds us more settled in our expectations. We feel assured that we have discovered everything interesting about our neighbourhood, primarily by virtue of our having lived there a long time. It seems inconceivable that there could be anything new to find in a place where we have been living for a decade or more. We have become habituated and therefore blind to it.

De Maistre tried to shake us from our passivity. In his second volume of room travel, *Nocturnal Expedition around my Bedroom*, he went to his window and looked up at the night sky. Its beauty made him feel frustrated that such ordinary scenes were not more generally appreciated: "How few people are right now taking delight in this sublime spectacle that the sky lays on uselessly for dozing humanity! What would it cost those who are out for a walk or crowding out of the theatre to look up for a moment and admire the brilliant constellations that gleam above their heads?" The reason people were not looking was that they had never done so before. They had fallen into the habit of considering their universe to be boring — and their universe had duly fallen into line with their expectations.

5.

I attempted to travel around my bedroom, but it was so small, with barely enough space for a bed, that I concluded that the de Maistrian message might prove more rewarding if it was applied to the neighbourhood as a whole.

So on a clear March day, at around three in the afternoon, several weeks after my return home from Barbados, I set out on a de Maistrian journey around Hammersmith. It felt peculiar to be outside in the middle of the day with no particular destination in mind. A woman and two small blond children were walking along the main road, which was lined with a variety of shops and restaurants. A double-decker bus had stopped to pick up pas-

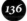

sengers opposite a park. A giant billboard was advertising gravy. I walked along this road almost every day to reach my Underground station and was unused to regarding it as anything other than a means to my end. Information that assisted me in my goal attracted my attention; all else was judged irrelevant. Thus, while I was sensitive to the number of people on the pavement, as potential impediments to my path, their faces and expressions were invisible to me — as invisible as the shapes of the buildings or the activity in the shops.

It had not always been thus. When I first moved to the area, my attention was less jealously focused. I had at that time not yet settled so firmly on the goal of reaching the Underground quickly.

On entering a new space, our sensitivity is directed towards a number of elements, which we gradually reduce in line with the function we find for the space. Of the four thousand things there might be to see and reflect on in a street, we end up being actively aware of only a few: the number of humans in our path, perhaps, the amount of traffic and the likelihood of rain. A bus that we might at first have viewed aesthetically or mechanically — or even used as a springboard to thoughts about communities within cities — becomes simply a box to move us as rapidly as possible across an area that might as well not exist, so unconnected is it to our primary goal, outside of which all is darkness, all is invisible.

I had imposed a grid of interests on the street, one that left no space for blond children and gravy adverts and paving stones and the colours of shop fronts and the expressions of businesspeople and pensioners. The power of my primary goal had drained me of the will to reflect on the layout of the park or the unusual mixture of Georgian, Victorian and Edwardian architecture along a single block. My walks along the street had been excised of any attentiveness to beauty, any associative thoughts, any sense of wonder or gratitude, any philosophical digressions sparked by visual elements. In their place, there was simply an insistent call to reach the Underground posthaste.

Now, following de Maistre, I tried to reverse the process of habituation, to dissociate my surroundings from the uses I had previously found for them. I forced myself to obey a strange sort of mental command: I was to look around me as though I had never been in this place before. And slowly, my travels began to bear fruit.

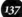

Once I began to consider everything as being of potential interest, objects released latent layers of value. A row of shops that I had always known as one large, undifferentiated, reddish block acquired an architectural identity. There were Georgian pillars around one flower shop, and late-Victorian Gothic-style gargoyles on top of the butcher's. A restaurant became filled with diners rather than shapes. In a glass-fronted office block, people were gesticulating in a boardroom on the first floor as someone drew a pie chart on an overhead projector. Just across the road from the office, a man was pouring out new slabs of concrete for the pavement and carefully shaping their edges. I boarded a bus and, instead of slipping at once into private concerns, tried to connect imaginatively with other passengers. I could hear a conversation in the row ahead of me. Someone in an office somewhere — a person quite high up in the hierarchy, apparently — didn't understand: he complained about how inefficient others were but never reflected on what he himself might be doing to contribute to that inefficiency. I thought of the multiplicity of lives going on at the same time at different levels in a city. I thought of the similarities of complaints — always selfishness, always blindness — and the old psychological truth that what we complain of in others, others will complain of in us.

The neighbourhood did not just acquire people and defined buildings through my reawakened attention; it also began to collect ideas. I reflected on the new wealth that was spreading into the area. I tried to think why I liked railway arches so much, and why the motorway that cut across the skyline.

It seemed an advantage to be travelling alone. Our responses to the world are crucially moulded by the company we keep, for we temper our curiosity to fit in with the expectations of others. They may have particular visions of who we are and hence may subtly prevent certain sides of us from emerging: "I hadn't thought of you as someone who was interested in flyovers," they may intimidatingly suggest. Being closely observed by a companion can also inhibit our observation of others; then, too, we may become caught up in adjusting ourselves to the companion's questions and remarks, or feel the need to make ourselves seem more normal than is good for our curiosity. But alone in Hammersmith in the middle of a March afternoon, I had no such concerns. I had the freedom to act a little weirdly. I sketched the window of a hardware shop and word-painted the flyover.

 UNIVERSAL EXPERIENCE *Art, Life, and the Tourist's Eye*

6.

De Maistre was not only a room traveller. He was also a great traveller in the classic sense. He journeyed to Italy and Russia, spent a winter with the Royalist armies in the Alps and fought a Russian campaign in the Caucasus.

In an autobiographical note written in 1801 in South America, Alexander von Humboldt specified his motive for travelling: "I was spurred on by an uncertain longing to be transported from a boring daily life to a marvellous world." It was this very dichotomy, "boring daily life" pitted against "marvellous world," that de Maistre had tried to redraw with greater subtlety. He would not have suggested to Humboldt that South America was dull; he merely would have urged him to consider that his native Berlin might have something to offer, too.

Dreams ever different ever varied endless voyages endless realms ever strange ever wonderful.

Joseph Cornell *Joseph Cornell's Theatre of the Mind: Selected Diaries, Letters and Files*

Eight decades later, Nietzsche, who had read and admired de Maistre (and spent much time in his own room), picked up on the thought:

"When we observe how some people know how to manage their experiences — their insignificant, everyday experiences — so that they become an arable soil that bears fruit three times a year, while others — and how many there are! — are driven through surging waves of destiny, the most multifarious currents of the times and the nations, and yet always remain on top, bobbing like a cork, then we are in the end tempted to divide mankind into a minority (a minimality) of those who know how to make much of little, and a majority of those who know how to make little of much."

There are some who have crossed deserts, floated on ice caps and cut their way through jungles but whose souls we would search in vain for evidence of what they have witnessed. Dressed in pink-and-blue pyjamas, satisfied within the confines of his own bedroom, Xavier de Maistre was gently nudging us to try, before taking off for distant hemispheres, to notice what we have already seen.

Bruce Chatwin *The Songlines,* p. 217

Every mythology has its version of the "Hero and His Road of Trials," in which a young man, too, receives a "call." He travels to a distant country where some giant or monster threatens to destroy the population. In a superhuman battle he overcomes the Power of Darkness, proves his manhood, and receives his reward: a wife, treasure, land, fame. These he enjoys into late middle age when, once again, the clouds darken. Again, restlessness stirs him. Again he leaves: either like Beowulf to die in combat or, as the blind Tiresias prophesies for Odysseus, to set off for some mysterious destination, and vanish.

> Most of us, not being heroes, dawdle through life, mis-time our cues, and end up in our various emotional messes. The Hero does not. The Hero ... takes each ordeal as it comes, and chalks up point after point.
>
> **Bruce Chatwin** *The Songlines*

Claudia Bell and John Lyall *The Accelerated Sublime: Landscape, Tourism, and Identity,* p. 136

[A] holiday is something that everyone can "achieve" at; it can be a success story for each person who purchases travel. It may also reflect success elsewhere: evidence that one has great skills and is paid well for them so they can afford these rewards.

Individuals may feel that they have failed at other social demands — jobs, marriage, wealth accumulation — but if one can afford the airfares and expenses, it is hard to fail at travel. Even a disastrous travel experience is, in retrospect, still a travel story, which can be embellished to make the participant look good. It will still add to the package of experiences that enhances their overall success. Good job, great family life, lovely home, money fine, lots of travel; what else is there?

Eric J. Leed *The Mind of the Traveler: From Gilgamesh to Global Tourism,* p. 61

Mobility confines the traveler's view of the world to brief instants. It places a characteristic distance between the mobile observer and the world he or she observes. It limits those observations to surfaces, exteriors, lines, and figures quickly glimpsed in passing. Jean Cocteau, on his journey around the world, admitted these limitations on the traveler's perceptions and was grateful for the modern technology of photography which transcended them: "It is a method I advocate. Either live with things or just glance at them. I hardly look. I record. I load my camera obscura. I will develop the image at home."[1]

1 Jean Cocteau, *My Journey round the World* (London: Peter Owen, 1958), p. 20.

UNIVERSAL EXPERIENCE *Art, Life, and the Tourist's Eye*

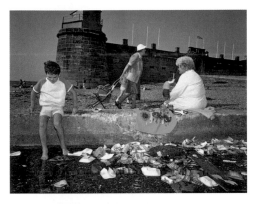

Martin Parr (British, b. 1952)
The Last Resort, 1983–86

Parr explores the panorama of British holidays in his series *The Last Resort* from the mid-1980s. The photographs depict working-class British families from Liverpool spending the day in New Brighton, then a run-down coastal resort town. However, instead of idyllic beach scenes, he shows us a dismal seaside with garbage in the water, people lounging on concrete, and kids with ice-cream running down their faces. Parr discredits the promises of glossy advertisements and delivers a realistic view of many family vacations. Parr's recent series *Common Sense* (1999) augments the concerns of *The Last Resort* with details of greasy food, sun-worshipers, and corporate logos that form today's landscape of global tourism.

Rem Koolhaas, Bruce Mau, and Hans Werlemann *S, M, L, XL*, p. 294
Never in history has distance meant less. Never has man's relationship with place been more numerous, fragile, and temporary. . . . In 1914, according to Buckminster Fuller, the typical American averaged about 1,640 miles per year of total travel, counting some 1,300 miles of just plain everyday walking to and fro. . . . Today, by contrast, the average American car owner drives 10,000 miles per year — and he lives longer than his father or grandfather. "At 69 years of age," wrote Fuller a few years ago, " . . . I am one of a class of several million human beings who, in their lifetimes, have each covered 3,000,000 miles or more."

Hans Ulrich Obrist *Interviews*
(with Rirkrit Tiravanija)

RT: People say to me, "Why don't you get an American passport?"

HUO: *What is your passport?*

RT: Thai. And I would say it would be a lot easier for me to travel but it would also mean that I would no longer recognize the fact that I have to struggle to move around. . . .

HUO: *So you have a lot of trouble at customs?*

RT: Yes, generally. Every two years I have to get a new visa to be in Germany, which gives me some freedom around Europe. But I can't go to England today — I have to go and get a visa. I can't go to Tokyo instantly or to America. It's collapsing. Places that used to be free are demanding more. It's like Scandinavia, which used to be a much more open and free place, but now you have to have a visa to go there.

The body senses as it moves.
John Urry *The Tourist Gaze*

John Urry *The Tourist Gaze*, p. 152
One effect of such mobile technologies is to change the nature of vision. The "static" forms of the tourist gaze, such as that from the balcony vantage point, focuses on the two-dimensional shape, colours and details of the view that is laid out before one and can be moved around with one's eyes.[1] Such a static gaze is paradigmatically captured through the still camera.

The nineteenth century development of the railway was momentous in the development of this more mobilised gaze. From the railway carriage the landscape came to be viewed as a swiftly passing series of framed panorama, a "panoramic perception," rather than something that was to be lingered over, sketched or painted or in any way captured.[2]

Ian Jack "The 12.10 to Leeds," pp. 74, 75–76, and 77–78

[T]he earliest evidence of railways . . . occurs in the Babylonian empire ruled by Belus, about 2245 BC. . . . Railways . . . as prepared tracks which by their construction keep the vehicle in place and guide it independently of human or animal interference, were probably first known in Greece. When Aristophanes was alive, around 400 BC, Greek ships were pulled across the isthmus at Corinth on wheeled cradles, which traveled along grooves cut into the rock. . . .

ABOVE
Rirkrit Tiravanija (Thai, b. 1961)
Untitled (from Baragas to Paracuellos de Garama, to Torrejòn de Ardoz to San Fernando or Coslada to Reina Sofía), 1994

In December 1994, Tiravanija walked a bicycle from the Madrid airport to Reina Sofia, the site of the exhibition *Cocido y Crudo*, a trip that resulted in the installation *Untitled (from Baragas to Paracuellos de Garama, to Torrejòn de Ardoz to San Fernando or Coslada to Reina Sofía)*. Traveling as a self-contained mobile unit, Tiravanija's bike carried a folding table, six folding chairs, pots and pans, and a video camera attached to the handlebars, which documented the trip from the perspective of the bicycle. The video reflects the people he met, the sights he saw, and the obstacles he encountered, and transforms the journey from a personal into a communal experience.

1 Mary Louise Pratt, *Imperial Eyes: Travel Writing and Transculturation* (London: Routledge, 1992), p. 222.

2 Wolfgang Schivelbusch, *The Railway Journey: Trains and Travel in the Nineteenth Century* (Oxford: Blackwell, 1986).

▼ *Longing for Places to Go*

Chiefly, however, railways grew and developed on the banks of the Wear, and Tyne, where the huge volumes of coal taken down steep banks to ships docked on those rivers made road transport increasingly impractical. It was here that the railway took on its modern meaning, as locomotives replaced horses as traction, and wooden rails gave way to iron. Continental Europe, when it came to import the technology of flanged wheels and iron rails from Britain in the last quarter of the eighteenth century, knew it as the *vole anglaise* or the *englischer Schienenweg*, the English railway.

Of the 750,000 route miles of railway which exist in the world today, sixty per cent measure 4 ft. 8½ in. from rail to rail. Across and under the Rockies, the Alps, and the Thames and the Hudson, past the cherry slopes of Mount Fujiyama, spreading into webs of freight yards, converging at junctions; shining and exact parallels, the reasons for their particular exactness lost to the mainstream of history. Trains followed this gauge to the battlefields of the American Civil War and the Somme, into the Vatican City, to the tragic little terminus under the gate at Auschwitz. On this gauge,

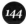

Buster Keaton outwitted the Union army. Across it, many silent heroines were tied. Riding above it, Cary Grant kissed Eva Marie Saint and remarked: "The train's a little unsteady" (and in their bedroom on the Twentieth Century Limited, Eva Marie Saint replied: "Who isn't?").

Michel Foucault "Space, Knowledge, and Power," p. 243
[A] new aspect of the relations of space and power was the railroads. These were to establish a network of communication no longer corresponding necessarily to the traditional network of roads, but they nonetheless had to take into account the nature of society and its history. In addition, there are all the social phenomena that railroads gave rise to, be they the resistances they provoked, the transformations of population, or changes in the behavior of people.... In France a theory developed that the railroads would increase familiarity among people and that the new forms of human universality made possible would render war impossible.... On the contrary, the railroads rendered war far easier to wage.

Joan Didion in Leed, *The Mind of the Traveler: From Gilgamesh to Global Tourism*, p. 14
To understand what was going on it is perhaps necessary to have participated in the freeway experience, which is the only secular form of communion Los Angeles has. Mere driving on the freeway is in no way the same

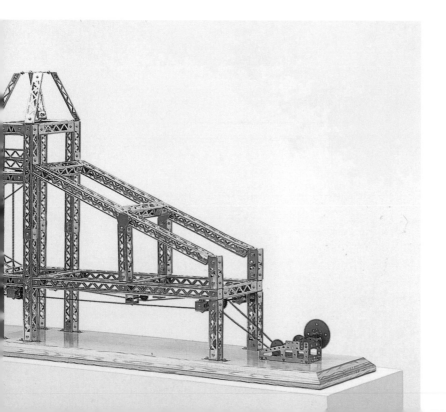

Michael Elmgreen and Ingar Dragset
(Danish and Norwegian, b. 1961 and 1968)
Short Cut, 2003

In *Short Cut*, Elmgreen and Dragset give the illusion that
a car and camper trailer have driven straight through
the center of the earth and emerged in the Galleria Vittoria
Emmanuele in Milan (for *Universal Experience*, *Short Cut*
was installed on the MCA plaza). Their whimsical and
nostalgic sculpture evokes family road trips but also im-
plies uncharted regions we have yet to explore in this
era of globalization.

At least to the more mobile and networked of us, place has become less about our origins on some singular piece of blood soil, and more about forming connections with the many sites in our lives. We belong to several places and communities, partially by degree, and in ways that are mediated.

Malcolm McCullough *Digital Ground: Architecture, Pervasive Computing, and Environmental Knowing*

as participating in it. Anyone can "drive" on the freeway, and many people with no vocation for it do, hesitating here and resisting there, losing the rhythm of the lane change, thinking about where they came from and where they are going. Actual participation requires a total surrender, a concentration so intense as to seem a narcosis, a rapture-of-the-freeway. The mind goes clean. The rhythm takes over. A distortion of time occurs.

Olu Oguibe "Forsaken Geographies: Cyberspace and the New World Other," pp. 46, 49, 50, and 51

While on a conference trip in Mexico in 1993, I witnessed an incident, which, though it was not entirely new to my experience and background in West Africa, nevertheless reminded me of the deep paradox of our common perceptions of progress and triumph at the turn of the twenty-first century. In the lobby of a three-star hotel in the heart of Guadalajara, birthplace of the Mexican nation, a child, crudely attired and hastily painted in the colours of an indigenous performer (having perhaps done the make-up himself), gestured towards staff and visitors. He was at most six, and he was there because he was not in school. He was there because he could not be in school.

The boy gestured, but he did not speak, which is not to say that he could not speak. Evidently, he could only gesticulate to the audience in that hotel lobby because he did not have their language. Our language. Someone offered him money, which he rejected, and at this point he was driven from the lobby by a member of staff. As he fled, the fellow turned to us and explained what the little boy wanted all along: drinking water.

I begin with this story because it is about communication, or the failure of communication. It is also about location and privilege. It is about power and its proclivity for insensitivity, and also about priorities. It is about our propensity to misunderstand, and in the process demean those who, through the unfortunate circumstances of their location and background, cannot lay claim to privileges of language and disposition; in our propensity to be so engrossed in our own worlds, we consign all others outside those worlds to absence. . . . Among us there were probably dollars in the thousands, state-of-the-art digital equipment, expensive clothing, innumerable degrees and diplomas, millions of miles in travel and adventure, a good deal of enlightenment, and wide knowledge of the arts and letters. . . . Yet, despite this bounty, none of us was disposed to provide this gesturing child with what he wanted: water, and comprehension. . . .

Like all its historical precedents, the digital trade route not only connects and traverses; it also delineates and severs Culture and the Brave New

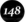

UNIVERSAL EXPERIENCE *Art, Life, and the Tourist's Eye*

World. The reputation of the digital super-highway as the greatest, most efficacious cultural manifestation of the democratic ideal since the printing press and photography, is today almost generally accepted among those who have access to its myriad opportunities. . . .

Increasingly we find that the greatest shortcoming of cyberculture is . . . in the unavailability of such facilities of participation and fulfillment to the majority; in its foreclosure to certain geographies, and in the general unwillingness of the privileged to account for the unrepresented. Cyberspace, as we have seen, is not the new, free global democracy we presume

Subodh Gupta (Indian, b. 1964)
This Side is the Other Side, 2003

Gupta takes inspiration from everyday life in New Delhi, casting common street objects such as bicycles, scooters, cans, boxes, and carts in bronze and chrome to mark their importance in Indian culture. The polished bronze and chrome also call attention to its incongruity with this country of extreme poverty. Of this work, a bronzed Vespa scooter carrying chrome milk pails, the artist said, "the scooter has traveled my roads so I cast her memories and journeys. She's almost a mechanized cow."

▼ *Longing for Places to Go*

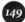

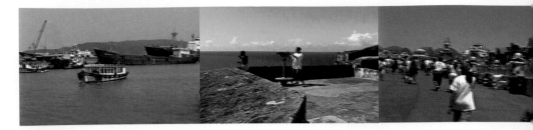

and defend, but an aristocracy of location and disposition, characterised, ironically, by acute insensitivity and territorialist proclivities.

Going through the June 6 issue of the *International Herald Tribune*, a news photograph attracted my attention. It is a photograph of Henry Ford III riding in the prototype of the motorcar that his great-grandfather, Henry Ford, drove in 1896. To many at the time the invention of the automated moving machine was an epitome of the creative capabilities of the human species. . . .

Over the course of this century, however, the technologies of automated mobility have found their enduring appeal in our ability to make their numerous possibilities and benefits available to the greater majority. This in itself owes to the vision and realism of those who, instead of configuring the automobile into an icon of privileged utopia, embarked upon a real course of democratising its possibilities. Henry Ford pledged to make the motorcar available to all. . . . Today not everyone may possess an automobile, yet almost everyone has access to some form of mass transit based on this technology. Such is the challenge facing us as members of an unarguably elite community.

ABOVE
Susan Giles (American, b. 1967)
Panzoomtilt (stills), 2004

Legions of amateur documentarians now travel with portable video cameras to capture their experiences. For *Panzoomtilt*, Giles collected travel footage from friends and acquaintances and edited together each of the most basic film shots — zoom in, zoom out, pan left and right, pan up and down — that direct how and what we see. Many of the scenes are only a few seconds long to reflect the brief and often superficial experiences one has as a tourist.

Capitalism has "universalized" history, in the sense that it has established systematic relations of social interdependence on a planetary scale (encompassing non-capitalist societies), thereby producing a single global space of temporal co-existence or coevalness, within which actions are quantifiable chronologically in terms of single standard of measurement: world standard time.

Peter Osborne *The Politics of Time: Modernity and the Avant-Garde*

Claudia Bell and John Lyall *The Accelerated Sublime: Landscape, Tourism, and Identity,* pp. 105 and 127

With the speeding up of travel, many events can be packed into one day, or into one trip. The accelerated opportunities to document mean that the very compressed or folded experience can have its moments unfolded into its supposed full weight at leisure.

In the same way that travel at first slowly increased in speed, and then more rapidly increased (and later increased its overt acceleration components), the body of the tourist is subjecting itself to the same increases in speed and acceleration. Where people once stood to look, then walked, they now run: cross-country, fell running, mountain running, ultra-distance running, endurance sport.

Barbara Kirshenblatt-Gimblett *Destination Culture: Tourism, Museums, and Heritage,* p. 137

Travel itself has become almost effortless, compared with its arduousness in earlier periods, and tourists look for "action" elsewhere. They fly in comfort to endure the rigors of whitewater rafting and rappelling. Scenic tourism gives way to adventure tourism, which the industry classifies as active (doing).

When we want to characterize some-one as a person of narrow experience and little education, we often use a phrase that entered the language in the late seventeenth century: "His horizons are limited." And it was first claimed in the eighteenth century, the age of the Grand Tour, that "travel broadens one's horizons."

Barbara Maria Stafford *Voyage into Substance: Art, Science, Nature, and the Illustrated Travel Account, 1760–1840*

VI Landing in the Mind

Travelers, in an effort to find deeper understanding of the world outside themselves, embark on journeys in search of new experiences. The writings and artwork in this section explore experience — how it is interpreted and represented — along with other ephemeral and intangible aspects of travel including pleasure and notions of the sublime.

Although many aspects of travel are physical, its truly transformative effects take place within the mind, where the symbolic contest between the familiar and the new occurs. To pass through this challenge to a habitual mode of being, travelers observe the norms, behaviors, and beliefs of different cultures and begin to understand various approaches to life as structures and patterns of behavior inherent to specific cultures rather than as universal phenomena. This knowledge results not only in an expansion of the travelers' comprehension of the places they visit, but also in a widened viewpoint through which to see and interpret the world at large.

Anish Kapoor
Cloudgate, 2004
Stainless steel
66 × 42 × 33 ft.
(20.1 × 12.8 × 10 m)
City of Chicago
See also p. 47.

Ian Kiaer (British, b. 1971)
Hakp-o dang (black), 2001

I want to build a house near a clean river.
When it's warm, I will open the windows.
Shadows of a bush are like a picture.
When I hear the river flowing, I forget
 all the worldly things.
A stranger comes to enjoy this beautiful
 landscape.
Fishermen are coming back to their homes.
Even a stranger comes to enjoy this
 mountain river,
As rivers are broad and long, fortunately
 I cannot hear the noise from the world.
I want even the fishermen not to come
 and go often.
As I am afraid that people might know
 this place and thus it might be opened
 to the world.

Hakp-o dang (black) is Kiaer's reflection on
a sixteenth-century Korean landscape paint-
ing by Yan Paeng Son (Hakp-o was his poet
name) that he discovered at the National
Gallery of Seoul while spending six months
in that city. The subject of the painting, the
only one surviving by this artist, is a group
of Confucian scholars talking near a pavil-
ion in the mountains with a poem (printed
above) inscribed in the upper right corner.
The poem describes Hakp-o's reservation
about visitors discovering his secret land-
scape and his desire for solitude. To create
a personal souvenir of his journey to the
poet's home in a remote village, Kiaer com-
bined a small scholar's table, models of
a mountain and the poet/painter's house,
and a small gray painting he found in
a local shop.

Eric J. Leed *The Mind of the Traveler: From
Gilgamesh to Global Tourism*, p. 45

Intellectually, the alienation of departure
gives the seasoned traveler the character of
"detachment" and "objectivity," the status of
observer. . . . In departure the traveler is "ob-
jectified" and becomes a thing persisting
outside those relations that identify him, an
autonomous individuality. The world be-
comes an array of objects, artifacts and ex-
emplars whose meaning is mysterious to
the outsider and must be decoded from ap-
pearances. Through being removed, one
may come to see one's native culture —
which once provided the lenses and mean-
ings through which one looked out upon
the world — as an object, a thing, a unified,
describable phenomenon.

Barbara Maria Stafford *Voyage into
Substance: Art, Science, Nature, and the
Illustrated Travel Account, 1760–1840*, p. 486

[A]rt involves the direct encounter of nature
with the self in the constantly adjusting act
of living. Perhaps its most striking legacy,
then, was in the era of methodology. The
traveler in search of fact inaugurated the
habit of constructing a never-ending series
of hypotheses concerning physical reality on
the basis of constant exposure to and
scrutiny of its mutable data. At a fundamen-
tal perceptual level, therefore, the scientific
discoverer promulgated an exploratory way
of looking at the world. Penetrating phenomena opened a new perspective
on the actual shape of existence, now viewed as an open-ended and inter-
secting sequence of experiences momentarily "realized" in concrete fragments
of reality and shifting aspects.

UNIVERSAL EXPERIENCE *Art, Life, and the Tourist's Eye*

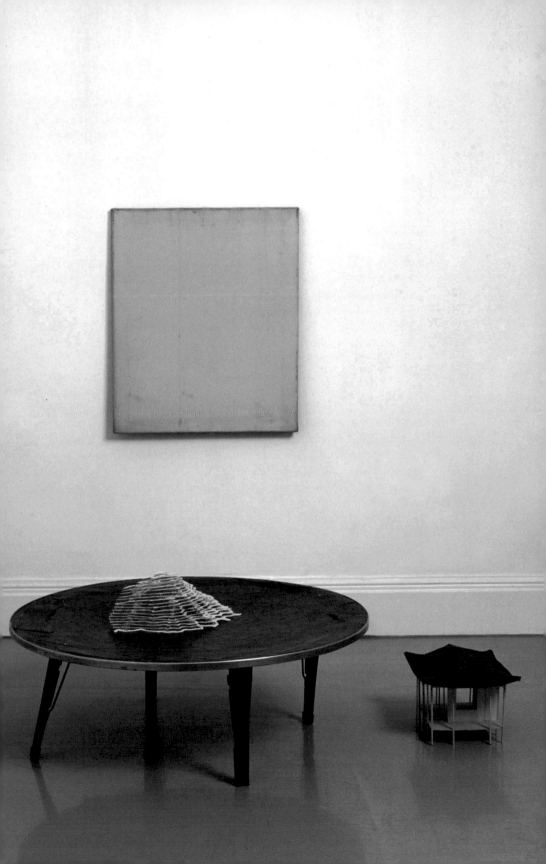

As an extension of this thought, it was the voyaging artist who first turned his studio into a laboratory devoted to the minute examination of palpable externalities out "in the field."[1] [H]e not only positioned himself in front of the world; he entered the world.

Alain de Botton *The Art of Travel*, pp. 106, 114–17, 120, and 122
I stood on the corner of the Calle de Carretas and the Puerta del Sol. . . . It was a sunny day, and crowds of tourists were stopping to take photographs and listen to guides. And I wondered, with mounting anxiety, What am I supposed to do here? What am I supposed to think?

[Alexander von] Humboldt was never pursued by such questions. Everywhere he went, his mission was unambiguous: to discover facts and to carry out experiments toward that end. . . .

In June 1802, Humboldt climbed up what was then thought to be the highest mountain in the world: the volcanic peak of Mount Chimborazo in Peru, 6,267 meters above sea level. . . . In spite of the danger, Humboldt found time to notice elements that would have passed most mortals by: "A few rock lichens were seen above the snow lines, at a height of 16,920 feet. The last green moss we noticed about 2,600 feet lower down. A butterfly was captured by M. Bonpland [his traveling companion] at a height of 15,000 feet and a fly was seen 1,600 feet higher."

How does a person come to be interested in the exact height at which he or she sees a fly? How does she begin to care about a piece of moss growing on a volcanic ridge ten inches wide? . . .

Curiosity might be pictured as being made up of chains of small questions extending outwards, sometimes over huge distances, from a central hub composed of a few blunt, large questions. In childhood we ask, "Why is there good and evil?" "How does nature work?" "Why am I me?" . . . The blunt large questions become connected to smaller, apparently esoteric ones. We end up wondering about flies on the sides of mountains or about a particular fresco on the wall of a sixteenth-century palace. We start to care about the foreign policy of a long-dead Iberian monarch or about the role of peat in the Thirty Years' War. . . .

1 James Henry Rubin, *Realism and Social Vision in Courbet and Proudhon* (Princeton, N.J.: Princeton University Press, 1980), pp. 63, 72–76.

UNIVERSAL EXPERIENCE *Art, Life, and the Tourist's Eye*

The critical distinction . . . is between reality (what is really out there, whatever that may be), experience (how that reality presents itself to consciousness), and expressions (how individual experience is framed and articulated).

Edward M. Bruner "Experience and Its Expressions"

On descending to the base camp below Mount Chimborazo, Humboldt . . . almost immediately began writing his "Essai sur la geographie des plantes," in which he defined the distribution of vegetation at different heights and temperatures. He stated that there were six altitude zones. . . . Flies were, he wrote excitedly, unlikely to be found above 16,600 feet.

Humboldt's excitement testifies to the importance of having the right question to ask of the world. It may mean the difference between swatting at a fly in irritation and running down a mountain to begin work on an "Essai sur la geographie des plantes."

Unfortunately for the traveler, most objects don't come affixed with the question that will generate the excitement they deserve. There is usually nothing fixed to them at all; when there is something, it tends to be the wrong thing. . . .

If a traveller was to feel personally involved with (rather than guiltily obedient towards) "the walls and ceilings of the church decorated with nineteenth-century frescoes and paintings. . . ." he or she would have to be able to connect these facts — as boring as a fly — with one of the large, blunt questions to which genuine curiosity must be anchored. . . .

A danger of travel is that we may see things at the wrong time before we have had an opportunity to build up the necessary receptivity, so that new information is as useless and fugitive as necklace beads without a connecting chain.

Eric J. Leed *The Mind of the Traveler: From Gilgamesh to Global Tourism*, pp. 5–6

Travel is the paradigmatic "experience," the model of a direct and genuine experience, which transforms the person having it. We may see something of the nature of these transformations in the roots of Indo-European languages, where *travel* and *experience* are intimately wedded terms.

The Indo-European root of *experience* is **per* (the asterisk indicates a retroconstruction from languages living and dead). **Per* has been construed as "to try," "to test," "to risk" — connotations that persist in the English word *peril*. The earliest connotations of *per* appear in Latin words for "experience": *experior* and *experimentum*, whence the English "experiment." This conception of "experience" as an ordeal, as a passage through a frame of action that gauges the true dimensions and nature of the person or object passing through it, also describes the most general and ancient conception of the effects of travel upon the traveler. Many of the secondary meanings of **per* refer explicitly to motion: "to cross space," "to reach a goal," "to go out.". . . One of the German words for experience, *Erfahrung*, is from the Old High German *irfaran*: "to travel," "to go out," "to traverse," or "to wander." The deeply rooted assumption that travel is an experience that tests and refines the character of the traveler is demonstrated by the German adjective *bewandert*, which currently means "astute," "skilled," or "clever" but originally (in fifteenth-century texts) meant merely "well-traveled."

[W]hat is an experience? If we look at the semantics of the word in different languages, there is a common emphasis on movement. Experience derives from experimenting, trying, risking, the German *Erlebnis* and the Swedish *upplevelse* from living through, living up to, running through, being part of, accomplishing. Again the focus is on personal participation, we have to be both physically and mentally *there*.

Orvar Löfgren *On Holiday: A History of Vacationing*

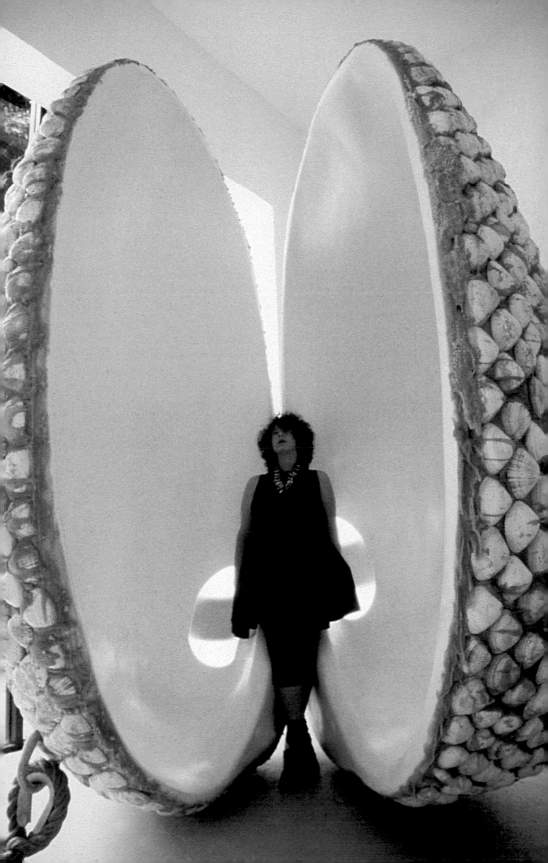

Orvar Löfgren *On Holiday: A History of Vacationing*, p. 95

"To have an experience" calls for a situation with a beginning and an end. In the everyday flow of activity the experience stands out, it is marked and distinctive. It is something we enter and exit, and the production of experiences — especially out of the ordinary ones that can be furthered by *rites de passage* — is a situating that involves both time and space.[1] Experiences always take place, but in ways that combine the realities of both the grounds we are treading and the mental images present. We neither have nor can be given experiences. We *make* them in a highly personal way of taking in impressions, but in this process we use a great deal of established and shared cultural knowledge and frames. And yet we share experiences only through representations and expressions. Here is the famous hermeneutical circle: experience structures expression and expression structures experience. Our associations are culturally conditioned and so are our afterthoughts, the ways in which we reflect on and express consciousness. What is possible to express, how can it be expressed? The anthropologist Allen Feldman pushes this argument even further: an event is not what happens but what can be narrated.[2]

> *Travel*: same word as *travail* — bodily or mental labour, toil, especially of a painful or oppressive nature, exertion, hardship, suffering. A journey. **Bruce Chatwin**
> *The Songlines*

Victor W. Turner "Dewey, Dilthey, and Drama: An Essay in the Anthropology of Experience," p. 12

There are no raw encounters or naive experiences since persons, including ethnographers, always enter society in the middle. At any given time there are prior texts and expressive conventions, and they are always in flux. We can only begin with the last picture show, the last performance. Once the performance is completed, however, the most recent expression sinks into the past and becomes prior to the performance that follows. . . . Life consists of retellings.

1 See Roger Abrahams, "Ordinary and Extraordinary Experiences," in Victor W. Turner and Edward M. Bruner, *The Anthropology of Experience* (Urbana, Ill.: University of Illinois Press, 1986), pp. 45–72.

2 Allen Feldman, *Formations of Violence: The Narrative of the Body and Political Terror in Northern Ireland* (Chicago: University of Chicago Press, 1991), p. 14.

UNIVERSAL EXPERIENCE *Art, Life, and the Tourist's Eye*

Roman Ondak (Slovakian, b. 1966)
Common Trip, 2000

Like ancient voyagers who recounted their jour-
neys, Ondak embraced the art of storytelling to
share his experiences of seeing famous build-
ings and sites around the world with relatives
and friends who rarely travel. He asked them to
draw, paint, or make models based on his de-
scriptions. Since the fall of communism in 1989
these relatives and friends can travel freely;
yet, many still do not for personal or economic
reasons. As an artist, however, Ondak travels
frequently for exhibitions, and this project tem-
porarily transformed his collaborators into
artists and tourists who have experienced the
Eiffel Tower, the White House, the Washington
Monument, the World Trade Center, Pisa Tower,
Brandenberg Gate, Cologne Cathedral, and
other renowned destinations. The group of illus-
trations creates a generalized portrait of travel
through imagined memories, preconceptions,
and naive representations.

Walter Benjamin "The Storyteller: Reflections on the Works of Nikolai Leskov," pp. 82–83

Experience which is passed on from mouth to mouth is the source from which all storytellers have drawn. And among those who have written down the tales, it is the great ones whose written version differs least from the speech of the many nameless storytellers. Incidentally, among the last named there are two groups which, to be sure, overlap in many ways. And the figure of the storyteller gets its full corporeality only for the one who can picture them both. "When someone goes on a trip, he has something to tell about," goes the German saying, and people imagine the storyteller as someone who has come from afar. But they enjoy no less listening to the man who has stayed at home, making an honest living, and who knows the local tales and traditions. If one wants to picture these two groups through their archaic representatives, one is embodied in the resident tiller of the soil, and the other in the trading seaman. Indeed, each sphere of life has, as it were, produced its own tribe of storytellers.

> **The most important thing happening in tourism today is not the construction of a new Sony Corporation Entertainment complex across the street from the Art Museum. It is the way San Francisco, or London, or Chicago is being shown to a new immigrant from Asia, Latin America or Africa, by someone from her family or region who arrived earlier.**
>
> **Dean MacCannell** *The Tourist: A New Theory of the Leisure Class*

Edward M. Bruner "Experience and Its Expressions," p. 11–12

It is in the performance of an expression that we re-experience, re-live, re-create, re-tell, re-construct, and re-fashion our culture. The performance does not release a preexisting meaning that lies dormant in the text.[1] Rather, the performance itself is constitutive. Meaning is always in the present, in the here-and-now. . . .

Selves, social organizations, and cultures, are not given but are problematic and always in production. Cultural change, cultural continuity, and cultural transmission all occur simultaneously in the experiences and expressions of social life. All are interpretive processes and indeed are experiences "in which the subject discovers himself."

1 See Jaques Derrida, *Of Grammatology* (Baltimore, Md.: Johns Hopkins University Press, 1974) and Roland Barthes, *S/Z* (New York: Hill and Wang, 1974).

UNIVERSAL EXPERIENCE *Art, Life, and the Tourist's Eye*

There are only two ways to live your life. One is as though nothing is a miracle. The other is as though everything is a miracle. Albert Einstein

Paul Valéry Excerpts from *Cahiers*, 1905–1935, p. 124

In general, when I recall a specific period in the past — (what I did *yesterday*, etc.) this memory is a fabrication, it has an a priori connotation, and I recognize it by the fact that it is not like a photograph taken at random — which is the true nature, the real nature of impressions that have actually been received by the mind.

Instead I see *what I need to see* — what has meaning, values. I need to make an effort to retrieve the non-connotative, the raw, the real — —

An effort is required to retrieve what one has really seen. — It does come back at the first attempt, but almost imperceptibly. — It comes back like a flash of lightning that leads to the false memory, the memory that conforms to connotative conventions.

Philippe Parreno (French, b. 1964)
Sound Pan, Paris, 2002, 2003, PAGE 163, LEFT
The Ice Man, Tokyo, 1995, 2003,
PAGE 163, RIGHT
Space World, Kitakyushu, 2003, 2003, BELOW
Fade to Black #2 (Welcome to Reality Park),
2003, OPPOSITE

Parreno's glow-in-the-dark posters are based
on events he has staged in various locations
around the world. He inscribed "Welcome
to Reality Park" on a large rock surrounded
by penguins in the Cape of Good Hope,
South Africa, as a greeting to his conceptual
global amusement park. In a Japanese
theme park, Parreno organized a perform-
ance in which humans dressed up as car-
toon characters and were asked to pan-
tomime a scenario about a universe without
time. In other events, a truck drove around
Kitakyuchu broadcasting doomsday mes-
sages, an ice sculpture melted and was
replaced daily in a Tokyo park, and students
replayed the 1978 World Cup Final as a
carefully choreographed dance. All of these
events took place unannounced so that they
blended in with their surroundings. Like
the events they represent, and equally any
sort of tourist experience, the images —
which appear as blank sheets of paper when
the gallery is lighted — create quick impres-
sions that feed our memory then slowly fade.

Chris Rojek "Indexing, Dragging, and the
Social Construction of Tourist Sights," p. 53
[M]yth and fantasy play an unusually large
role in the social construction of *all* travel
and tourist sights. . . . The physical move-
ment to new places and situations obvi-
ously invokes the unfamiliar. This, in turn,
invites speculation and fantasy about the
nature of what one might find. . . . Spatially
speaking then, travel experience involves
mobility through an internal landscape
which is sculptured by personal experience
and cultural influences as well as a journey
through space. . . . Metaphorical, allegorical
and false information remains a resource in
the pattern of tourist culture as an object of
reverie, dreaming and speculation.

Richard Shusterman "Come Back to Pleasure," pp. 33–35, 38, 41, and 46–47

Up until modern times, to identify art with the pursuit of pleasure was not at all a way of trivializing it, for pleasure was anything but a trivial matter, even for philosophers. The ancients (most notably the Cyrenaics and Epicureans) often defined pleasure as the prime good and usually saw it as an essential component of happiness. . . . Looking back on the ancients at the very dawn of modern thought, Michel de Montaigne confirmed the primacy of pleasure: "All the opinions in the world agree on this — that pleasure is our goal — though they choose different means to it.". . .

More than making life sweet, pleasure makes continued life possible by offering the promise that it is worth living. But if pleasure enhances activity and advances life by such enhancement, what, then, are the special forms and values of *art's* pleasures? . . .

Art first affords, at the most basic level, the variegated pleasures of sense: rich qualities of color, shape, sound, texture, and so on. One should not forget the term *aesthetic* derives from the Greek word for sense perception. The

Reverie remains a key pleasure in travelling's confection of pleasures. The freedom to daydream, to lose oneself in reverie, is part of travel's promise of freedom, part of the traveler's privilege.

Peter D. Osborne *Travelling Light: Photography, Travel, and Visual Culture*

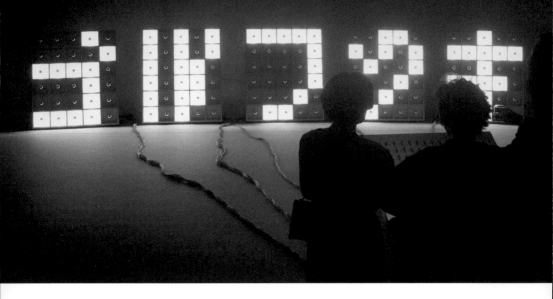

pleasures of intensified perception, typically derived from the artwork's particularly rich or intense sensory qualities, are part of what makes it stand out from the ordinary flow of perception as a special aesthetic experience worthy of the name of art. . . . And then there are art's pleasures of meaning and expression, which satisfy our need for significance and desire for communication. Such pleasures motivate the creating artist as well as the critic and the public, who engage in interpretation both to explain the pleasures they derive from the work and to deepen them.

The pleasures of meaning and expression point to another crucial dimension of art's enjoyment, which is often obscured — its deeply social dimension. Too often it is assumed that art's enjoyment is subjective, hence essentially private and narrowly individualistic. But even if one feels one's aesthetic pleasure in one's own mind and senses, this neither precludes the shared character of our enjoyment nor prevents our enjoyment from being heightened by our sense of its being shared. Whether in the theater, the concert hall, the museum, or the cinematheque, our aesthetic experience gains intensity from the sense of sharing something meaningful, of communicating

silently yet deeply by communally engaging the same potent meanings and visions of beauty and by experiencing shared pleasures. . . . By creating and reinforcing group solidarity through the sharing of communicative pleasures, art's entertainment performs a crucial social function whose role in the evolution of human culture and society should not be overlooked. . . .

In secular society, museums and concert halls have replaced churches as the places one visits on the weekend for spiritual edification. The dominant mood of the audiences is reverently solemn and humorless. Joy and laughter are altogether out of place. People now attend the sacred halls of art as they once attended church, gratified that they have come and gratified that they soon may go. . . .

Pleasure's importance is often intellectually forgotten since it is unreflectively taken for granted. We tend to forget its deep significance because we also assume its uniformity and tend to identify pleasure as a whole with its lightest and most frivolous forms. A similarly misleading presumption of uniformity is operative when we conclude that popular art must be aesthetically inferior because we identify such art with its worst examples and assume that its character and value should be more or less uniform in all its works.

For this reason, it is important to emphasize once again the variety of pleasures in art and life. Think of how this variety is strikingly expressed in our vocabulary of pleasure, which goes far beyond the single word. While theorists of pleasure have long contrasted the extremes of sensual voluptuousness

OPPOSITE
Melik Ohanian (French, b. 1969)
SLOW MOTION — from SLAVE to VALSE, 2003

SLOW MOTION is a work about a metaphorical evolution of human interaction from "slave to valse (waltz)." The work begins with the letters S-L-A-V-E on each of the five light boxes. Viewers can create texts and shapes using a circuit board that is connected to the light boxes. At the end of the exhibition the same letters are programmed to spell V-A-L-S-E (waltz). An exploration of language and translation, the low-tech analog display facilitates a collaboration among viewers to determine what we perceive on the signs.

(voluptas) with the sacred heights of religious joy *(gaudium)*, there is also delight, satisfaction, gratification, gladness, contentment, pleasantness, amusement, merriment, elation, bliss, rapture, exultation, exhilaration, enjoyment, diversion, entertainment, titillation, fun — and the list could go on. While the pleasures of fun and pleasantness convey a sense of lightness

 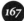

that may seem close to insignificance, those of rapture, bliss, and ecstasy clearly should remind us just how profound and potently meaningful pleasures can be. Such pleasures, as much as truth, help constitute our sense of the sacred and help found our deepest values.

But in highlighting the power and significance of these exalted pleasures, it would be wrong to dismiss the value of the lighter ones. Merriment can offer welcome relief from the strains of ecstasy but also provides a useful contrast to highlight its sublimity; besides, lighter pleasures have their own intrinsic charm. The purpose in learning the diversity of pleasures is not to select only the highest and reject the others, but to profit best from enjoying them all, or at least all that we can happily manage.

Besides the triviality and uniformity of pleasure, we must confront perhaps the most stubborn dogma of all: the opposition of pleasure to meaning and truth. This presumed conflict lies at the heart of the rejection of art as entertainment.... The misguided opposition of pleasure and knowledge rests on the false assumption that pleasure is an overpowering sensation that is unrelated to the activity through which it occurs and can even distract from that activity through its own felt power. This assumption rests in turn on a shallow empiricism that equates experience with passive sensation rather than activity.

In contrast, the classic appreciation of pleasure finds support in Aristotle's idea that pleasure is an inseparable part of the activity through which it is experienced and which it "completes" by contributing zest, intensity, and concentration. To enjoy tennis is not to experience agreeable feelings in one's sweating racket hand or running feet; it is rather to play the game with gusto and absorbed attention. Likewise, the enjoyment we derive from art is different from the pleasant sensations that we may experience while regarding an artwork or that we might obtain from something else, like a cup of good coffee or a steam bath. To enjoy an artwork is rather to take pleasure in perceiving and understanding the work's qualities and meanings. Such pleasure tends to intensify our active concentration on the work, thus enhancing our perception and understanding....

> At any bungy jumping site thousands of bungy jumpers leap over the edge. They know how to verbally express excitement as they fall: Yeeh Haah!! They say — scream — what they know should be screamed. **Claudia Bell and John Lyall**
> *The Accelerated Sublime:*
> *Landscape, Tourism, and Identity*

Cai Guo-Qiang (Chinese, b. 1957)
Transient Rainbow: Explosion Project for
MoMA, New York, USA, 2002

Known for lavish performances he calls
Projects for Extraterrestrials, Guo-Qiang
treats the earth as his museum. He began
making paintings with gunpowder — a
reference to Chinese history — and these
works evolved into large-scale public
explosions and firework displays staged
around the world. One of them, a ten-
kilometer line of explosions that extended
the Great Wall of China, was visible from
space. The grand scale of these works
creates a new perspective, making view-
ers feel connected to the universe at
large. Guo-Qiang has compiled footage
from several explosions including *Tran-
sient Rainbow* for *Universal Experience.*

As pleasure does not preclude but rather strengthens understanding, so advocacy of enjoyment does not entail a leveling of evaluative standards. Some works should be enjoyed more and differently than others, because they are better or different in style. Bad works should not be enjoyed when properly understood, Eliot concludes, "unless their badness is of a sort that appeals to our sense of humor."[1] Drollery, we should not forget, also belongs to the multiform pleasures of art.

I close with a cautionary reminder. Advocating art's pleasures should not mean substituting them for the pleasures of life while also neglecting those victims of injustice who know more misery than joy. Nor should we forget that even art of radical social protest gains power from the zest of righteous anger and the thrill of common struggle, pleasures that enhance or complete (in Aristotle's sense) the activity of protest. To think that prizing pleasure means condemning art to frivolity and narcotic escapism is one more fallacy based on the presumption that all pleasures are uniform and shallow. This belief also rests on the trite but deadly dogma that opposes art to life.

Claudia Bell and John Lyall *The Accelerated Sublime:*
Landscape, Tourism, and Identity, pp. 4–5
The "sublime" is an abstract quality in which the dominant feature is the presence or idea of transcendental immensity or greatness: power, heroism, or vastness in space or time. The sublime inspires awe and reverence, or possibly fear. It is not susceptible to objective measurement; rather, that feeling of being overwhelmed dislocates the rational observer.

1 T. S. Eliot, *Of Poetry and Poets* (London, Faber, 1957), p. 115.

UNIVERSAL EXPERIENCE *Art, Life, and the Tourist's Eye*

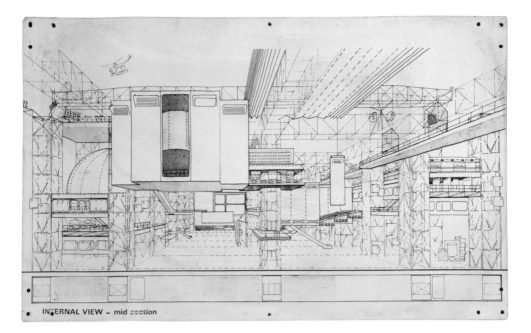

INTERNAL VIEW – mid section

The earliest determination of the sublime is generally attributed to Longinus, also called Dionysius Longinus . . . or Pseudo-Longinus, author of *On the Sublime*, dating from the first century A.D. He used the term *sublime* to refer to literature, specifically "the echo of greatness of spirit" — the moral and imaginative power of the writer that pervades a work.

Centuries later the publication of Burke's *Philosophic Enquiry into the Origin of Our Ideas of the Sublime and Beautiful* in 1756 gave the term wider currency. Burke's sublime was a wildly passionate response to the sublime object, instilling astonishment, terror, and dread. It was contrasted against (rather than continuous with) the grandly beautiful. The emotion expressed was distress, not overwhelming pleasure or joy.

Kant's adaptation of Burke's ideas noted the pleasure of the sublime; the sublime was therefore not the reverse of beautiful. In his *Critique of Judgment* (1790) he identifies the sublime as a negative pleasure, as the mind is both attracted and repelled by the object — a paradoxical pleasure. His versions of the

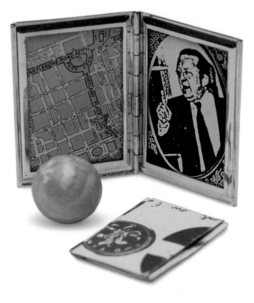

Nano Museum
Curated by
Hans Ulrich Obrist

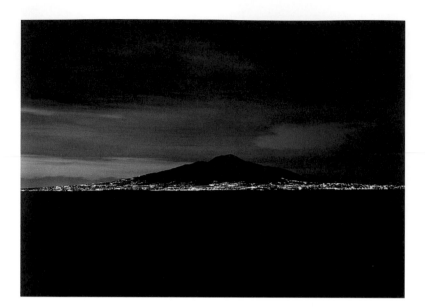

sublime include the immensely vast and the dynamic sublime: a violent storm, a volcanic eruption, a raging ocean — any powerfully frightening natural force. In each of his cases the term *sublime* is applied particularly to the emotions and the mind, not the object of the gaze. In his analysis, the sublime inspired wonder, reverence, and respect. To both philosophers, the sublime was about the viewer rather than the object; nature could arouse a sense of the sublime.

By the late seventeenth century, travelers in describing certain landscapes used the word *sublime*. The emphasis was on sensation. The sublime contrasted with the picturesque: the picturesque was pretty, and of human scale; the sublime was vast, powerful, forbidding, terrifying, awe-inspiring and held the possibility of death.

Piotr Uklanski (Polish, b. 1968)
Untitled (Vesuvius), 2000, ABOVE
Untitled (Parco nazionale dell' Abruzzo), 2000,
OPPOSITE

Mt. Vesuvius erupted in 79 AD, eradicating the cities of Pompeii and Herculaneum. It became a symbol of the sublime landscape, evoking awe and fear. The amazingly preserved city of Pompeii has become one of Italy's most popular tourist attractions. Uklanski captured a nightscape of modern Vesuvius, aglow with city lights, and compares the picturesque scene with an equally beautiful but lesser known landscape of *Parco nazionale dell' Abruzzo (National Park of Abruzzo)*, a model for the balance between nature, conservation, and human interest. See also p. 251.

UNIVERSAL EXPERIENCE *Art, Life, and the Tourist's Eye*

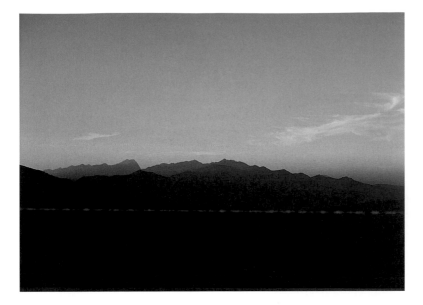

Alain de Botton *The Art of Travel*, pp. 167, 169, and 176
Sublime landscapes do not therefore introduce us
to our inadequacy; rather, to touch on the crux of
their appeal, they allow us to conceive of a familiar
inadequacy in a new and more helpful way. Sublime
places repeat in grand terms a lesson that ordinary
life typically introduces viciously: that the universe
is mightier than we are, that we are frail and tem-
porary and have no alternative but to accept limita-
tions on our will; that we must bow to necessities
greater than ourselves. . . .

It is no coincidence that the Western attraction
to sublime landscapes developed at precisely the mo-
ment when traditional beliefs in God began to wane.
It is as if these landscapes allowed travellers to expe-
rience transcendent feelings that they no longer felt
in cities and the cultivated countryside. . . .

A consistent theme in engagement with the sublime is not to wholly identify oneself with a transcendent ideal power but to enjoy that as an abstract, exciting, but unachievable possibility. At the sites of sublimity the unattainable looks more possible.

Claudia Bell and John Lyall
The Accelerated Sublime: Landscape, Tourism and Identity

 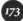

Sublime places gently move us to acknowledge limitations that we might otherwise encounter with anxiety or anger in the ordinary flow of events. It is not just nature that defies us. Human life is as overwhelming. But it is the vast spaces of nature that perhaps provide us with the finest, the most respectful reminder of all that exceeds us. If we spend time in them, they may help us to accept more graciously the great, unfathomable events that molest our lives and will inevitably return us to dust.

OPPOSITE
Marine Hugonnier (French, b. 1969)
Ariana (stills), 2003

Hugonnier's *Ariana* is the first in a trilogy of films about how it has become increasingly difficult to gain access to historically significant landscapes and panoramas. Recorded in Afghanistan during 2002, *Ariana* follows a director of photography, an anthropologist, a geographer, a sound engineer, and a local guide as they document a panorama of the Pandjshir Valley, an area outside Kabul, to understand how its topography — mountains surrounding a valley — kept it isolated from Soviet and Taliban control. The crew was refused permission to ascend the Hindu Kush mountains because of their strategic location, and thus returned to the city of Kabul, where they were granted access to film from a television tower. The resulting panorama over the city and mountains exceeded their expectations and, overcome with the magnificent view, they stopped filming. See also p. 12.

Claudia Bell and John Lyall *The Accelerated Sublime: Landscape, Tourism, and Identity*, p. 6
[F]loating about in people's heads are all the images of extreme, wild, rugged, beautiful landscape that they have been exposed to by paintings, photographs, and television and that body of received knowledge of the "pure" spiritual values of nature itself. . . .

The tourist, in engaging and collecting them, having them stuffed in their back pocket, is one of the vectors for dispersing them around the globe. Indeed, the articulations that gain the greatest mileage are those euphoric encodings that might bring in most visitors.

Landscapes are culture before they are nature; constructs of the imagination projected onto wood and water and rock. Simon Schama
Landscape and Memory

UNIVERSAL EXPERIENCE *Art, Life, and the Tourist's Eye*

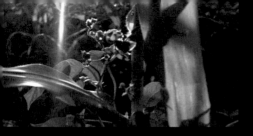

We wouldn't be able to shoot a panorama

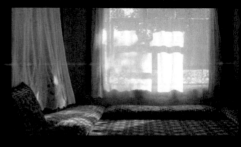

The ones we would make of the valley now,
would remain incomplete.

Wasn't it also the sweet memory of a tourist attraction that
wasn't to be missed on holidays when we were children?

Here!

Travelers often seek to capture and consume ephemeral events and spaces. Early travelers made laborious sketches and paintings to provide visual proof of their experiences. With the development of photography and printing, the object of the tourist's gaze could easily be captured and reproduced. Contemporary innovations in transportation and communication ensure that images are recorded instantly, certifying that we have actually been somewhere and seen something as we travel faster and further.

Yet despite this technology, we still return from trips bearing gifts and souvenirs. We seek tangible reminders of our travel, from miniature pyramids to pieces of the Berlin Wall. The writings and artwork in this section explore our desire to possess individual pieces or replicas of the world — postcards, relics, and photographs — in order to hold the world within our grasp.

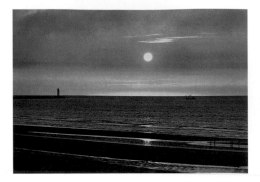

Alain de Botton *The Art of Travel*, p. 214

A dominant impulse on encountering beauty is to wish to hold on to it, to possess it and give it weight in one's life. There is an urge to say, "I was here, I saw this and it mattered to me."

But beauty is fugitive, being frequently found in places to which we may never return or else resulting from rare conjunctions of season, light and weather. How then to possess it, how to hold on to the floating train, the halva-like bricks or the English valley?

The sightseer measures his satisfaction by the degree to which the [site] conforms to the preformed complex. If it does so, if it looks just like the postcard, he is pleased; he might even say, "Why it is every bit as beautiful as a picture postcard!"... The highest point, the term of the sightseer's satisfaction, is not the sovereign discovery of the thing before him; it is rather the measuring up of the thing to the criterion of the preformed symbolic complex.

Rem Koolhaas, Bruce Mau, and Hans Werlemann
S, M, L, XL

Orvar Löfgren *On Holiday: A History of Vacationing*, pp. 88–90

"This space may be used for communication" was a direction often printed on early postcards. Gradually the space allotted to text expanded to the modern standard of half of the reverse, which has made postcard writing into a minimalistic art with its own traditions and standard formulas. The function of its text links it to vacation greetings. But to whom do you mail cards and why?

In a world where telephones and e-mail have encroached on the traditional territory of letter writing, postcards are still a popular (and less demanding) medium. You mail cards to people you'd never dream of sending a letter to. There are rules of reciprocity — the network of people who *expect* to get a card from you. They will also know what to expect in terms

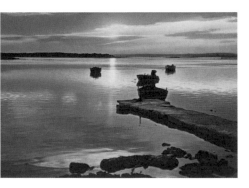

Hans-Peter Feldmann
Untitled (Sunsets), 1994
See also p. 68.

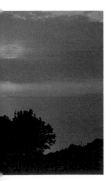

VII *Wish You Were Here!*

of stock phrases and selected topics. A classic vacation postcard with palm trees and blue water from Majorca has an equally classic reverse:

Palma, 9 August 1966
Hello there!

Just want to send a sunny greeting from a wonderful place. We bask in the sun, swim, and have great fun. Hope you're having good weather and are all right. Here it's 25° centigrade in the water and we'll miss that when we get home!

All the best,
Ruth and Herbert

The discourse on the weather and stock phrases like "Wish you were here," "Having a wonderful time," "We are fine, how are you?" have their parodic parallel in the subgenre of holiday cards with preprinted messages and empty spaces for adding the desired adjective: weather here is…, food is…, mother-in-law's temper is….

The postcard is a private message, ready to be read by others. If postcards in the past often ended up in albums, many vacationers' greetings of today tend to end up as public exhibitions. Some of them land on the front of the fridge or the kitchen bulletin board, but many are exposed at work. During the last few decades they have, at least in Sweden, been one of the most common forms of decoration in the office, the canteen, or the locker room.

90 North Latitude, April 7th

**My dear Jo,
I have won out at last. Have been here a day. I start for home and you in an hour. Love to the "kidsies."**

Bert .

Robert Edwin Perry
"The Pole Is Mine"

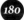

Susan Sontag From *On Photography*, pp. 153–56, 160–62, 167, and 179

In the preface to the second edition (1843) of *The Essence of Christianity*, [Ludwig] Feuerbach observes about "our era" that it "prefers the image to the thing, the copy to the original, the representation to the reality, appearance to being" — while being aware of doing just that. And his premonitory complaint has been transformed in the twentieth century into a widely agreed-on diagnosis: that a society becomes "modern" when one of its chief activities is producing and consuming images, when images that have extraordinary powers to determine our demands upon reality and are themselves coveted substitutes for firsthand experience become indispensable to the health of the economy, the stability of the polity, and the pursuit of private happiness.

Feuerbach's words — he is writing a few years after the invention of the camera — seem, more specifically, a presentiment of the impact of photography. For the images that have virtually unlimited authority in a modern society are mainly photographic images, and the scope of that authority stems from the properties peculiar to images taken by cameras.

Most contemporary expressions of concern that an image world is replacing the real one continue to echo, as Feuerbach did, the Platonic depreciation of the image: true insofar as it resembles something real, sham because it is no more than a resemblance. But this venerable naive realism is somewhat beside the point in the era of photographic images, for its blunt contrast between the image ("copy") and the thing depicted (the "original") — which Plato repeatedly illustrates with the example of a painting — does not fit a photograph in so simple a way. Neither does the contrast help in understanding image-making at its origins, when it was a practical, magical activity, a means of appropriating or gaining power over something. The further back we go in history, as E. H. Gombrich has observed, the less sharp is the distinction between images and real things; in primitive societies, the thing and its image were simply two different, that is, physically distinct, manifestations of the same energy or spirit. Hence, the supposed efficacy of images in propitiating and gaining control over powerful presences. Those powers, those presences were present in *them*.

For defenders of the real from Plato to Feuerbach to equate image with mere appearance — that is, to presume that the image is absolutely distinct from the object depicted — is part of that process of desacralization, which

separates us irrevocably from the world of sacred times and places in which an image was taken to participate in the reality of the object depicted. What defines the originality of photography is that, at the very moment in the long, increasingly secular history of painting when secularism is entirely triumphant, it revives — in wholly secular terms — something like the primitive status of images. Our irrepressible feeling that the photographic process is something magical has a genuine basis. No one takes an easel painting to be in any sense co-substantial with its subject; it only represents or refers. But a photograph is not only like its subject, an homage to the subject. It is a part of, an extension of that subject, and a potent means of acquiring it, of gaining control over it.

Photography is acquisition in several forms. In its simplest form, we have in a photographic surrogate possession of a cherished person or thing,

a possession which gives photographs some of the character of unique objects. Through photographs, we also have a consumer's relation to events, both to events which are part of our experience and to those which are not—a distinction between types of experience that such habit-forming consumership blurs. A third form of acquisition is that, through image-making and image-duplicating machines, we can acquire something as information (rather than experience). Indeed, the importance of photographic images as the medium through which more and more events enter our experience is, finally, only a byproduct of their effectiveness in furnishing knowledge dissociated from and independent of experience.

This is the most inclusive form of photographic acquisition. Through being photographed, something becomes part of a system of information, fitted into schemes of classification and storage which range from the crudely chronological order of snapshot sequences pasted in family albums to the dogged accumulations and meticulous filing needed for photography's uses in weather forecasting, astronomy, microbiology, geology, police work, medical training and diagnosis, military reconnaissance, and art history. Photographs do more than redefine the stuff of ordinary experience (people, things, events, whatever we

see — albeit differently, often inattentively—with natural vision) and add vast amounts of material that we never see at all. Reality as such is redefined — as an item for exhibition, as a record for scrutiny, as a target for surveillance. The photographic exploration and duplication of the world fragments continuities and feeds the pieces into an interminable dossier, thereby providing possibilities of control that could not even be dreamed of under the earlier system of recording information: writing. . . .

The problem with Feuerbach's contrast of "original" with "copy" is its static definitions of reality and image. It assumes that what is real persists, unchanged and intact, while only images have changed: shored up by the most tenuous claims to credibility, they have somehow become more seductive. But the notions of image and reality are complementary. When the notion of reality changes, so does that of the image, and vice versa. "Our era" does not prefer images to real things out of perversity but partly in response to the ways in which the notion of what is real has been progressively complicated and weakened, one of the early ways being the criticism of reality as façade which arose among the enlightened middle classes in the last century. . . .

A steadily more complex sense of the real creates its own compensatory fervors and simplifications, the most addictive of which is picture-taking. It is as if photographers, responding to an increasingly depleted sense of reality, were looking for a transfusion — traveling to new experiences, refreshing the old ones. Their ubiquitous activities amount to the most radical, and the safest, version of mobility. The urge to have new experiences is translated into the urge to take photographs: experience seeking a crisis-proof form.

As the taking of photographs seems almost obligatory to those who travel about, the passionate collecting of them has special appeal for those confined — either by choice, incapacity, or coercion — to indoor space. Photograph collections can be used to make a substitute world, keyed to exalting or consoling or tantalizing images. . . .

Photography, which has so many narcissistic uses, is also a powerful instrument for depersonalizing our relation to the world; and the two uses

are complementary. Like a pair of binoculars with no right or wrong end, the camera makes exotic things near, intimate; and familiar things small, abstract, strange, much farther away. It offers, in one easy, habit-forming activity, both participation and alienation in our own lives and those of others — allowing us to participate, while confirming alienation. . . .

The powers of photography have in effect de-Platonized our understanding of reality, making it less and less plausible to reflect upon our experience according to the distinction between images and things, between copies and originals. It suited Plato's derogatory attitude toward images to liken them to shadows — transitory, minimally informative, immaterial, im-

UNIVERSAL EXPERIENCE *Art, Life, and the Tourist's Eye*

potent co-presences of the real things which cast them. But the force of photographic images comes from their being material realities in their own right, richly informative deposits left in the wake of whatever emitted them, potent means for turning the tables on reality — for turning *it* into a shadow. Images are more real than anyone could have supposed. And just because they are an unlimited resource, one that cannot be exhausted by consumerist waste, there is all the more reason to apply the conservationist remedy. If there can be a better way for the real world to include the one of images, it will require an ecology not only of real things but of images as well.

Nancy Spector *Felix Gonzalez-Torres,* pp. 42, 56–58, 62–65, and 81
[Rainer Maria] Rilke's semiautobiographical novel *The Notebooks of Malte Laurids Brigge* (1910) includes a passage in which true aesthetic achievement is deemed impossible without a lifetime of accumulated experiences that have almost literally become a part of the artist — his lifeblood. . . . "Verses are not, as people imagine, simply feelings," he writes. "They are experiences. For the sake of a single verse, one must see many cities, men, and things, one must know the animals, one must feel how the birds fly."[1] Accordingly, artis-

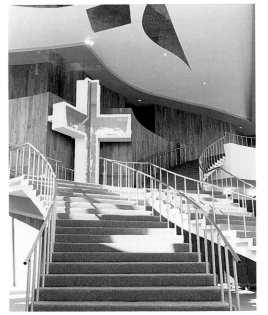

Shirana Shahbazi
(Iranian and German, b. 1974)
From the series *Real Love/ Shanghai,* 2004, TOP
From the series *Painted Desert,* 2004, BOTTOM

In her portraits, still lifes, and landscape photographs, Shahbazi has expanded upon her pictorial overview of daily life of Iranian women to present images of daily life around the world. This installation of photographs taken in Shanghai, Iran, and across the United States enhances commonalities over differences.

tic expression should reflect the complexity of a life lived, take account of the myriad events — both significant and seemingly trivial — that occur and are then forgotten, only to be recalled again in altered form. As Rilke writes:

> One must be able to think back to roads in unknown regions . . . to mornings by the sea, to the sea itself, to seas, to nights of travel that rushed along on high and flew with all the stars — and it is not yet enough if one may think of all this. One must have memories of many nights of love. . . . [O]ne must also have been beside the dying, must have sat beside the dead in the room with the open window. . . . And still it is not yet enough to have memories. For it is not yet the memories themselves. Not till they have turned to blood within us, to glance and to gesture, nameless and no longer to be distinguished from ourselves — not till then can it happen that in the most rare hour the first word of a verse arises in their midst and goes forth from them.[2]

The archetype of the voyage has traditionally captured the imagination of the West, symbolizing progress, the quest for the new, conquest, and freedom. It would be difficult to name a work in the Western literary canon — from Homer, Virgil, and Ovid through Melville and Hemingway — that does not rehearse the theme of travel in some manner. It has been argued that the laws of narrative, as a linear plot structure, conform to those of travel itself, in that travel is the movement between two points — a convergence in space and time — the shape of which is drawn as a line on the map. To this end, Michel de Certeau once claimed that "every narrative is a travel narrative."[3] The literary motif of the voyage is framed by a rupture — leaving home, for instance — and a potential resolution of the situation that arises, which is often embodied in the return. The temporal span between these two positions permits the process of transmutation so critical to the concept of travel to occur.

Gonzalez-Torres's references to and deployment of travel in his art bring time, an element generally suppressed in the visual art, into his work. In particular, his stacks of imprinted papers and mounds of edible sweets delineate a poetic topography activated in time by the viewer's physical and perceptual participation. Free for the taking and endlessly replenishable, these works defy the solidity of conventional sculpture. In their relationship to Minimalist and

1 Quoted from John J. L. Mood, ed. and trans., *Rilke on Love and Other Diffiiculties* (New York: W. W. Norton, 1975), pp. 93–94.

2 Ibid., p. 94

UNIVERSAL EXPERIENCE *Art, Life, and the Tourist's Eye*

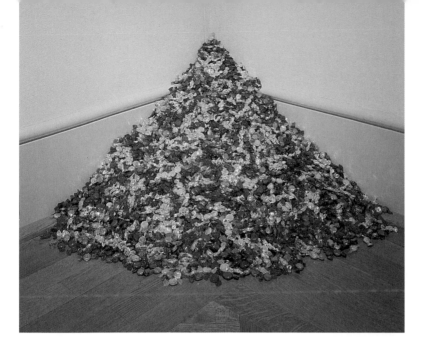

Post-Minimalist forms, they literalize the seriality intrinsic to these genres, while making explicit the quotidian nature of their materials. With paper stacks and candy spills that change shape, shrink, even disappear, depending on the viewers' appetites, the artist recasts a static art form into something emphatically temporal. Vision, physical interaction, and memory are actively engaged to draw each viewer into a spatial narrative that extends over real time while referencing the past and picturing the future. . . .

Allusions to travel are embedded in the circulatory nature of this endlessly replaceable work. Premised on physical accessibility, public dispersal, and continuous renewal, the paper stacks and candy spills literally give of themselves, yielding to the touch of the viewer. Gonzalez-Torres describes this phenomenon as "one enormous collaboration with the

Felix Gonzalez-Torres
(American, 1957–1996)
Untitled (Portrait of Ross in L.A.), 1991

Gonzalez-Torres, in a spirit of generosity, encouraged visitors to take a piece of his artworks with them. He equated his piles of candy with viruses, a metaphor that relates to the dissemination of his work within a cultural sphere. *Untitled (Portrait of Ross in L.A.)*, a memorial to Gonzalez-Torres's partner who died of AIDS, begins at Ross's body weight and diminishes over time as visitors take a piece of the candy. For many viewers the candy becomes a souvenir of their experience in the museum, giving new life to the work as it travels with visitors wherever they go.

3 Quoted in Georges Van Den Abbeele, *Travel as Metaphor: From Montaigne to Rousseau* (Minneapolis: University of Minnesota Press, 1992), p. xix.

Few tourists come home from a vacation without something to show for it, whether it is match-covers, folk art, or rolls of exposed film. The type of vacation chosen and the proof that we really did it reflect what we consider "sacred." The Holy Grail is the myth sought on the journey, and the success of a holiday is proportionate to the degree that the myth is realized.

Nelson H. H. Graburn
"Tourism: The Sacred Journey"

public," in which the "pieces just disperse themselves like a virus that goes to many different places — homes, studios, shops, bathrooms whatever."...

As the sheets of paper and candies travel to disparate sites and contexts, however, they inevitably assume different meanings, ones quite distinct from the original aesthetic. In this way, according to Gonzalez-Torres, the pieces "reinvent themselves." The candies get eaten or lost in a pocket or passed on to friends. The papers are used for sketching or are tacked onto the wall like posters.

The migratory nature of Gonzalez-Torres's giveaway work defies the arbitrary division between the realms of public and private space....

As the artist explains, "When information 'travels' (as it is taken out of one context into another) it can gain other, more real meanings."...

[T]he passage from the public dimension to the private, from memory to fantasy, can be described as "traveling."... While monuments are created to address communal needs, souvenirs exist for the individual person, the "tourist" seeking reminders of his or her particular encounter with the world. Susan Stewart has written about souvenirs as "objects of desire":

> The souvenir reduces the public, the monumental, and the three-dimensional into the miniature, that which can be enveloped by the body, or into the two-dimensional representation [the postcard or the photograph], that which can be appropriated within the privatized view of the individual subject.[1]

Souvenirs represent the transformation from the public realm to the private. They concretize memory and embody nostalgia by seeming to incarnate moments past; in their narrative of reminiscence, souvenirs privatize history.[2]...

1 Susan Stewart, *On Longing: Narratives of the Miniature, the Gigantic, the Souvenir, the Collection* (Durham, N.C.: Duke University Press, 1993), pp. 137–38.

UNIVERSAL EXPERIENCE *Art, Life, and the Tourist's Eye*

When speaking about the concept of travel, the artist often describes times when dreams of certain places have turned out to be so accurate that when he visited the places dreamt of, he felt as if he had actually been there before, as if they were part of his "blood-memory.". . .

In Gonzalez-Torres's metaphoric art, the idea of traveling touches upon so many things — memory, fantasy, transmutation, libidinal exchanges, longing, and loss. "Traveling is also about dying," declares the artist. "It is, after all, about death."

Travel presupposes a circular route — a going forth, a turning around, and a return — a search for "elsewheres," and a homecoming. Of course, within the artist's nomadic vision, . . . the definition of "home" is constantly shifting, as points of departure and destinations change over time. "As with all artistic practices," the artist asserts, "[my work] is related to the act of leaving one place for another, one which proves perhaps better than the first."[3]

Claudia Bell and John Lyall *The Accelerated Sublime: Landscape, Tourism, and Identity*, pp. 137–38 and 141

The desire for attainable enrichment is stimulated by daily bombardment of signs and images of things to consume. . . . Each journey means more experiences to add to one's catalog, and more resources for personal/identity construction.

With the tourists' unprece-

Souvenirs are tangible evidences of travel that are often shared with family and friends, but what one really brings back are memories of experiences. As [Edmund] Carpenter puts it so well: "The connection between symbol and things comes from the fact that the symbol — the word or picture (or artifact) — helps give the "thing" its identity, clarity, definition. It helps convert given reality into experienced reality, and is therefore an indispensable part of all experience."
Nelson H. H. Graburn "Tourism: The Sacred Journey"

dented access to money or credit to spend on novel experiences, market researchers seek consumer responses to imagery, perceived style, satisfaction, and fulfillment. The search today (compared, for instance, with the idealistic 1960s) is not for harmony with the rest of society but for assertive

2 Ibid, p. 138.

3 Quoted from the press release of Gonzalez-Torres's exhibition at Andrea Rosen Gallery, New York, January 20 – February 24, 1990.

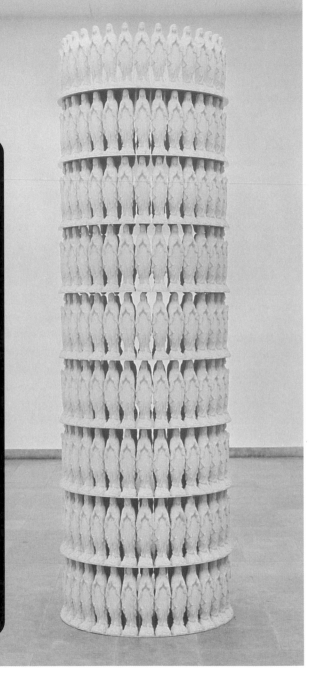

Katharina Fritsch
(German, b. 1956)
*Warengstell mit Madonnen
(Display Stand with Madonnas)*,
1987/89
Aluminum, plaster, and paint
106 ⁵⁄₁₆ × 32 ⁵⁄₁₆ in. dia.
(270 × 82.1 cm)
Courtesy of Matthew Marks
Gallery, New York, RIGHT
*Warengstell mit Vasen
(Display Stand with Vases)*,
1987/89/2001, OPPOSITE
Warengstell II (Display Stand II),
1979–1984, PAGE 192

Exploring the relationship
between high art and
tchotchkes, Fritsch created
sculptural arrangements of
souvenir-like items. *Display
Stand with Vases* is a pyramid
of 145 mass-produced plastic
vases with painted cruise
ships and *Display Stand with
Madonnas* is a column of 288
acid-yellow Madonna figurines
copied from a shop in Lourdes,
France. Fritsch arranged small
multiples of her own work
on glass shelves in *Display
Stand II* as personal memen-
tos of her artistic career that
are also commercial items.
See also p. 177.

UNIVERSAL EXPERIENCE *Art, Life, and the Tourist's Eye*

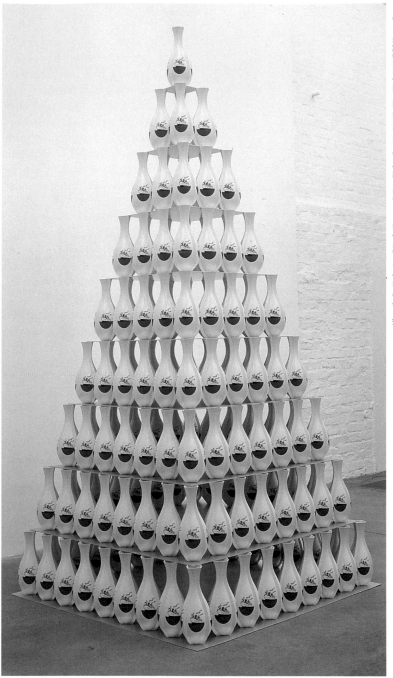

VII *Wish You Were Here!*

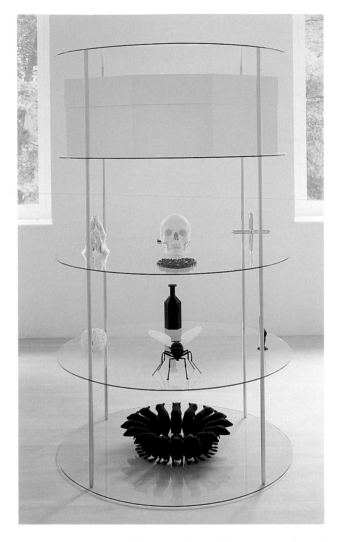

self-expression. This is competitive: One competes with others and with one's past self (what one could purchase say five years ago). . . . Individuals affirm their own choices by comparing them with those made by others. Within one's peer group and friendship network, individuality may need to be expressed by choosing a "different" holiday. For a short period of each year, there is a time to make life more interesting and exciting. . . .

The tourist as purchaser claims ownership of experiences of the other; they have, indeed, "been there" and "done that." Their evidence is presented in their display of mementos and photographs, and in their subjective narratives. Each story is personal to them, because they feature in it.

New experiences are purposely collected along the way. These imbue the tourist with greater knowledge: greater than they had before and greater than those at home who have never been, seen or done these things.

The most prevalent visual demand is for the great global icons, the images plastered on every form of media: to see the real thing, to cast one's eyes over it, to assess how it measures against familiar representatives, to assess how one measures against it. For instance, a verdict on a work by Salvadore

UNIVERSAL EXPERIENCE *Art, Life, and the Tourist's Eye*

> **It's the most famous painting in the world and a must-see for anyone visiting Paris. But most people fight through the crowds to spend a mere fifteen seconds in front of it — just long enough to grab a snapshot.**
>
> **Amelia Gentleman** "Smile, please"

Dali or on the Mona Lisa: "But it's so small!" On the Kinkaku-Ji Temple at Kyoto: "It really is *so* Japanese!"

There are two clear goals. First: to supersede the expectations based on familiarity with reproductions. Second: or not! If a tourism experience does not match expectations, at least the tourist has the consolation of superior knowledge of what it is really like. One has seen the real thing and can authoritatively make evaluative pronouncements. Such a person is a knowledgeable product of travel capitalism.

Nelson H. H. Graburn "Tourism: The Sacred Journey," p. 33
The chosen style of tourism has its counterpart in types of souvenirs. . . . Items made specifically for the tourist market have much less symbolic appeal, and their authenticity is often overstated.[1]

The limitations of tourist travel, especially for jet-setters who cover so much ground so fast, diminish experienced reality and the momentos and souvenirs serve as cues by which to relive the experience at a slower pace. In photography, to get oneself in the picture is common to tourists of both Occidental and Oriental origins as evidence of identity and placement. If they are not afraid of soul-loss, native peoples often project themselves into tourists' pictures as a momentary escape from their environment . . . as a means of "getting into" the imagined happiness and affluence of the tourist's home situation. As one impoverished African in a remote ex-colonial country said to the anthropologist who was taking last-minute photos of all his informants, "And when you develop the photo, please make me come out white."

1 Nelson H. H. Graburn, ed. *Ethnic and Tourist Arts: Cultural Expressions from the Fourth World* (Berkeley and Los Angeles: University of California Press, 1976).

VIII *The World for*

This section explores travelers' desire for the unknown to be made familiar — analyzed, ordered, and displayed. Beginning with the 1893 Chicago Columbian Exposition — an early effort to represent the known and unknown world — it also focuses on anthropology, with its systems of research, methods of analysis, and premise that understanding people and cultures is possible.

By purchasing prepackaged holidays, many tourists insulate themselves from the unforeseen and the unfamiliar. Throughout the world, the proliferation of museums, as well as McDonald's, Disney stores, and theme parks, is a result of the demand for ordered encounters with the

Maurizio Cattelan
(Italian, b. 1960)
Untitled, 1998
Papier mâché, paint,
costume, and mask
12 9/16 × 8 1/4 × 9 7/16 in.
(32 × 21 × 24 cm)
Courtesy of Marian Goodman
Gallery, New York
Greeting visitors at The Museum
of Modern Art, New York
See also p. 94.

a Buck

unknown. Often embodying the desire for the exotic presented in a recognizable form, museums, increasingly popular tourist destinations, have become at times symbolic targets of the anxiety surrounding originality and artifice.

197

Erik Mattie *World's Fairs,* pp. 88–89 and 97

The 1893 World's Columbian Exposition was held to commemorate the discovery of the New World by Christopher Columbus in 1492. The fact that that the festivities took place 401 instead of four hundred years after this date can be attributed to delays in the preparatory phase of exhibition planning. Various American cities fought over the honor to host the prestigious

event . . . before Congress – after eight years of indecision – finally awarded the event to Chicago. This was a major victory for the booming city, which sought to rid itself of the provincial label bestowed on it by its great East Coast rivals. Similarly, the fair would allow the entire American nation to shed a sense of cultural inferiority long held in regard to Europe. By surpassing the great exhibitions of Paris, the Columbian Exposition would establish both the host city and the host country as economic and cultural powers.

The architects [Daniel H. Burnham] chose had to represent the various regions of a unified nation (the Civil War still weighed on the American conscience); and he wanted architects capable of a stylistically unified architectural statement that would eclipse any European precedent. . . . Burnham's choice of École des Beaux Arts-trained architects . . . satisfied these obligations. . . . The buildings were to be covered

with staff, a bright white plaster mixture, so they would appear as marble. Thus the fair came to be known as the "White City."

The Columbian Exposition, with participants from no fewer than fifty nations, was huge in every sense of the word. Logistically, the event was well organized. A small electric train transported visitors around the site via a looping track, and a rudimentary moving sidewalk carried fairgoers from entry pier to fairgrounds. The fair was also a major factor in Chicago's decision to create its metro system, the fourth in the world. Though electricity was becoming a commonplace, the fair's large-scale application of it was unique; in the evening, the buildings were dazzlingly illuminated. In the event of short circuit, the exhi-

UNIVERSAL EXPERIENCE *Art, Life, and the Tourist's Eye*

Bruno Serralongue (French, b. 1968)
Escalier Central, Expo 2000, 2000, BELOW
Asia Hall, Expo 2000, 2000, OVERLEAF TOP
Pavillon du XXIème siècle, Expo 2000, 2000, OVERLEAF BOTTOM

Taking the theme "Humankind-Nature-Technology: A New World Arising," the 2000 Hannover World Expo represented more than 200 countries, housing some in a convention center and others in buildings that reflected indigenous architectural styles. Serralongue's photographs document the food, cars, and customs that were re-created to give as close to authentic impression of the various countries' cultures as possible, while encouraging commercial development and exchange. His images suggest the contentious relationship between retaining traditions and developing technologies for the future.

bition's own fire brigade came to the rescue. Every type of service was available to attendees, including telephone and telegraph. The fair was heavily policed, and a sanitation crew made the entire site spotless every night.

The Midway fairgrounds featured the original Ferris Wheel, George Ferris's 260-foot answer to the Eiffel Tower and one of the icons of the fair. The Midway was also the location of the fair's ethnological exhibitions – including an "Esquimaux Village" and a "Native American Show." Controversy erupted when Innuits complained of gross mistreatment and

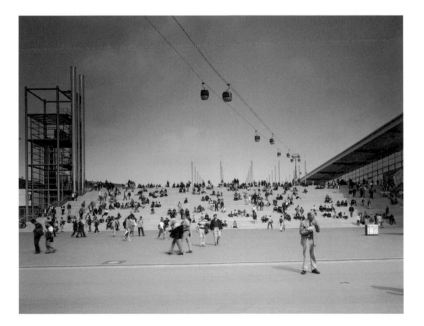

UNIVERSAL EXPERIENCE *Art, Life, and the Tourist's Eye*

exploitation. If the inclusion of such exhibits seem disturbing today, equally troubling is the exclusion of African Americans from participation in the fair. This prompted the publication of the treatise *The Reason Why The Colored American is not in the Columbian Exposition,* coauthored by Frederick Douglas.

Timothy Mitchell "Orientalism and the Exhibitionary Order," pp. 495–96, 498–99, and 502

In 1889 . . . 32 million people visited the Exposition Universelle . . . in Paris to commemorate the centenary of the Revolution and to demonstrate French commercial and imperial power. . . .[1]

This world-as-exhibition was a place where the artificial, the model, and the plan were employed to generate an unprecedented effect of order and certainty.

[T]he four members of the Egyptian delegation to the Stockholm Orientalist conference spent several days in Paris, climbing twice the height (as they were told) of the Great Pyramid in Alexandre Eiffel's new tower, and exploring the city and exhibition laid out beneath. . . .

The Arabic account of the student mission to Paris devoted several pages to the Parisian phenomenon of *le spectacle,* a word for which its author knew of no Arabic equivalent. . . . among the different kinds of spectacle he described were "places in which they represent for the person the view of a town or a country or the like," such as "the Panorama, the Cosmorama, the Diorama, the Europorama and the Uranorama." In a panorama of Cairo, he explained in illustration, "it is as though you were looking from on top of the minaret of Sultan Hasan, for example, with al-Rumaila and the rest of the city beneath you."[2]

The effect of such spectacles was to set the world up as a picture. They ordered it up as an object on display to be investigated and experienced by the dominating European gaze. . . .

Arabic accounts of the modern West became accounts of these curious object-worlds. . . . Such accounts devote hundreds of pages to describing the peculiar order and technique of these events – the curious crowds of spectators, the organization of panoramas and perspectives, the arrangement of natives in mock colonial villages, the display of new inventions and commodities, the architecture of iron and glass, the systems of classification,

1 Tony Bennett, "The Exhibitionary Complex," *New Formations* 4 (spring 1998), p. 96.

2 Rifa'a al-Tahtawi, *al-A'mal al-kamila* 2 (Beirut: al-Mu'assasa al-Arabiyya li-l-Dirasat wa-l-nashr, 1973), p. 121.

the calculations of statistics, the lectures, the plans, and the guidebooks — in short, the entire method of organization that we think of as representation. Despite the careful ways in which it was constructed, however, there was something paradoxical about this distinction between the simulated and the real, and about the certainty that depends on it. … [I]t was not always easy to tell where the exhibition ended and the world itself began. The boundaries of the exhibition were clearly marked, of course, with high perimeter walls and monumental gates. But, as the Middle Eastern visitors continually discovered, there was much about the organization of the "real world" outside, with its museums and department stores, its street facades and Alpine scenes, that resembled the world exhibition. Despite the determined efforts to isolate the exhibition as merely an artificial representation of a reality outside, the real world beyond the gates turned out to be more and more like an extension of the exhibition. Yet this extended exhibition continued to present itself as a series of mere representations, representing a reality beyond. We should think of it, therefore, not so much as an exhibition but as a kind of labyrinth, the labyrinth that, as Derrida says, includes in itself its own exits.[3] But then, maybe the exhibitions whose exits led only to further exhibitions were becoming at once so realistic and so extensive that no one ever realized that the real world they promised was not there.

OPPOSITE
Judith Hopf, Natascha Sadr Haghighian, and Florian Zeyfang
(German, b. 1969, 1967, and 1965)
Proprio Aperto (stills), 1998

With the proliferation of contemporary art fairs, international biennials, and touring exhibitions, it has become increasingly common for people to travel long distances to see artworks. Sixty-four countries participated in the last International Art Exhibition of the Venice Biennial and many maintain permanent pavilions. Hopf, Sadr Haghighian, and Zeyfang examine how the pavilions are used in the winter when the crowds disappear, showing the evidence of squatters and graffiti in the empty buildings. This off-season exploration of this most famous international art exhibition shows its unintended impact and how tourists' presence — and absence — affects local communities.

3 Jaques Derrida, *Speech and Phenomena and Other Essays on Husserl's Theory of Signs* (Evanston, Ill.: Northwestern University Press, 1973), p. 104

UNIVERSAL EXPERIENCE *Art, Life, and the Tourist's Eye*

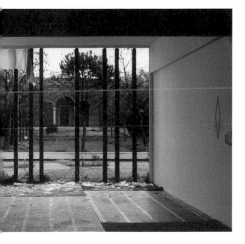

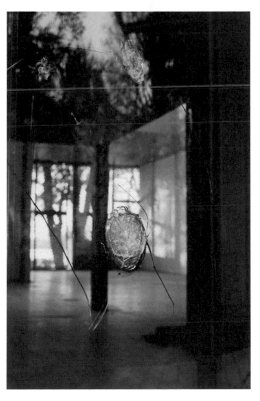

Multimedia Art
Asia Pacific

Beijing Biennial

media_city
seoul

Echigo-Tsumari
Triennial

Carnegie Intern

SITE Santa Fe

Gwangju
Biennial

Yokohama Triennial

L.A. Biennial
California Biennial

Shanghai Biennial

Fukuoka Asian
Art Triennial

Busan
Biennial

FotoFes
Biennial

Taipei Biennial

*Biennial and Triennial
International Contemporary
Art Surveys Worldwide*

Intera

Mexico City Biennial

CP Open
Biennial

Asia-Pacific Triennial

Biennial of Electronic Arts Perth

Biennial of Sydney

UNIVERSAL EXPERIENCE *Art, Life, and the Tourist's Eye*

Werklietz Biennial
Berlin Biennial
Ars Baltica Triennial
Sculpture Biennial Muensterland
Momentum Nordic Festival
Tallinn Print Triennial
Baltic Triennial
Paper Art Düren
Gothenburg Biennial
Artist's Book Triennial
Lodz Biennial
Documenta
Prague Biennial
Majdanek Triennial
Liverpool Biennial
Wro Media Art Biennial
London Biennial
International Photo Triennial
Leuven Biennial
Ars Electronica
Bonn Biennial
Periferic Biennial
Paris Biennial
Biennial of Visual Arts
Lyon Biennial
Ljubljana Biennial
...treal Biennial
Cetinje Biennial
...oronto Outdoor Art Exhibition
St. Etienne Design Biennial
Istanbul Biennial
Asian Contemporary Art Week
Tirana Biennial
Manifesta
Photo New York
BIG Torino
Arles Exhibition of Photography
Whitney Biennial
Barcelona Art Report
Florence Biennial
Venice Biennial
...rcoran Biennial
Seville Biennial
Valencia Biennial
Meran Biennial
Venice Architecture Biennial
Triennial India
...edia Jam Biennial
...ana Biennial
Cairo Biennial
Asian Art Biennial
Sharjah Biennial
Latin American and Caribbean Print Biennial
Caribbean Biennial
Bamako Exhibition of African Photography
Dak'Art
...Multiple City
Cuenca Biennial
Biennial Ceará América
Luanda Triennial
International Festival of Video/Art/Electronica
...Biennial
Mauritius Triennial of the Indian Ocean
São Paulo Biennial
Mercosul Biennial of Visual Arts
Biennial of Video and New Media
Johannesburg Biennial
Buenos Aires Biennial

VIII *The World for a Buck*

Mary Kelly "Re-viewing Modernist Criticism," p. 100

An exhibition takes place; its spacio-temporal disposition, conventions of display, codes of architecture construct a certain passage, not the continuous progression of images unfolding on the cinema screen, but the flickering, fragmented frames of the editing machine; a passage very much at the disposal of the spectator to stop frame, rewind, push forward; it displays discernible openness, a radical potential for self-reflexivity. There is nevertheless a logic of that passage, of partition and naming.

Theodor W. Adorno *Prisms*, pp. 175–77, 182, and 183

The German word, *'museal' ['museumlike']*, has unpleasant overtones. It describes objects to which the observer no longer has a vital relationship and which are in the process of dying. They owe their preservation more to historical respect than to the needs of the present. Museum and mausoleum are connected by more than phonetic association. Museums are like the family sepulchres of works of art. . . . Anyone who does not have his own collection (and the great private collections are becoming rare) can, for the most part, become familiar with painting and sculpture only in museums. . . .

> **Museums need visitors and the tourism industry, more than any sector of the economy, can deliver the hordes to museum doors. By one estimate, seven billion tourists will be moving around the globe annually by the year 2000.**
>
> **Barbara Kirshenblatt-Gimblett**
> *Destination Culture: Tourism, Museums, and Heritage*

Standing among the pictures offered for contemplation, [Paul] Valéry mockingly observes that one is seized by a sacred awe; conversation is louder than in church, softer than in real life. One does not know why one has come — in search of culture or enjoyment, in fulfilment of an obligation, in obedience to a convention. Fatigue and barbarism converge. Neither a hedonistic nor a rationalistic civilization could have constructed a house of such disparities. Dead visions are entombed there.

[F]or [Marcel Proust] it is only the death of the work of art in the museum which brings it to life. When severed from the living order in which it functioned, according to him, its true spontaneity is released — its uniqueness, its "name," that which makes the great works of culture more than culture. . . .

It is something subjective . . . that Proust considers to be preserved in the work's afterlife in the museum. . . .

Proust's subjectivism looks to art for the ideal, the salvation of the living.

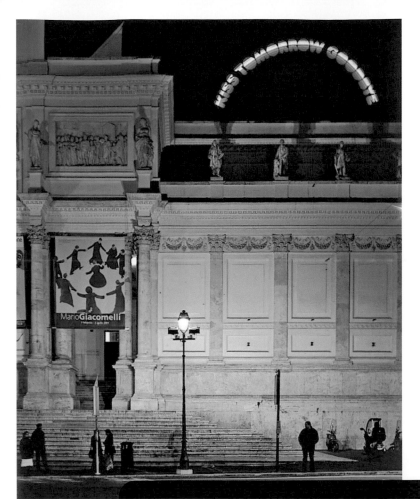

Ugo Rondinone (Swiss, b. 1963)
KISS TOMORROW GOODBYE, 2001
Plexiglas, neon, and aluminum
446⅛ × 179⅛ in. (11.3 × 4.6 m)
Courtesy Galerie Eva Presenhuber, Zurich

Commercial signs are usually designed to create desire for products. Rondinone's rainbow neon slogans, however, advertise a desire for human connection. The rainbow letters spell out romantic phrases like "Our Magic Hour," "Hell, Yes," "Guided By Voices," and "Love Invents Us," and are taken from Rondinone's solo exhibition titles. Illuminating the area around them, they provide an unexpected glimmer of poetic idealism in the urban environment.

Nicolas Bouvier *The Japanese Chronicles*, p. 201

I think of the Louvre, that tomb. I tell myself that all museums should be like this one: flowing directly from the arteries of an old man who has a right to its objects, to handle them and love them, make them shine, and, if they get chipped a little by mistake, a skillful factotum repairs them so well that they are more beautiful than before. These museums — you find them in the provinces — are the only ones to provide truly enchanted moments, the only ones where there is still a chance to discover, between the stuffed sables and the Bantu shield, an authentic Stradivarius, or even some pharmacy jars — that seem so fated to be yours that they're enough to transform the most honest man into a thief. The only museums where, thanks to genius and disorder, the past is not arbitrarily cut off from the present. Take the Greuze Museum in Tournus: under the

Olafur Eliasson (Danish, b. 1967)
The Weather Project, 2003
Installation: Turbine Hall
Tate Modern, London
October 16, 2003 – March 21, 2004

Eliasson's *The Weather Project*, one of the Tate Modern's Unilever series of projects in Turbine Hall, is a prime example of an artwork that became a tourist attraction. Over the course of the exhibition, millions of visitors experienced the atmospheric installation, which simulated a hazy, sunny day with mist, mirrors, and hundreds of monofrequency lamps arranged in a circle at the end of the hall. Like many of Eliasson's projects that simulate weather conditions, this work creates in viewers a heightened perception of their surroundings by incorporating climatological effects indoors. Eliasson has said that his works allow viewers to "see yourself sensing."

stairs there is a stoneware pot with blue motifs that's easily two hundred years old. One wonders whether Greuze had ground his colors there; no, it belongs to the concierge who puts mashed cherries in it to make brandy.

Barbara Kirshenblatt-Gimblett *Destination Culture: Tourism, Museums, and Heritage*, p. 132

Museums have long served as surrogates for travel, a particularly important role before the advent of mass tourism. They have from their inception preserved souvenirs of travel, as evidenced in their collections of plants, animals, minerals, and examples of the arts and industries of the world's cultures. While the museum collection itself is an undrawn map of all the places from which the materials have come, the floor plan, which determines where people walk, also delineates conceptual paths through what becomes a virtual space of travel.

Exhibiting artifacts from far and wide, museums have attempted from an early date to reconstruct the places from which these things were

brought. The habitat group, period room, and re-created village bring a site otherwise removed in space or time to the visitor. During the nineteenth century, exhibitions delivered to one's door a world already made smaller by the railroad and steamship. Panoramas featured virtual grand tours and simulated the sound and motion of trains and ships and the atmospheric effects of storms at sea. A guide lectured and otherwise entertained these would-be travelers. Such shows were celebrated in their own day as substitutes for travel that might be even better than actually going to the place depicted.

ABOVE
Gabriel Orozco
(Mexican, b. 1962)
Turista Maluco (Crazy Tourist), 1991

Orozco's photograph of oranges arranged on market stalls in Brazil is titled *Turista Maluco (Crazy Tourist),* the name locals gave him after he made this sculptural intervention in the market. It leads us to consider how locals perceive visitors and the potential impact of one individual, but also reflects Orozco's interest in different modes of display and how context affects our understanding of everything from art to oranges. See also p. 222.

Hans Ulrich Obrist *Interviews,* p. 656
(with Gabriel Orozco)

HUO: *The MoMA installation in which you oscillate between the inside and the outside leads of course to the question of how you deal, in more general terms, with the museum.*

GO: I'm very sensitive to museums and I can recognize that they are very different from each other. At this point in my life

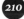

UNIVERSAL EXPERIENCE *Art, Life, and the Tourist's Eye*

Museums are quintessentially places of seeing, of the making visible, of the tourist gaze.

John Urry *The Tourist Gaze*

I know many museums from the inside and the outside: the offices, the washrooms, the guards (not to mention the trustees and the curators), and I can recognize the differences and the specificity of each one. The atmosphere of the building and the people at ARC is very different from Beaubourg, not to mention the atmosphere at MoMA. I try to take the museum as a real thing so I try to be aware of their accidents, their history, and their limitations, and I work with museums as I work with a market in Cachoeira, Brazil, or the cemetery in Timbuktu. I don't think the museum is a fictional place. I think it is as real as a cemetery or as a market in which you can have dead things, live things, rotten things.

Nelson H. H. Graburn "The Museum and the Visitor Experience," pp. 178 and 181

Museums are inextricably related to that phenomenon known as "tourism." Both museums and tourism are relatively modern phenomena which were once exclusively the province of the rich and powerful and which developed, especially during the Victorian era, into institutions for the ordinary citizen. Both are "public" in that they are mass phenomena that take place away from the private home, and both involve the magic of a "trip," an out-of-the-ordinary experience. . . .

As the crowds increase and heretofore inexperienced classes of visitors arrive, cognitive dissonance begins to cause some to be frustrated and others to be bored. "Museumitis" is becoming a common disease; after half an hour or an hour of what is supposed to be a pleasant experience, the visitor gets turned off, develops headaches, and feels tired. This is due at least in part to the fact that a museum is a strange place in that the subject matter

 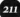

Herostratos . . . set fire to the world famous temple of Artemis in 356 BC in order to preserve his name for posterity, and was condemned not only to death but — unsuccessfully — to oblivion by means of a prohibition against mentioning his name.

Dario Gamboni *The Destruction of Art: Iconoclasm and Vandalism since the French Revolution*

slides past the walking visitor like a kaleidoscope, demanding attention and a change of focus at a pace not experienced elsewhere. In a museum, as opposed to in a church or school, the tempo of the experience is controlled not by the person orchestrating the event but by the visitor himself; and thus a heavy burden of the decision-making falls upon the visitor, who must decide to move on or stay, to avoid the crowd or be pushed on at a difficult pace, to read or not to read the labels, to glance at or study the exhibit.

Dario Gamboni *The Destruction of Art: Iconoclasm and Vandalism since the French Revolution*, pp. 190–91 and 202–3

[T]he "will" to visit a museum or perform another cultural activity is . . . a complicated matter, engaging multiple and possibly conflictual combinations of interests, desires, anticipated pleasures, representations, and duties. Second, in the last few decades, deep social, cultural, political and economic transformations have contributed to a widening of the museum's public, so that even 25 years ago, an American specialist could attribute "the increase in museum vandalism in recent years" not only to "the heightening of human tension in modern

OPPOSITE
Thomas Hirschhorn (Swiss, b. 1957)
Chalet Lost History, 2003

Many museum collections include objects with a provenance marked by war. In 2003, museum collections in Iraq were pillaged for everything from cultural relics to air-conditioning units, and publicly owned property was suddenly in individuals' hands. Hirschhorn relates looting to the primacy of looking at and acquiring meaning from images in contemporary culture. In *Chalet Lost History* he inundates the viewer with contemporary cultural artifacts (pornographic magazines, newspaper war photographs, books, and texts by poet Manuel Joseph), cardboard representations of historical monuments (pyramids of Egypt), and commonplace commercial items (fans, refrigerators, bottles, corporate logos, and fake dollar bills) in a three-room "chalet" with faux-wood covered walls.

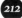

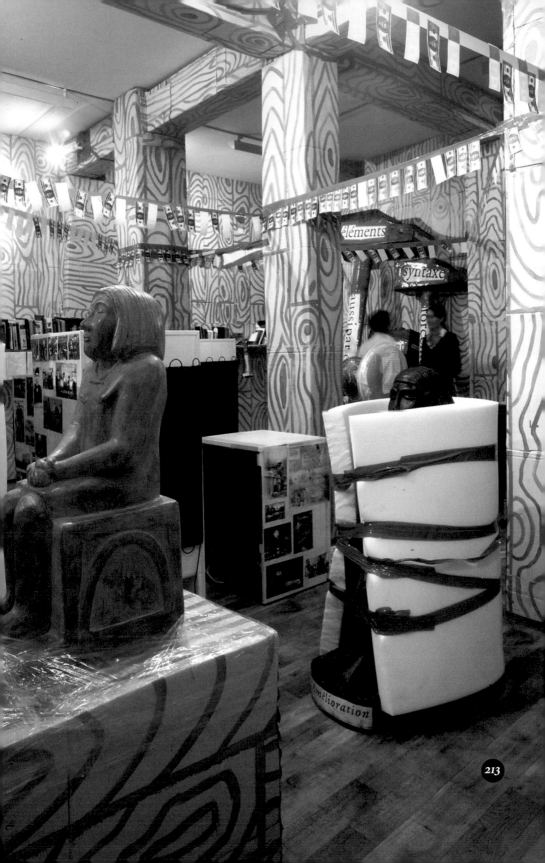

éléments

syntaxe

213

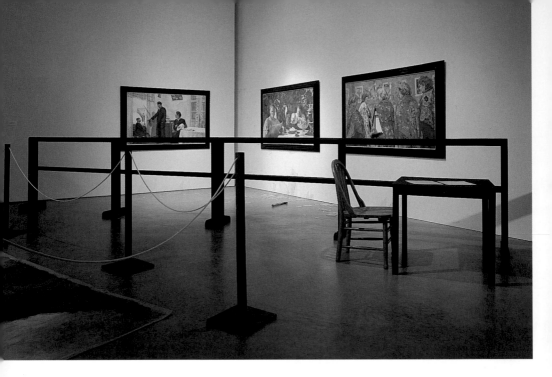

society," but also to the fact that "museums are faced with vastly increased and diversified audiences which include a segment of the public not previously conditioned to restraint in viewing."[1]

Third, the development of modern and contemporary art and its equally widening inclusion in museum presentations (in "general" as well as in specialized institutions) account for a much augmented possibility that even voluntary and cultivated visitors encounter works that escape or defy their aesthetic expectations. All of this has tended to attenuate the difference between museum and non-museum contexts, or even — particularly with modern and contemporary art — to make it almost irrelevant. . . . [M]useums may be said to raise the threshold restraining the enacting of physical aggression, or to effect a selection among potential aggressors involving a greater "interest" or involvement in the work and in the deed, a greater degree of premeditation, and a greater willingness to be recognized as the author of one's action and to suffer sequels that follow from it.

On Whit Sunday, 21 May 1972, shortly before noon, while a crowd of people who had attended Mass in St. Peter's in Rome were leaving the cathedral, a man jumped into the aisle Capella della Pietà and battered with a hammer Michelangelo's sculpture of the Virgin holding her dead son

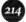
UNIVERSAL EXPERIENCE *Art, Life, and the Tourist's Eye*

in her lap, shouting: "I am Jesus Christ. Christ is risen from the dead." The action was seen by many, and was even photographed. A fireman overcame the assailant, a 33-year-old Hungarian-born émigré to Australia named László Toth, who had to be pro-

Toth had simultaneously attacked a sacred object, an element of heritage, a work of art, and a symbol of the Roman Catholic Church, and observed that the hammer Toth had used for his action was a sculptor's tool, establishing a symmetrical relation between the destructive and the creative "touch."

Dario Gamboni *The Destruction of Art: Iconoclasm and Vandalism since the French Revolution*

tected from the congregation and was carried away. The Pope had roses brought, knelt and prayed himself before the statue, and awarded the Knight's Cross of the Gregorian order to the fireman because he had preserved more than a work of art, "the very symbol of the mother of God."[2] After his arrest, Toth repeated that he was Christ and stood ready for crucifixion, but also pretended to be Michelangelo. God had commanded him to destroy the statue of the Madonna, because being eternal, He could have no mother.

[László Toth] arrived in Rome in June 1971, not knowing a word of Italian, with the intention, as he later explained to his lawyer, of being recognized as Christ. He sent letters to Pope Paul VI and tried to meet him . . . to no avail. The Church, he concluded, could only accept a dead Christ, and resolved to attack the Pietà as a symbol of this "incredible" practice.

OPPOSITE
Ilya and Emilia Kabakov
(Russian, b. 1933 and 1945)
The Artist's Despair or the Conspiracy of the Untalented, 1994

Occasionally the news reports on vandalism toward an artwork: in 1972 Michelangelo's *Pieta* was smashed, in 1974 Tony Shafrazi spray painted "Kill Lies All" on Picasso's *Guernica* at MOMA in response to the My Lai massacre, and a young Brit poured black ink into Damien Hirst's formaldehyde-encased sheep. The Kabakovs' installation resembles a traditional exhibition of social realist paintings, and like many of their works refers to exhibition design and ideologies. It appears that someone has climbed over the guard rail and smashed the glass in front of the paintings, an unsettling reflection on how powerfully and viscerally some people respond to art, despite museum codes of proper viewing behavior.

1 Caroline Keck, "On Conservation," *Museum News: the Journal of the American Association of Museums*, L (May 1972) p. 9.

2 Peter Moritz Pickshaus, *Kunstzerstörer: Fallstudien: Tatmotive und Psychogramme* (Reinbek bei Hamburg: Rowohlt Taschenbuch Verlag GmbH, 1988).

 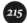

Frederick Turner "Reflexivity as Evolu-
tion in Thoreau's *Walden,*" pp. 84–87

As a systematic field of study, the dis-
cipline of anthropology arose in Eu-
rope and America during the nine-
teenth century. Of course, there were
already Ancient Greek, Moslem, Euro-
pean, Indian, Chinese, and Japanese
travelers' tales and accounts of "bar-
barian" customs; but it took a peculiar
kind of civilization to produce anthro-
pology proper. . . . European and
American civilization is uniquely priv-
ileged in having produced, paradoxi-
cally, the discipline which asserts that no society is uniquely privileged. The
problem can only be escaped by denying the raison d' être of anthropology,
which is that anthropology actually gives a better account of a society to the
rest of the world than that society can, unaided, give of itself. . . . Of course,
every society is unique in its own way. But the realization of the fact by the
West gave it an asymmetrical position of epistemological superiority, a re-
flexive capacity not shared by other societies. . . .

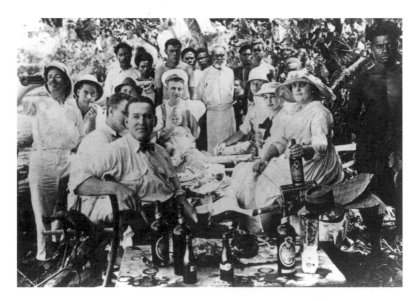

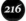**UNIVERSAL EXPERIENCE** *Art, Life, and the Tourist's Eye*

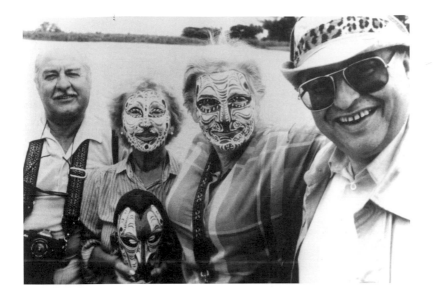

The anthropology of experience may be a new topic in current circles, but I contend that it may also be at the very root of the discipline: that only when we learned how to be harmoniously and creatively alienated from ourselves were we able to understand the ideas of cultural aliens. . . .

For the first time since the Renaissance, when the societies of pagan antiquity had come to serve as models in the initiation of the elite, the West had grasped alien cultures as being possibly exemplary or superior to its own. . . .

If it is true that some form of personal voyage of self-discovery must accompany any genuine understanding of another culture, then we may have the beginnings of an explanation for the uniqueness of the West in having generated an anthropological tradition.

[Anthropologists] . . . experience personal conversion that involves culture shock, self confrontation, a profound alienation from their own culture, a sense of being only a child in their newly adopted culture, an initiation into its mysteries, and an acceptance by it. Eventually, the anthropologist becomes the culture's spokesperson, interpreter, and protector against the culture from which he or she originally came.

Frederick Turner
"Reflexivity as Evolution in Thoreau's *Walden*"

The anthropology of tourism, though novel in itself, rests upon sound anthropological foundations and has predecessors in previous research on rituals and ceremonials, human play, and cross-cultural aesthetics.

Nelson H. H. Graburn "Tourism: The Sacred Journey"

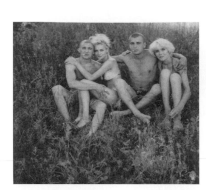
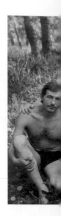
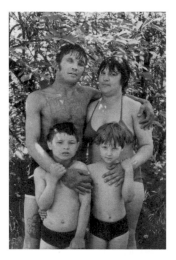
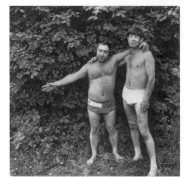

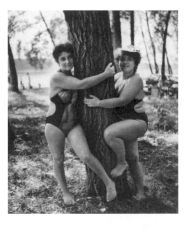

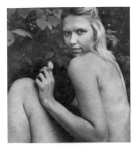

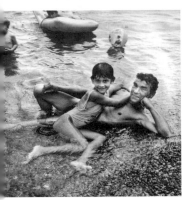

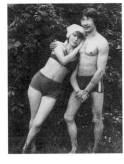

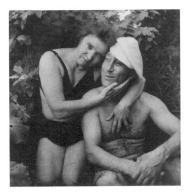

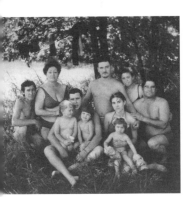

Nikolay Bakharev (Russian, b. 1946)
Relationship Series, 1983–2002

For more than fifteen years, Bakharev has sold black-and-white portraits to Siberians vacationing near the Tom River in Novokuznetsk, Russian Siberia. Acting as an anthropological study of leisure, these works reflect his archive of hundreds of images of couples, children, friends, and families and dispel conceptions of Siberia as barren tundra. The tender, sometimes humorous ways the vacationers arranged themselves for the camera provides insight into their relationships.

One of the difficulties faced by local people is that they had little ability to control the manner of their contact with outsiders.

Robert Hitchcock
"Cultural, Economic, and Environmental Impacts of Tourism"

James Lett Epilogue for "Touristic Studies in Anthropological Perspective," pp. 275–78

The fact that anthropologists have, lately, purposely turned their attention to the study of tourism can only be seen as a welcome and overdue development. In the second half of the century, anthropologists have discovered tourists everywhere they have gone. . . . Modern tourism accounts for the single largest peaceful movement of people across cultural boundaries in the history of the world. Given that, tourism is unavoidably an anthropological topic. As a discipline whose raison d'être is the exploration and explication of cultural similarities and differences, anthropology cannot ignore the phenomenon of tourism and retain its identity. . . .

The anthropological literature on tourism can be broadly divided into two categories. . . . On the one hand, there are those anthropologists, like Nelson Graburn, who are interested in exploring the culturally defined meanings that the experience of tourism holds for the tourist and those he or she encounters; on the other hand, there are those anthropologists, like Dennison Nash, who are interested in assessing the range of empirical effects that tourism has upon the sociocultural systems of host societies.

Graburn has argued that tourism can best be analyzed as a near-universal manifestation of the pan-human need for play and recreation whose origin is grounded in the invariable tendency for human beings to assign meaning to their activities, while Nash has argued that tourism can best be viewed as a near-universal form of travel pursued by people at leisure whose origin cannot be determined but whose cultural variability can be assessed. Graburn suggests that tourism is preemi-

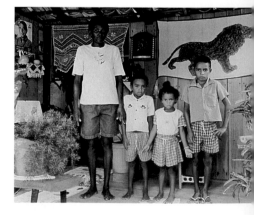

UNIVERSAL EXPERIENCE *Art, Life, and the Tourist's Eye*

nently a secular ritual, and that in many contemporary societies it fulfills functions once met by sacred (or, more precisely, supernatural) rituals. Nash questions Graburn's contention that the need to alternate between ordinary and non-ordinary experiences is innate or universal, and he asks why such a need, if it did exist, would necessarily express itself in touristic form. While Graburn would prefer to explore the symbolic meaning of tourism, Nash would prefer to analyze the political and economic effects of touristic development. . . .

BELOW AND OPPOSITE
Sharon Lockhart (American, b. 1964)
Apeú-Salvador: Families/ The Reis Family/ Maria do Livramento Soares dos Reis, Marco Antônio Soares dos Reis, Maria Lucileide Soares dos Reis, Marco José Soares dos Reis/ Apeú-Salvador, Pará, Brazil/ Survey of Kinship Relations in a Fishing Community/ Anthropologist: Isabel Soares de Souza, 1999

For these photographs, Lockhart collaborated with anthropologists Ligia Simonian, who surveyed the population in the Rio Aripuanã region of the Amazon in Brazil, and Isabel Soares de Souza, who undertook kinship studies on the small island of Apeú-Salvador, as a means of generating images. Simonian interviewed families in the main room of their own homes while Lockhart photographed the vacant rooms. Lockhart also created portraits of families, and unlike traditional documentary studies, collaborated with the subjects to determine how their portraits would be taken.

The theoretical difference between Professors Graburn and Nash is a common one in anthropology, for it reflects the distinction between those who wish to study *the maintenance of human identity* and those who wish to study the *maintenance of human life. Cross-culturally, the maintenance of human identity is most frequently accomplished through such activities as ritual, play, and art. . . . Cross-culturally, the maintenance of human life is invariably accomplished, except in the most extraordinary circumstances, through learned and shared subsistence strategies. . . .* Thus in analyzing tourism most anthropologists have either described the ways in which

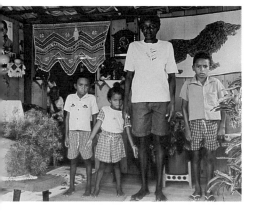

 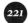

tourism is used as a symbolic means of expressing and maintaining human identity, or they have described the social, political, economic, and environmental effects that result from using touristic modes of production to maintain human life. . . .

In the final analysis, what unites all anthropological approaches to tourism is the discipline's uniquely holistic and comparative perspective. Anthropologists may differ as to whether they wish to study symbolic systems of meaning or behavioral systems of adaptation, but all anthropologists agree that all aspects of sociocultural systems are interrelated — and all anthropologists agree that their theories must be applicable to all people in all places at all times.

George Ritzer and Allan Liska "'McDisneyization' and 'Post-Tourism': Complementary Perspectives on Contemporary Tourism," pp. 96–99

"The McDonaldization of society". . . perspective . . . is a modern grand narrative viewing the world as growing increasingly efficient, calculable, predictable, and dominated by controlling non-human technologies. While most grand narratives (such as that of Karl Marx) offer a utopian view of the future, this one . . . has a more dystopian emphasis upon the increasing irrationality of rationality.

Disney World (to take a specific Disney park) is efficient in many different ways, especially in the way it processes the large numbers of people that would easily overwhelm a less rationalized theme park. The set prices for a daily or weekly pass, as well as the abundant signs indicating how long a wait one can expect at a given attraction, illustrate calculability (although, as we will see, Disney World is also in a sense a shopping mall oriented to getting people to spend far more than they do on their daily pass). Disney World is highly predictable – there are no midway scam artists to milk the visitor; there are teams of workers who, among their other cleaning chores, follow the nightly parades cleaning up debris, including animal droppings, so that visitors are not unpleasantly surprised when they take an errant step.

Indeed Disney theme parks work hard to be sure that the visitor experiences no surprises at all. And Disney World is a triumph of non-human technology over humans. This is not only true of the numerous mechanical and electronic attractions, but even the human employees whose performances (through lip-synching, for example) and work (following scripts) are controlled by non-human technologies. Finally, there is no lack of irrationalities of supposed rationality at Disney World: long lines and long waits make for great inefficiency; costs (for food, the unending hawking of Disney products, both in and out of the parks) mount up, become incalculable, and often make what is supposed to be an inexpensive vacation highly costly. Most importantly, what is supposed to be a human vacation turns, for at least some, into a non-human or even a dehumanizing experience.

Disney's theme parks came of age in the same era as McDonald's. Fascinatingly, the original Disneyland and the first outlet of the McDonald's chain both opened in the same year — 1955. They are based on and

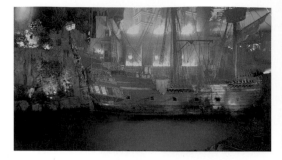

manifest many of the same principles. McDonald's has arguably been the more powerful symbol and force in our age, if for no other reason than its 18,000 or so outlets worldwide . . . are more ubiquitous than the few Disney theme parks. Of course, it could be argued that Disney's movies, television programmes, and products make it even more omnipresent than McDonald's. But if McDonald's has been the paradigm of rationality for society as a whole, Disney has certainly been the model for the tourist industry.[1] For example, it could easily be argued that, to the chagrin of professional gamblers, Las Vegas hotels, and the city in general, are increasingly coming to exemplify the Disney model. Las Vegas looks increasingly like a huge theme park and many of its large hotels are at least in part, theme parks. This is a trend that was begun several decades ago by Circus Circus and is epitomized, at least until it too is surpassed, by the MGM Grand. According to one expert on gambling, Las Vegas is [already] gambling's "Disney World."[2] While McDonald's itself has not been without influence in the tourist industry, it is Disney and its phenomenal success that has been most responsible for bringing the principles of McDonaldization (or of rationalization) to the tourist industry. Combining the two, perhaps we can talk, if the reader will

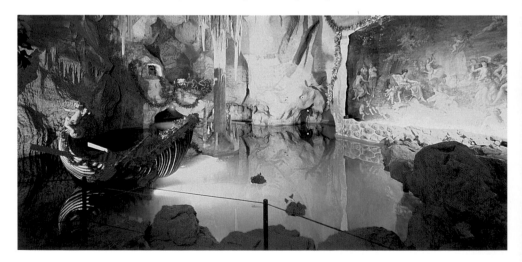

UNIVERSAL EXPERIENCE *Art, Life, and the Tourist's Eye*

excuse the creation of another, uglier neologism — "the McDisneyization" of the tourist industry.

Whatever its source, it is easy to argue that the tourist industry in general, and virtually every theme and amusement park in particular, has been McDisneyized, at least to some extent. Cruise ships are being McDisneyized, taking on the appearance of floating theme parks. (And Disney has its own cruise ship, the Big Red Boat, to take tourists to Disney World.) Beyond cruise ships, theme parks, and casinos, shopping malls have been

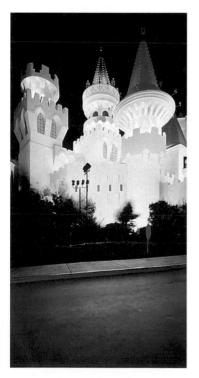

McDisneyized, coming to look more and more like amusement parks; the largest (Mall of America in Minneapolis and the West Edmonton, Alberta mega-mall) include rides, even roller coasters. One could extend this list much further, but the point is that through the influence of Disney theme parks, at least in part,

1 Alan Bryman, *Disney and his Worlds* (London: Routledge, 1995), p. 179.

2 J. Grochowski, "Vegas' Virtual Reality: The City of Illusion Keeps Gambling on Reinvention," *Chicago Sun-Times*, October 8, 1995.

Alexander Timtschenko
CLOCKWISE FROM UPPER LEFT
Treasure Island, 1997;
Caesars, Caesars, Caesars, 1997;
Excalibur II, 1999;
Tannhauser, 1998
See also p. 73.

 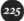

NL Architects (Pieter Bannenberg, Walter Van Dijk, Kamiel Klaasse, and Mark Linnemann; Dutch, b. 1959, 1962, 1967, and 1962)
Cruise City, City Cruise, 2003

Amsterdam-based NL Architects transforms the familiar into the unexpected. Their ongoing interest in mobility and transportation dates to their first "office" — the car in which they commuted together to and from Delft University of Technology in the early 1990s. Recently their research has focused on how cruise ships can integrate into the infrastructure of cities around the world. As part of this investigation into how the tourist industry is changing the appearance of the world around us, they create fantastic digital images such as these hybrid aircraft carriers transformed into floating amusement parks.

many aspects of the tourist world have been McDonaldized. Not only do these tourist attractions look more and more like Disney theme parks, but they come to embrace the four basic principles of McDisneyization and to generate new irrationalities of rationality. . . .

Accustomed to a McDonaldized lifeworld, many people appear to want:

Highly predictable vacations. They may not want to be in lock step with fellow tourists, but many want few, if any, surprises. One could argue that as our everyday life grows more and more predictable, we have less and less tolerance for, and ability to handle, unpredictable events. . . .

Highly efficient vacations. The same point applies here: accustomed to efficiency in their everyday lives, many people tend to have little tolerance for inefficient vacations. They tend to want the most vacation for the money (hence the popularity of cruises and package tours), to see and do as much as possible in the time allotted, and so on. . . .

Highly calculable vacations. Many people want to know in advance how much a vacation is going to cost and they abhor cost overruns. They also want to have itineraries that define precisely where they will be at a given time and for how long. Cruises, for one, typically have all of these characteristics and it is this that goes a long way toward explaining their booming popularity.

Highly controlled vacations. This can take various forms. For example, there is a preference for dealing with people whose behavior is tightly controlled by scripts . . . rather than with those who are free to behave as they wish. Disney parks are infamous for the tight control they exercise over not only how their employees behave, but how they dress, how long their hair and nails can be, what kinds of jewellery they may wear.

> **The traveler was active; he went strenuously in search of people, of adventure, of experience. The tourist is passive; he expects interesting things to happen to him. He goes "sight-seeing."**
>
> **Daniel J. Boorstin** *The Image: A Guide to Pseudo-Events in America*

UNIVERSAL EXPERIENCE *Art, Life, and the Tourist's Eye*

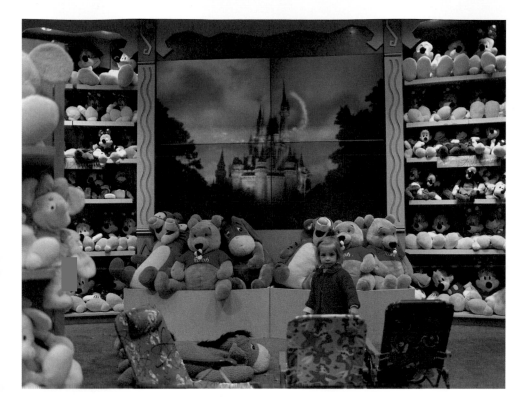

Louis Marin "Disneyland: A Degenerate Utopia," p. 54

Disneyland is a fantasmatic projection of the history of the American nation, of the way in which this history was concieved with regard to other peoples and to the natural world. Disneyland is an immense and displaced metaphor of the system of representations and values unique to American society.

This projection has the precise function of alienating the visitor by a distorted and fantasmatic representation of daily life, by a fascinating picture of the past and the future, of what is estranged and what is familiar: comfort, welfare, consumption, scientific and technological

ABOVE
Brian Ulrich (American, b. 1971)
Cleveland, OH, 2003

Ulrich photographs of malls, grocery stores, warehouses, and other commercial locations allow us to stop and notice these familiar places with a distant perspective. His recent photographs were taken at popular tourist destination shops such as the American Girl Place in Chicago. In this image, the young girl is effaced by the toys in the Disney store. Rather than celebrating the excitement of purchasing items, Ulrich captures people at moments when they appear lost and overwhelmed by the products that surround them.

progress, superpower, and morality. But this projection no longer has its critical impact: yes, to be sure, all the forms of alienation are represented in Disneyland, and we could believe Disneyland is the stage of these representations thanks to which they are known as such and called into critical question. But, in fact, this critical process is not possible in Disneyland in so far as the visitor to Disneyland is not a spectator estranged from the show, distanced from the myth, and liberated from its fascinating grasp. The visitor is on the stage; he performs the play; he is alienated by his part without being aware of performing a part. In "performing" Disney's utopia,

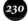 **UNIVERSAL EXPERIENCE** *Art, Life, and the Tourist's Eye*

the visitor realizes the models and the paradigms of his society in the mythical story by which he imagines his social community has been constructed.

Kevin Conley "How High Can you Go," p. 51.

Probably nobody has logged more coaster time than Richard Rodriguez, who has set so many world records for the longest coaster ride that the "Guinness Book of World Records" finally changed its rules. In 2000, he did two thousand straight hours, or more than eighty-three days, round the clock. To prepare for his marathons, Rodriguez pads out the car he'll ride

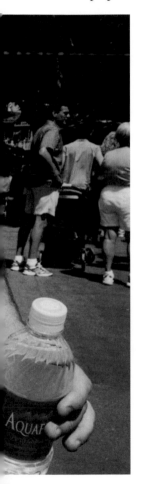

in. He sets up a curtain so that he can answer the calls of nature. He brings cream to avoid windburn, because at this point his marathons are "the equivalent of driving from Key West to northern Washington on a highway with your head sticking out the window," he said. "But one of the most difficult physical things is when you get five young girls riding in front of you and in back of you," he told me. "And what do they do when they go downhill? They scream. Have you ever heard a young girl or boy scream in unison when they're going down the hill, it's nasty. But screaming is a life passage. They've got to do it."

Jonathan Hernandez (Mexican, b. 1972)
Traveling Without Moving, 1998–2003
Chromogenic development print
mounted on aluminum
71 × 47¼ in. (180 × 120 cm)
Courtesy of the artist and Kurimanzutto, Mexico City

In his photographic series *Traveling Without Moving*, Hernandez focuses on paradigms of tourist behavior. Hernandez reverses the attraction to the tourists themselves, implicating himself among those he portrays. In this image, the fanny pack, Mickey Mouse t-shirt, and water bottle reflect a stereotypical outfit for Disneyland visitors while providing the basic tools for surviving an entire day in the Magic Kingdom.

IX *Authentic Misery*

The richest 20% of people in the world own 80% of its capital, a division that continues to widen. Some people of privilege travel to observe others' suffering, seeing such travel as an opportunity for transcendence. Others travel to experience war or poverty directly or to see sites of past traumas, which have often been sanitized and are now places of communal remembrance. These sites have the potential to reinvigorate our humanity, to inspire empathy with the less fortunate, or even to motivate us to work to help mitigate suffering. However, some tourists, upon observing tragedy and misfortune, seem merely to experience a voyeuristic arousal or a sense of superiority. The writings and artworks in this section explore tragic tourism of both the present and the recent past.

There is a new trend in travel: Intelligent people wanting to explore their world. A land devoid of fast food, hotels, tours, bus tours, concrete dinosaurs or even pay toilets. Before Thomas Cook invented the tour, people were hesitant to just head out and wander around. After all, it was dangerous out there. There were criminals, wars, disease, kidnappers . . . well, you get the point. . . .

[T]he truly interesting and educational things on this planet occur in areas of high-intensity living. Places where people warn you not to go. But let's go there expecting danger, not thinking we can get vaccinated against it.

Robert Young Pelton
The World's Most Dangerous Places

Elizabeth Diller + Ricardo Scofidio
Tourisms: suitcase Studies, 1991
Installation view
Mixed-media installation
Suitcases and fabricated ceiling
10 × 60 × 30 ft. (3 × 18.3 × 9.1 m).
See also p. 126.

233

Some of the first American tourists to Asia in the postwar period were the "advisors" sent by the U.S. military to Vietnam. We all know the results of that holiday in the sun. Today, the embedded reporters in Iraq have undertaken their own more virulent kind of tourism.

Douglas Fogle "The Occidental Tourist"

Robert Young Pelton *The World's Most Dangerous Places*, pp. 45–47

War zones are pretty easy places to understand, as are their players. . . . There are front lines, kill zones and safe zones, but before you get to stumble around in these you need to get in. . . . You want to play, you pay. War zones are the epitome of entrepreneurial start-ups. Everything from taxis to bottled water costs. . . .

But how do you get "in"? How do you actually meet up with the "rebels"? . . . Believe it or not, smart rebels usually have a press office in London, Paris or Washington with unlisted offices in Damascus, Tripoli or Khartoum. To get in, you need permission either from the rebels . . . or the government. . . . The rebels will give you a contact name, a place and time to show up, and a letter that just as likely will put you in jail. Naturally, when you show up there will be no one there to meet you and you will discover that you can just take a bus like everyone else does. It's all about rebels pretending to have infrastructure. . . .

HOW TO SURVIVE WAR ZONES
Remember that small wars are not carefully planned or predictable activities. More importantly, land mines, shells, stray bullets, and booby traps have no political affiliation or mercy. Keep the following in mind.

Contact people who have returned or are currently in the hot zone. Reliefweb is a good starting point. Do not trust the representations of rebels or government contacts. Check it out yourself.

Avoid politics, do not challenge the beliefs of your host, be firm but not belligerent about getting what you need. Talking politics with soldiers is like reading *Playboy* with the pope. Be aware of internal intelligence agents using you.

Do not engage in intrigue or meetings that are not in public view. They still shoot spies. Listen more than you talk. Getting to know your hosts is important.

UNIVERSAL EXPERIENCE *Art, Life, and the Tourist's Eye*

Travel only under the permission of the controlling party. In many cases you will need multiple permission from officers, politicians, and the regional commander.

Carry plenty of identification, articles, letters of recommendation and character references. They may not keep you out of jail, but they may delay your captors long enough for you to effect an escape.

Bring photographs of your family, friends, house, dog or car. Carry articles you have written or ones that mention you. A photo ID is important, letters with impressive seals are good, but even a high school yearbook can provide more proof of your existence.

Check in with the embassy, military intelligence, local businessmen and bartenders. Do not misrepresent yourself, exaggerate or tell white lies. Keep your story simple and consistent.

Dress and act conservatively. Be quietly engaging and affable, and listen a lot. Your actions will indicate your intentions as the locals weigh their interest in helping you. It may take a few days for the locals to check you out before they offer any assistance. Be aware that the people you are seen casually associating with could be the enemy of your host.

Remember that it is very unusual for noncombatants and nonjournalists to be wandering around areas of conflict without specific permission. If you are traveling, make sure you have the name of a person that you wish to see, an end destination and a reason for passing through.

Understand where the front lines are and the general rules of engagement, and meet with journalists and photographers (usually found at the hotel bar) to understand the local threats. Don't be surprised if NGOs are not thrilled to see you.

Carry a lot of money hidden in various places, and be ready to leave or evacuate at any time. This means traveling very light. Chose a place to sleep that would be survivable in case of a rocket or shell attack.

Visit with the local Red Cross, UN, embassy and other relief workers to understand the situation. They are excellent sources of health information and may be your only ticket out. They also are busy, so don't expect too much.

If warranted, buy and wear an armored vest or flak jacket. Carry your blood type and critical info (name country, phone, local contact, allergies) on a laminated card or written on your vest. Wear a Medic-Alert bracelet. Have evac insurance.

Carry a first aid kit with syringes, antibiotics, IV needles, anesthetics, and painkillers as well as the usual medication. It might be wise to use autoinject syringes. Discuss any emergency needs with your doctor in advance.

Understand and learn the effect, range and consequences of guns, land mines, mortars, snipers and other machines of war.

Get life and health (and KRE if relevant) insurance and don't lie. Tell them the specific country you will be traveling to. Also check with the emergency evacuation services to see if they can go into a war zone to pull you out.

Carry a military-style medical manual to aid in treating field wounds. Take a first aid class and understand the effects and treatment of bullet wounds and other major trauma.

Luc Sante "Tourists and Torturers," p. A23

So now we think we know who took some of the photographs at Abu Ghraib. The works attributed to Specialist Jeremy Sivits are fated to remain among the indelible images of our time.... It is arguable that without them, news of what happened within the walls of that prison would never have emerged from the fog of classified internal memos. We owe their circulation and perhaps their existence to the popular technology of our day, to digital cameras and JPEG files and e-mail. Photographs can now be disseminated as quickly and widely as rumors.

The pictures from Abu Ghraib are trophy shots. The American soldiers included in them look exactly as if they were standing next to a gutted buck or a 10-foot marlin. That incongruity is not the least striking aspect of the pictures. The first shot I saw, of Specialist Charles A. Graner and Pfc. Lynndie R. England flashing thumbs up behind a pile of their naked victims, was so jarring that for a few seconds I took it for a montage. When I registered what I was seeing, I was reminded of something. There was something familiar about that jaunty insouciance, that unabashed triumph at having

inflicted misery upon other humans. And then I remembered: the last time I had seen that conjunction of elements was in photographs of lynchings.

Like the lynching crowds, the Americans at Abu Ghraib felt free to parade their triumph and glee not because they were psychopaths but because the thought of censure probably never crossed their minds. In both cases a contagious collective frenzy perhaps overruled the scruples of some people otherwise known for their gentleness and sympathy. . . . The Americans in the photographs are not enacting hatred; hatred can coexist with respect, however strained. What they display, instead, is contempt; their victims are merely objects.

You might have heard about the strings of human ears collected by some soldiers in Vietnam, or read the story, reported in *Life* during World War II, about the GI who blithely mailed his girlfriend in Brooklyn a Japanese skull as a Christmas present. And the concept of the human trophy is not restricted to warfare, but permeates the history of colonialism, from the Congo to Australia, Mexico to India.

That prison guards would pose captives — primarily noncombatants, low-level riffraff — in re-enactments of cable TV smut for the benefit of their friends back home emerges from the mode of thinking that has prevented an accounting of civilian deaths in Iraq since the beginning of the war. . . .

The possible consequences of the Abu Ghraib archive are numerous, many of them horrifying.

Robert Young Pelton *The World's Most Dangerous Places,* pp. 62–63

TERRORIST PLACES
There is no simple advice to give on how to avoid being the victim of a terrorist attack. A random bomb attack or murder attempt is simply the most devastating, sickening thing a human can survive. It doesn't make sense; it's evil and inspires terror in anyone that reads about it. . . . It's not pretty. And you don't forget.

HOW TO SURVIVE TERRORIST PLACES
There is no real epicenter to terrorism against travelers. Terrorists will seek you out wherever they can. Here are at least a few pointers.

 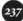

Terrorism is not about killing people, but about dispersing the threat of death by producing frightening images.

Mark Wigley "Insecurity by Design"

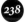

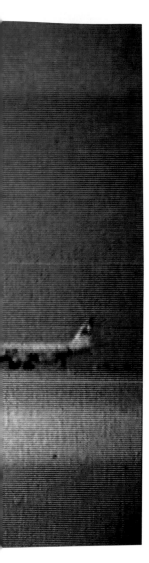

Understand what is going on in the world. The OSAC database, Real World Rescue and other free security news sources are ideal.

Don't assume our government has any idea of when and where attacks will happen. They have very poor intelligence inside fundamentalist groups. State Department information is not specific and should be regarded as simply warnings.

Highly touristed areas in countries with poor security are ideal for attacks. There are over two dozen groups actively seeking to harm Americans or our interests.

Don't confuse crime with terrorism, military actions with murder, or rebel groups with terrorist groups. Terrorism is directed against innocent people without warning. That usually *includes* you.

Stay away from group tours, expat hangouts, pre-planned political events and U.S.-related businesses, hotels, and installations.

LEFT
Johan Grimonprez (Belgian, b. 1962)
Dial H-I-S-T-O-R-Y (still), 1997

In the disturbing video *Dial H-I-S-T-O-R-Y*, Grimonprez chronicles several airplane hijackings from the 1950s to 1990s, incorporating news footage and interviews with victims. This image from the film shows three hijacked jets on a desert airstrip in Amman, Jordan on September 12, 1970. Viewing this 1997 film in a post–September 11, 2001 world amplifies its horror while reminding the viewer that the current, heightened fear of terrorism and air travel is not new for many around the globe.

Principal Sources of Refugees

(as of December 31, 2003)
U.S. Committee for
Refugees and Immigrants
World Refugee Survey 2004

This table shows the countries that have produced the greatest numbers of refugees and asylum seekers. It is derived from data on individuals granted asylum during the year and with pending asylum claims at year's end. It does not include persons granted permanent status (or who, in USCR's view, are well on their way to receiving such a status) in another country. The figures are rounded and often understate the totals.

Former Palestine	3,000,000*
Afghanistan	2,500,000*
Sudan	600,000
Myanmar	586,000*
Congo-Kinshasa	440,000
Liberia	384,000*
Burundi	355,000
Angola	323,000*
Vietnam	307,200
Iraq	280,600*
Eritrea	280,000*
Somalia	277,000
Colombia	233,600
Croatia	209,100
Western Sahara	190,000*
China	157,500
Bosnia and Herzegovina	142,200
Bhutan	128,700
Sri Lanka	105,700
North Korea	101,700*
Serbia and Montenegro	70,100
Sierra Leone	68,000
Tajikistan	59,800
Philippines	58,500
Côte d'Ivoire	55,000
Russia	49,000
Rwanda	46,000*
Central African Republic	41,000
Turkey	40,000
Nigeria	39,000
India	35,800
Iran	35,000
Cuba	28,200*
Uganda	28,000
Haiti	25,800
Georgia	25,000
Indonesia	23,600
Mauritania	23,000
Pakistan	21,000
Mexico	20,700
Congo-Brazzaville	20,000
Ethiopia	19,000
Cambodia	16,100
Laos	15,000
Senegal	13,000
Ghana	12,000
Guatemala	11,600
Ukraine	11,200

** Sources vary significantly.*

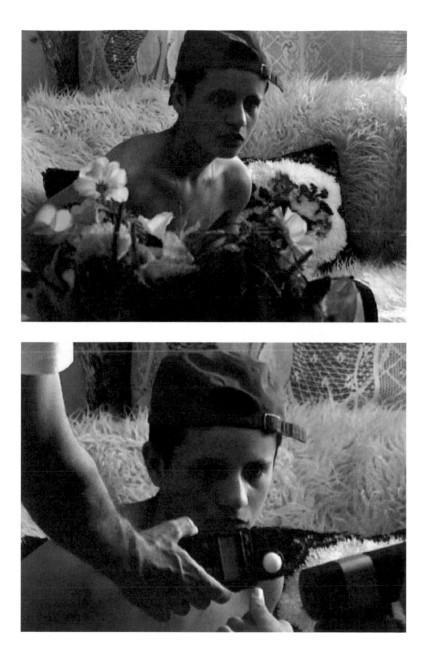

Robert D. Kaplan *From Togo to Turkmenistan, From Iran to Cambodia —
A Journey to the Frontiers of Anarchy*, pp. 419–420

Graham took me to Tuol Sleng, a school in the heart of Phnom Penh that
the Khmer Rouge had converted into a prison and torture facility after they
emptied out the city. Experts estimate that between sixteen and twenty thou-
sand persons passed through Tuol Sleng between 1976 and early 1979. Except
for six known cases, none came out alive. After the Vietnamese liberated
Phnom Penh and opened the prison to the public, comparisons between
Tuol Sleng and Auschwitz and Dachau were inescapable. . . . Almost all the
victims of Tuol Sleng were them-
selves Khmer Rouge, or relatives
of Khmer Rouge, who fell afoul of
party doctrine at a time when that
doctrine, in addition to chang-
ing almost daily, was actually
known only to a select and in-
creasingly paranoiac inner circle
that included Pol Pot and Khieu
Samphan.

> [T]he "reconstructions" that now stand in for the Auschwitz experience mean that the tourist is encountering a simulacrum, a fiction, that he names, perhaps too flippantly, "Auschwitzland."
>
> **Griselda Pollock** "Holocaust Tourism: Being There, Looking Back, and the Ethics of Spatial Memory"

But Tuol Sleng was different
from Auschwitz and Dachau in a
more important way. Auschwitz
and Dachau had been converted into museums. They had been sanitized by
Western curators with heating and air-conditioning, polished-glass display
cases, stage lighting, museum shops, and modern toilets for the visiting
public. Tuol Sleng had gone through no such sterilization process. The dis-
play cases were crude. It was miserably hot. Rats scavenged in the hallways
and wretched toilets. I saw dust balls, spiderwebs, and dried blood splattered
on the peeling walls. For all I knew, the Khmer Rouge might have left yes-
terday. The building, with a wire net stretched over the balconies so that tor-
ture victims could not commit suicide, had literally been left as it was. The
smells of human feces, human sweat, and dead flesh had been erased — that
was the only difference. In such a setting, the sight of chains, fingernail and
nipple pliers, and photographs of young women with swollen and black-
ened eyes achieve an effect that you do not find in Europe's particular hells.

Nine miles south of Phnom Penh was Choeng Ek, a Khmer Rouge ex-
termination site where 129 mass graves holding 8,985 corpses of men,

women, children, and infants had been unearthed. Choeng Ek was the original killing field from which the film got its name. The drive from Phnom Penh through flat paddy fields graced by swaying sugar palms was reminiscent of the film footage. Water buffaloes meandered over the grave pits. White water-lilies dotted nearby wetlands.

Two tomato-colored tour buses pulled up. One unloaded a group of Thais and the other a group of Greek tourists. The groups looked alike: prosperously middle-class, with expensive cameras, sunglasses, and "casual" clothes. Each group contained the usual one or two shouters, fifty-year-old men who acted like teenage boys. The shouters insisted on being photographed while holding one of the bleached human limbs lying about. Some of the Thais and Greeks appeared uncomfortable about this, and remained quiet. But by the time both tour buses departed, everyone was back in good cheer. This year Cambodia, next year Hawaii.

Lucy R. Lippard Excerpt from "Tragic Tourism," in *On the Beaten Track: Tourism, Art, and Place*, pp. 118–120 and 122

What are we to make of the popularity of such tourist targets as celebrity murder sites, concentration camps, massacre sites, places where thousands have been shot down, swept away in floods, inundated by lava, herded off to slavery, crushed by earthquakes, starved to death, tortured, murdered, hung, or otherwise suffered excesses the rest of us hope we will never experience? Are these our sacred sites? Are we drawn to such places by prurience, fear, curiosity, mortality (there but for the grace of god go I), or delusion (it *can't* happen to me)? Or have we been blindly conditioned and sold a blockbuster bill of goods, convinced that it is not only all right but socially responsible to wallow in others' miseries? That it is "respectful" to follow the paparazzi to Diana's grave, simultaneously imitating and vilifying them?

At these tragic sites, these vast memento mori, we can contemplate mortality and evil. We can pay homage to those less fortunate than we have been (so far), enjoying vicarious restitution for our relatively good luck, a knock on wood that it continue. Yet however high-minded our approaches, the insidious elements of voyeurism and sensationalism will creep in. Tourists visit such sites to get a whiff of catastrophe, to rub a bit closer against disaster than is possible in television, movies, or novels — although the imagination has to work a little harder when confronted with the blank terrains, the empty rooms, the neatly mowed lawns, the negligible remains of real tragedy.

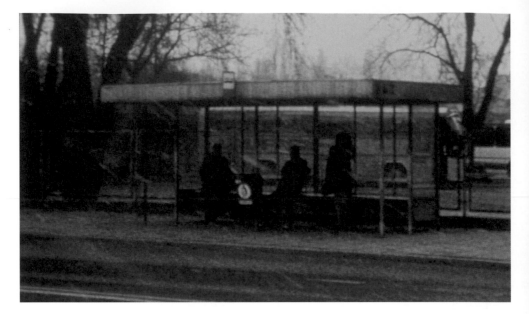

Tragic tourism, more than any other branch of the industry, raises the question of motivation. Tourism in general gets its bad name — travel in search of the sensational or the merely entertaining — from motives that are virtually unmeasurable, generally by those who presume their own to be purer or "higher." We have no way of knowing what other people are feeling when they visit those redolent places. False reverence may be paraded; deep sadness may be hidden.

The conflict between spectacle and engagement is heightened at the site of tragedy, mediated by awe if the site itself is visually overwhelming. If people travel to find what is missing in their daily lives, the grandeur of catastrophe and cataclysm is, oddly, right up there near the head of the list, along with adventure and hedonism. . . .

Even as some tourists relish the tragic, others prefer not to be exposed to it, aided by a national propensity to denial that endows tragic tourism with a social mission. The Ellis Island Immigration Museum recently agreed, after some hesitation, to display three (out of fifteen) graphic photographs of the mass murders of Armenians by Turks; they had been suppressed as "too gory and gruesome" for public consumption. . . .

Historical tours are billed as educational fun but can equally function as anecdotes to the onset of amnesia, which is perhaps the ultimate tragedy.

The closer we are to forgetting, the closer to the surface of events and emotions alike, the further we are from the depths where meaning and understanding reside. Public memorials and visited sites are the battlegrounds in a life-and-death struggle between memory, denial, and repression.

In recent times, few greater tragedies have overtaken the western nations than the genocide of six million Jews during World War II, accompanied by the murders of antifascist resisters, homosexuals, gypsies, and people with disabilities. Thousands of monuments to the Holocaust have been erected all over the world, and there are hundreds of museums and institutions devoted to this tragedy, which has come to represent (and overshadow) all human inhumanity in the modern mind. These monuments attract some 900,000 people annually to Dachau, 750,000 to Auschwitz, 600,000 to the Anne Frank House, 1,250,000 to Yad Vashem in Jerusalem. Many of these people are perhaps better defined as "pilgrims" than as "tourists." James Young observes that "it seems likely that as many people now visit Holocaust memorials every year as died in the Holocaust itself."[1]

All known tragic sites are heavy with associations and fantasies. Unpeopled places marking the sites of human tragedy must be repeopled by visitors who, if they are open and attuned enough, become surrogates for the absent, the commemorated. Each tragic site has a different impact on different groups and individuals. . . . Each site also has its own local context and character, its own landscape. The subtleties lie in gauging the power of what remains, physically and informationally. Is a neatly restored torture chamber more impressive than a poignantly deteriorating ruin? Can we picture better what it was like to be there through detailed documentation, or through our own imaginations piqued by place? For me, an empty field with a forlorn weathered marker is more evocative than an

> OPPOSITE
> **Darren Almond** (British, b. 1971)
> *Oswiecim, March 1997* (still), 1997
>
> Almond filmed two bus stops in Auschwitz to infer the effect of time during the horrific tragedies that took place there during World War II. One of the bus stops is filled with tourists waiting to go to the concentration camp museum, the other takes people to the outskirts of the small town. The black-and-white film runs at a painfully slow pace, allowing viewers to contemplate the history of the site while watching people wait for a bus that never arrives — a metaphor for the rescue that never arrived for the millions interred in the camps.

1 James Young, "It Seems Likely," in *The Texture of Memory: Holocaust Memorials and Meaning* (New Haven, Conn: Yale University Press, 1993), p. x.

antiseptically manicured lawn with an elaborate monument. The weed-choked Jewish cemeteries in Poland may be more poignant because their neglect continues as testimony to an antisemitism that colors Polish memories of World War II, a bias that still echoes the conditions of the war itself.

"To the extent that we encourage monuments to do our memory-work for us," writes Young, "we become that much more forgetful. In effect, the initial impulse to memorialize events like the Holocaust may actually spring from an opposite and equal desire to forget them." Commemorative structures, often pompous and inadequate to the occasion, inspire secondary memories that can color or even interfere with responses to the primary event. When an emotionally riveting site is visited with a crowd, the surrounding company can be a turn-off or a turn-on. If the responses of others are reverent, emotional, respectful, an ambiance arises within which one feels those emotions oneself (unless, of course, sentiment disgust you). If the responses of others are noisily casual, disinterested, or even insulting, unrelated anger can overcome homage and melancholy. If the mood of disrespect is contagious, the site or event can slip from one's grasp. The inevitable hermeticism of a tragic site is matched by a silence that is often the most appropriate response. But there's often also something to be said for the sounds of children whooping it up in a blissful ignorance around a field of graves.

Certainly the journey's rhythm counts; it is far more mind-boggling to come suddenly upon a massacre site than to arrive after lines of highway billboards have bragged and begged for visitors. Is this a side trip or a pilgrimage? Is the tragic site sandwiched between a picnic and a theme park, caught on the run during a work trip? Are our ties to it powerful enough to disrupt business as usual? Tourists, or those consuming the sites, are not always from elsewhere. To what extent should the local, everyday audience be taken into consideration? Their responses are bound to be different from those arriving for the first time. Does proximity breed indifference? The constant reminder is one quiet but powerful local strategy. In the wake of revelations about the hording of Jewish money in Swiss bank accounts, for instance, a proposal was made to put historical plaques on all apartments and all museum-housed art works stolen from Jews who died in the Holocaust, detailing the life and fate of the lost owner. Maybe the banks should be marked as well. Remembrance is the only way to compensate the dead.

 UNIVERSAL EXPERIENCE *Art, Life, and the Tourist's Eye*

Eeva Jokinen and Soile Veijola "The Disoriented Tourist: The Figuration of the Tourist in Contemporary Cultural Critique," pp. 47–48

The sextourist criss-crosses the globe to get sexual and emotional satisfaction with the help of women (to a lesser extent, men) of another ethnicity, often to avoid social and moral consequences in his own culture. Some sextourists return to the same places many times, but, on the other hand, "other places beckon, not tested yet, perhaps more hospitable, certainly able to offer new chances. . . . If natives cease to amuse, one can always try to find the more amusing ones."[1]

To all practical purposes of a theory, the sextourist is, by definition, a man. (By definition but not by term, which, not surprisingly, masks the sexual division implied in the phenomenon.) If international sextourism had to do (only or mainly) with women's economy of desire, there would, most probably, be no such institution (even if there are individual women and groups of women out there practising sextourism). As a worldwide, institutionalised phenomenon, sextourism deals with the male imaginary and, consequently, stands out as a solid support of the masculine symbolic order. . . .

Is the sextourist "a gypsy of his own language" — if we were to imagine, for a moment, his own language as the unsensual (as is often claimed) and guilt-ridden sexuality and body culture of the Western culture? No, the sextourist is no gypsy since his "immigrance"— sextourism — does not estrange him from his own language. His language is,

> **Throughout the world and throughout history, women have been the medium of connection between men of different groups, as institutionalized in the practices of exogamy and prostitution.**
>
> **Eric J. Leed** *The Mind of the Traveler: From Gilgamesh to Global Tourism*

1 Z. Bauman, "Från pilgrim till turist (From Pilgrim to Tourist)," *Moderna Tider* (September 1994), pp. 20–34.

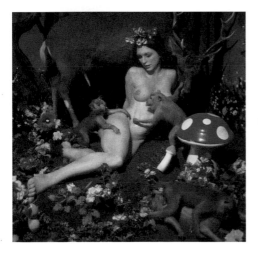

Kyoichi Tsuzuki
Hokkaido Erotic Museum, 1994
See also p. 84.

and continues to be, the master's language and he, home and abroad, speaks it from a singular position of interlocution without providing a position for an equal partner of another sex. By speaking his own language in new places he turns continents, cities, neighbourhoods and women into the "body-matter" of prostitution. The printed version of this "body-matter" is, then, called (the "universal" language of) pornography. . . .

One could also argue that the sextourist is not an ethical or moral subject who is responsible for the abuse of Third World women, since "everybody does it".[2]. . . Indeed, in defence of the sextourist it can be said that the vast pornographic literature of sexual encounters presents him as he/it, as a third person statement. . . . In the sex business, no man — himself — is responsible. . . .

Indeed, being a tourist more generally can be defined as having or taking no responsibility for the social situation one is a part of.

Jacob Holdt *American Pictures: A Personal Journey through the American Underclass,* p. 14

I hope that the [images] will make young Americans rediscover their fantastic country — not as a series of postcards seen from sterile campers, but through being together with their beautiful fellow citizens. Especially I hope that it will get some of the millions of young unemployed people in Europe as well as America to start vagabonding in order to study the society that has made them unemployed. To be a vagabond — contrary to popular belief — is the very opposite of being a parasite. Not only do you voluntarily withdraw from the labor force, allowing the few available jobs to go to those whose need is greater than your own — especially older workers, who tend to disintegrate without their job identity — but the vagabond also withdraws from any claim to welfare or unemployment benefits from fellow citizens. But most importantly, vagabonding is capable of fulfilling a vital role within modern society: attending to the emotional needs of the poor and lonely.

As a vagabond you soon discover that the worst thing is not your fear of other people, but other people's fear of you. When you have seen drivers' fear of you as a vagabond, you begin to understand for instance how difficult it must be to be black in a white society. Your own fear of people can be overcome, because it is irrational and unfounded in reality, but you are powerless in the face of other people's fear of you: it immediately locks you

2 Bauman, "Från pilgrim till turist (From Pilgrim to Tourist),"
Moderna Tider (September 1994), p. 242

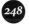

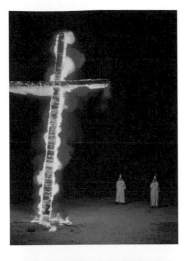

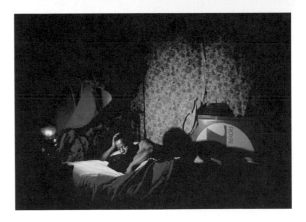

Jacob Holdt (Danish, b. 1947)
American Pictures, 1981–1991

Holdt personified the idea of the solitary wanderer as
a vagabond in the 1960s when he came from Denmark to
hitchhike around the U.S. Befriending drug addicts, prosti-
tutes, businessmen, and poor families, he took snapshots to
document his experiences. Holdt has only recently begun
to exhibit his social documentary photographs in museums.
Previously this collection of images existed only as a narrated
slide presentation called *American Pictures*, in which Holdt
expressed his concerns about racism and poverty in
this country. The images, taken forty years ago during the
civil rights era, question Holdt's position as a European man
coming to the U.S. to document a poor and mostly black
culture of which he is not a part, suggesting parallels
to artists such as Larry Clark, Diane Arbus, and Nan Goldin,
who also developed relationships with their subjects.

up in a ghetto. Therefore start small. Invite every single hitchhiker or tourist
home, not to speak of others who have a need for a roof over their heads or
human togetherness. You will discover that they are far more interesting
than books like this one. And if you already have all your floor space filled
up or for other reasons are not able to have them staying with you, then
please send them to me.

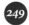

X *The Universal Hom*

Syndrome

Piotr Uklanski (Polish, b. 1968)
Untitled (John Paul II), 2004

As the representative of Poland to the 2004 São Paulo Biennial, Uklanski chose to empha-size the relationship between Poland and Brazil by creating an aerial view portrait of Pope John Paul II (Karol Wojtyla, who is also Polish) through arranging 3,500 Brazilian soldiers into the shape of the Pope's profile. While the people of Brazil and Poland are traditionally Catholic, the Pope is in many ways a universal symbol of different cultures unifying under a common faith. See also p. 172

Few people have traveled to all of the places they wish to visit, and while some dream of travel, many dream of home. Still others — cos-mopolitans — create a home wherever they go. The art-works and writings in this section reflect upon the often irrational urge for travel, along with society's conflicting definitions of the exotic, foreign, and universal.

In the archetypical story of the hero, prevalent in various cultures, the individual leaves his or her home for an adventure. In this journey — which is often per-ceived as a test or an initiation — the hero faces a challenge and consequently achieves a new level of awareness, skill, or even rebirth. Forever changed by the experience, the individual's worldview is altered and transformed. Through this transformation, the hero returns home with enhanced abilities for the commu-nity's benefit. This recurring quest can be interpreted either as a desire for internal, personal fulfillment or on a societal level as an attempt by a particular culture to understand and integrate the foreign and the other into an understanding of universal existence.

Ian Hacking *Mad Travelers: Reflections on the Reality of Transient Mental Illnesses,* pp. 7–8, 21, 27–30, and 81–82

THE FIRST FUGUEUR

It all began "one morning last July when we noticed a young man of twenty-six crying in his bed. . . . He had just come from a long journey on foot and was exhausted, but that was not the cause of his tears. He wept because he could not prevent himself from departing on a trip when the need took him; he deserted family, work, and daily life to walk as fast as he could, straight ahead, sometimes doing 70 kilometers a day on foot, until in the end he would be arrested for vagrancy and thrown in prison."[1] . . .

The young man's name was Albert; he was an occasional employee of the local gas company, and the first fugueur. He became notorious for his extraordinary expeditions to Algeria, Moscow, Constantinople. He traveled obsessively, bewitched, often without identity papers and sometimes without identity, not knowing who he was or why he traveled, and knowing only where he was going next. When he "came to," he had little recollection of where he had been, but under hypnosis he would recall lost weekends or lost years.

Medical reports of Albert set off a small epidemic of compulsive mad voyagers whose epicenter was Bordeaux, but which soon spread to Paris, all France, Italy, and, later, Germany and Russia. Fugue became a medical disorder in its own right. . . .

Overhearing a place-name, Albert felt compelled to set out. At some point he was astonished at where he had got to, often destitute, sometimes arrested. . . . Thus once someone spoke of Marseille; when he got there, people talked of Africa,

1 Philippe Tissié, *Les Aliénés Voyagerus* (Paris: Doin, 1887), p. 3.

In Islam, and especially among the Sufi Orders, *siyahat* or "errance" — the action or rhythm of walking — was used as a technique for dissolving the attachments of the world and allowing men to lose themselves in God. The aim of the dervish was to become a "dead man walking": one whose body stays alive on the earth yet whose soul is already in Heaven. A Sufi manual, the *Kashf-al-Mahjub*, says that, towards the end of his journey, the dervish becomes the Way not the wayfarer, i.e. a place over which something is passing, not a traveler following his own free will.

Bruce Chatwin *The Songlines*

UNIVERSAL EXPERIENCE *Art, Life, and the Tourist's Eye*

so he took ship for Algeria, where he had numerous adventures and in some desperate place, was counseled by a Zouave to go home. . . .

In every parting there is a latent germ of madness.

Johann Wolfgang von Goethe

Tissié . . . describes Albert . . . as suffering from "pathological tourism.". . .

[The 19th century] is the era of popular tourism, epitomized in the English-speaking world by the company that ran the business of touring Europe and the Levant for many years: Thomas Cook and Son. We are not talking about the grand tours of British aristocrats, county landowners, or American figures in the novels of Henry James. I refer to tourism for the masses. Cook began by hiring railway coaches to take evangelicals to temperance meetings. In the second half of the nineteenth century, Cook's tourists, as they were called, were everywhere. We are talking about seven million tickets a year by the end of the century. . . .

The great era of building popular tourist hotels was in full swing. You can chart the expansion of Switzerland as a destination simply by the hotels completed year by year – and yes, in 1882 . . . Albert found a friend who talked about Switzerland, filling Albert with an obsession to go there, which he did.

Travel was not only for Cook's tourists. Travel was rebellion, poetry. Flaubert's orientalism, trips to Egypt, Salammbô. . . . Baudelaire penned some of his fantasies from a Bordelais balcony and embarked from the port of Bordeaux itself. Can we see Arthur Rimbaud (1854–1891) as fugueur? Mad? . . . He did himself often speak of *fugue*, meaning the word in its ordinary sense, "flight." His flights took him to places even more exotic than Albert's, even to the heart of Ethiopia, and they took place about the same times as Albert's fugues. . . .

Jules Verne (1828–1905) captured the minds of whole generations with his trips to the center of the earth, to the moon, to the bottom of the sea, and (when Albert was thirteen years old) around the world in eighty days. This is the golden era of travel journalism, Robert Louis Stevenson with a donkey in the Cévennes or describing the new vineyards of Napa and Sonoma, whose rootstock was the savior of the ancient but infected grapes of Bordeaux. There is Mark Twain at one end of travel writing and Karl Baedeker at the other. . . .

 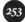

Albert fascinates some of us because travel has become part of the learned life and of middle-class life in general. But more than tourism hovers in the background. The "voyage" is our metaphor for self-discovery. Michel Montaigne — mayor of Bordeaux, 1581–85 — created the genre that we call the essay, but he also, in a small way, contributed to another genre, the travel diary. Montaigne was a driven traveler, seeking out health, or at least relief from the crippling pain of gallstones. . . . Travel, for Montaigne, was not exactly flight, but it was escape, a way stage between one set of *Essays* and the next.

The idea of life as a journey was cemented for the English reader by *Pilgrim's Progress*. The reader of German will invoke Goethe in Italy. Montaigne, Bunyan, Goethe: these are not just accounts of travel but epigones for their respective cultures. The trip is a many-faceted symbol for our moral consciousness, sometimes positive, but also negative, as in that great amorality play, contemporary mass tourism, whose destination is 10 percent cathedrals, 20 percent eating, and 70 percent shopping

You can read Albert in so many . . . ways precisely because travel signifies so much in the whole of Western civilization, from the *Odyssey* to outer space, with much else, including John Bunyan's soul, packed in between. . . .

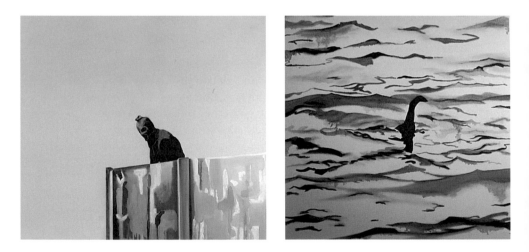

Fugue perfectly fitted between two social phenomena that loomed very large in contemporary consciousness: romantic tourism and criminal vagrancy, one virtuous, one vicious. Both were deeply important to the middle classes, because one stood for leisure, pleasure, and fantasy escape, while the other stood for fear of the underworld. So fugue, as a phenomenon, was not interesting to ordinary people who did not go on meaningless and compulsive trips, people who could control their fantasies or indulge in them. It was an option that for the less fortunate lay between affluence and crime.

Eeva Jokinen and Soile Veijola "The Disoriented Tourist: The Figuration of the Tourist in Contemporary Cultural Critique," p. 37

The most striking and off-putting trait of strangers is that they are *neither* neighbours nor aliens. Or, rather – confusingly, disturbingly, terrifyingly – they are (or may be – who knows) both. Neighbourly aliens. Alien neighbours. In other words, *strangers*. That is, socially distant yet physically close. The aliens within physical reach. Neighbours outside social reach. Inhabitants of no man's land – a space either normless or marked with too few rules to make orientation possible. Agents and objects of an intercourse which for that reason is doomed to remain disconcertingly erratic, hazardous, with no assurance of success. Intercourse with the strangers is always an incongruity. It stands for the paucity or incompatibility of the rules which the non-status or confused status of the stranger invokes.[1]

OVERLEAF
Thomas Schütte (German, b. 1954)
Ganz Grosse Geister (Big Spirits XL), 2004

With these giant effigies of amorphous beings that recall the rotund icon of travel guides, the Michelin man, Schütte challenges statuary traditions, giving mass and presence to vaporous beings. The three chimeric figures reflect a world of imagination, filled with aliens, ghosts, and goblins.

Julia Kristeva "By What Right Are You a Foreigner?" pp. 39–40

Who is a foreigner?

The one who does not belong to the group, who is not "one or them," the other.

If one goes back through time and social structures, the foreigner is the other of the family, the clan, the tribe.

Within the crowd of foreigners — on the increase in the contemporary world — who either do not wish or cannot either become integrated here or return where they came from, a new form of individualism develops: "I

1 Z. Bauman, *Postmodern Ethics* (Oxford: Blackwell, 1993) pp. 153–54.

 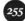

belong to nothing, to no law, I circumvent the law, I myself make the law." This stance on the part of the foreigner certainly arouses the unconscious sympathy of contemporary subjects — unbalanced, wanting everything, dedicated to the absolute, and insatiable wanderers.

In that sense, the foreigner is a "symptom" (Danèle Lochak): psychologically he signified the difficulty we have of living as an *other* and with others; politically he underscores the limits of nation-states and of the national political conscience that characterises them and that we have all deeply interiorised to the point of considering it normal that there are foreigners, that is, people who do not have the same rights as we do.

Victor Segalen *Essay on Exoticism: An Aesthetics of Diversity*, pp. 61, 64, 67, and 68

Of Exoticism. . . . Its universal power: if I place Exoticism at the center of my vision of the world, if I take pleasure in seeking it, exalting it, creating it when I cannot find it, signaling its existence to those who are worthy of it and who are on the lookout for it — those who are worthy of it and who did not have an idea of it — it is not because Exoticism is a unique aesthetic force, but because it is a fundamental Law of the Intensity of *Sensation*, of the exaltation of Feeling, and therefore of living. It is through Difference and in Diversity that existence is made glorious.

When I conceived of this, I thought it was simply a "way of seeing," my own; and I took on the task of simply conveying the way the world seemed to me in its most favorable aspect: in its diversities. . . .

UNIVERSAL EXPERIENCE *Art, Life, and the Tourist's Eye*

But certain ideas that are the result of certain general observations . . . lead me to grant my theory of Exoticism greater general validity. . . . And I now realize, in this state of Solitude, that it is much more vast than I first thought; and that it encompasses — whether they wish it or not — ALL MEN, MY BROTHERS — WHETHER I WISH IT OR NOT.

It is in seeing how diverse values tend to intermingle, to come together, to become defiled, that I understood how all men were submissive to the Law of Exoticism. It is because of the Debasement of Exoticism on the surface of the Earth that I resolved to convene all men, my brothers — so that they will feel it a little, this law, which I first thought to be only a personal aesthetics. . . .

The exotic Tension of the World is decreasing. Exoticism, a source of Energy — mental, aesthetic, or physical (though I do not like to mix levels) — is on the wane.

— The means of Wearing Down Exoticism on the surface of the Globe: everything we call Progress. The laws of applied physics; mechanical modes of travel making people confront each other, and — horror — intermingling them, mixing them up without making them fight each other. . . .

— But, perhaps, in some other parts of the Universe, new Diverse worlds are coming into existence . . .

NTUGIRE UBWOBA
No TENGAR MIEDO
No tengas miedo ! HE БОJ CE
نترس
|No tengas miedo !
Ma bęrıı
nebaides ! Vær
КОРЫ Я ПА
N
小市から ないで
Var inte rädd !
U se tšabe
No tengas miedo
Mrwigira ubwoba
Nu ai teamã
Dừng sợ ! ÄRA KARD
Bui rgad, bui het
لا تخف
Qait be afraid
Sala mbeto pepe
Usiogope
NE BOJ SE ! डरो नहीं

— The first voyage around the world must have been the most disenchanting. Luckily, Magellan died before his return. As for his pilot, he simply completed his task without worrying about that horrific thing: there was no longer an utter Remoteness in the world! . . .

To this day, the word *Exoticism* has hardly been more than a synonym for "impressions of faraway lands," of climates, of foreign races; and too often misused by being substituted for that word, which is yet more compromised, "colonial." . . .

I agree to call "Diverse" everything that until now was called foreign, strange, unexpected, surprising, mysterious, amorous, superhuman, heroic, and even divine, everything that is

Qorxma
edd
OJ SA
যো না
Mos ki friké
Eaunt nit!
Nduwawie
JANGAN TAKUT
Ekki vera hrædd
ino tila
No Tengas Miedo
Don't be afraid
لا تخف
YY AЙ
Nm temere
Nu te teme
Não Tenha Medo
Nemij strad
as miedo
'Aua le fefe
Sa mataku
TIBZAX
OUA TEKE ILIFIA
ASUSTADO
لا تخف
Лatapceл.
Не-страху
Hal keiu kyst
Huwag Matakot
No tenga temor
لا تخف
Don't be afraid
Ko Banga Te!

other; — that is to say, in each of those words, emphasize the dominance of the *essential* Diversity that each of those terms harbors *within it*.

I continue to give to the word "aesthetics" its specific meaning, which is that of an exact science that the professional thinkers have imposed upon it and which it retains. It is at once the science of spectacle and the beautification of spectacle; it is the most marvelous tool of knowledge. It is knowledge which cannot be and should not be anything but a means, not of all the world's beauty, but of that aspect of beauty that each mind, whether it wants to or not, retains, develops, or neglects. This is the appropriate vision of the world.

For in searching instinctively for Exoticism, I have sought Intensity, Power, that is, life.

When asked where he came from, Socrates said not "From Athens" but "From the world."

Eric J. Leed *The Mind of the Traveler: From Gilgamesh to Global Tourism*

List of works

Current at the time of printing. Subject to change. Works marked with an asterisk are not included in the Hayward Gallery showing.

Vito Acconci p. 158
(American, b. 1940)
Lives in Brooklyn,
New York

*Convertible Clam
Shelter,** 1990
Fiberglass, clamshells,
steel, rope, lights, and
sound equipment
Closed: 48 × 120 × 96 in.
(121.9 × 304.8
× 243.8 cm)
Installed dimensions
variable
Collection Museum
of Contemporary Art,
Chicago, gift of Camille
O. Hoffmann

Doug Aitken p. 129
(American, b. 1968)
Lives in Los Angeles

the moment, 2005
Video installation with
11 plasma screens and
mirrors (16 mm film
transferred to digital
video player)
Dimensions variable
Collection of Donna
and Howard Stone,
courtesy of 303 Gallery,
New York

Darren Almond p. 245
(British, b. 1971)
Lives in London

Oswiecim, March 1997,
1997
Two 8mm parallel films
with sound transferred
to DVD
6 minutes, 30 seconds
Courtesy of Matthew
Marks Gallery, New York

Nikolay Bakharev
p. 219
(Russian, b. 1946)
Lives in Novokuznetsk,
Russia
All works are from
Relationship Series and
are courtesy of Regina
Gallery, Moscow

No. 35, n.d.
Gelatin silver print
11 7/8 × 11 7/8 in.
(30.2 × 30.2 cm)

No. 15, 1983
Gelatin silver print
11 13/16 × 11 11/16 in.
(30 × 29.8 cm)

No. 20, 1984–86
Gelatin silver print
11 13/16 × 11 15/16 in.
(30 × 30.3 cm)

No. 25, 1984–86
Gelatin silver print
11 13/16 × 11 7/8 in.
(30 × 30.2 cm)

No. 7, 1985
Gelatin silver print
11 7/8 × 11 7/8 in.
(30.2 × 30.2 cm)

No. 23, 1985
Gelatin silver print
11 7/8 × 11 7/8 in.
(30.2 × 30.2 cm)

No. 8, 1986
Gelatin silver print
11 13/16 × 11 13/16 in.
(30 × 30 cm)

No. 12, 1986
Gelatin silver print
11 7/8 × 11 7/8 in.
(30.2 × 30.2 cm)

No. 3, 1988
Gelatin silver print
15 × 11 9/16 in.
(38.2 × 29.4 cm)

No. 9, 1988
Gelatin silver print
11 7/8 × 11 7/8 in.
(30.2 × 30.2 cm)

No. 43, 1990
Gelatin silver print
11 13/16 × 11 13/16 in.
(30 × 30 cm)

No. 44, 1990
Gelatin silver print
11 13/16 × 12 in.
(30 × 30.5 cm)

No. 65, 1991–93
Gelatin silver print
15 7/16 × 11 11/16 in.
(39.2 × 29.8 cm)

No. 70, 1991–93
Gelatin silver print
11 7/8 × 11 7/8 in.
(30.2 × 30.2 cm)

No. 102, 1991–93
Gelatin silver print
11 7/8 × 13 11/16 in.
(30.2 × 34.8 cm)

No. 75, 1994–97
Gelatin silver print
11 13/16 × 11 15/16 in.
(30 × 30.3 cm)

No. 79, 1994–97
Gelatin silver print
11 1/4 × 11 11/16 in.
(33.7 × 29.8 cm)

No. 80, 1994–97
Gelatin silver print
11 11/16 × 12 in.
(29.8 × 30.5 cm)

No. 83, 1994–97
Gelatin silver print
11 13/16 × 12 1/16 in.
(30 × 30.6 cm)

No. 107, 2002
Gelatin silver print
11 7/8 × 11 7/8 in.
(30.2 × 30.2 cm)

Olivo Barbieri p. 116
(Italian, b. 1954)
Lives in Carpi and
Rome, Italy

site specific_roma 04,
2004
35mm film transferred
to DVD
12 minutes, 8 seconds
Courtesy of BRANCO-
LINI GRIMALDI ARTE
CONTEMPORANEA
ROMA; Spazio
Erasmus Brera, Milan

**Matthew
Buckingham** p. 58
(American, b. 1963)
Lives in New York

A Man of the Crowd,
2003
16mm film installation
with glass and steel
frame
20 minutes
Courtesy of the artist
and Murray Guy,
New York

Chris Burden p. 144
(American, b. 1946)
Lives in Los Angeles

Tower of London Bridge,
2003
Stainless steel
reproduction Mysto
Type 1 Erector parts
30 × 96 × 12 in.
(76.2 × 243.8 ×
30.5 cm)
Courtesy of Gagosian
Gallery, New York

Mircea Cantor p. 77
(Romanian, b. 1977)
Lives in Paris and
Nantes, France

Tribute, 2004
Video transferred to
DVD with music by
Philip Glass
2 minutes, 34 seconds
Courtesy of Yvon
Lambert, Paris and
New York

Jeff Carter p. 34
(American, b. 1967)
Lives in Chicago

Great Circle (Mecca),
2002
Aluminum, Plexiglas,
and neon
18 × 4 × 5 in.
(45.7 × 10.2 × 12.7 cm)
Edition of 3
Courtesy of the artist
and Kavi Gupta Gallery,
Chicago

Maurizio Cattelan
p. 94
(Italian, b. 1960)
Lives in New York

Hollywood, 2001
Chromogenic
development print,
Plexiglas, and
wooden frame
70⅞ × 157½ × 5⅞ in.
(180 × 400 × 14 cm)
Courtesy of Marian
Goodman Gallery,
New York

Phil Collins p. 240
(British, b. 1970)
Lives in Brighton,
England

How to Make a Refugee,
2000
Video transferred to DVD
11 minutes
Courtesy of Kerlin
Gallery, Dublin

**Abraham
Cruzvillegas** p. 184
(Mexican, b. 1968)
Lives in Mexico City

Untitled retrieval, 2004
Slide projection
Courtesy of the artist
and Kurimanzutto,
Mexico City

Tacita Dean p. 105
(British, b. 1965)
Lives in Berlin

Trying to Find the Spiral
Jetty, 1997
Audio CD
27 minutes
Courtesy of Marian
Goodman Gallery,
New York

**Elizabeth Diller +
Ricardo Scofidio**
p. 126
(American, b. 1954
and 1935)
Live in New York

Interclone Hotel, 1997
Slide projection
Courtesy of Diller +
Scofidio + Renfro,
New York

**Michael Elmgreen
and Ingar Dragset**
p. 146
(Danish and
Norwegian,
b. 1961 and 1968)
Live in Berlin

Short Cut,* 2003
Mixed-media
installation with car
and camper
Installed, approx.:
98¼ × 334¾ × 118 in.
(250 × 850 × 300 cm)
Courtesy of Galleria
Massimo De Carlo and
Fondazione Nicola
Trussardi, Milan

Rudolf Stingel (Italian, b. 1956)
Untitled, 1991

Stingel, who considers himself a painter,
uses nontraditional materials such as pink
and white Styrofoam, aluminum and gold
foil, and wallpaper. In 1991, he covered
the floor of Daniel Newburg Gallery with
bright orange carpet and in 2004, he
installed pink and blue floral carpet in
Vanderbilt Hall at New York City's Grand
Central Station, recontextualizing this
domestic material in a public space. For
Universal Experience, Stingel covered a
gallery floor with bright orange carpet,
remaking the work from 1991.

Hans-Peter Feldmann p. 68
(German, b. 1941)
Lives in Düsseldorf, Germany
All works courtesy of 303 Gallery, New York

Landscapes, 1978 / 2004
Hand-colored
ink-jet prints
8 prints, each:
33 × 44 in.
(84 × 112 cm)

Untitled (Eiffel Tower), 1990
Ink-jet prints
24 prints, each:
7½ × 5½ in.
(19 × 14 cm)

Untitled (Sunsets),1994
Ink-jet prints
12 prints, each: 8 × 10 in.
(20.3 × 25.4 cm)

Urs Fischer p. 6
(Swiss, b. 1973)
Lives in New York

A place called Novosibirsk, 2004
Cast aluminum, epoxy resin, iron rod, string, and acrylic paint
98⅛ × 30½ × 41⅝ in.
(249 × 77.5 × 105 cm)
Edition of 2 + 1 AP
Courtesy of Galerie Eva Presenhuber, Zurich, and Sadie Coles HQ, London

Peter Fischli and David Weiss p. 183
(Swiss, b. 1952 and 1946)
Live in Zurich

Visible World, 1986–2001
Light tables and transparencies
1,104 × 27 × 33 in.
(2,805 × 69 × 83 cm)
Collection of Adam Sender, New York

Katharina Fritsch p. 192
(German, b. 1956)
Lives in Düsseldorf, Germany

Warengestell II (Display Stand II),* 2001
Glass, aluminum, and objects by Fritsch, 1981–2001
79¹⁵⁄₁₆ × 47¼ in. dia.
(203 × 120 cm)
Collection of Keith and Kathy Sachs, Pennsylvania

Warengestell mit Vasen (Display Stand with Vases), 1987 / 89 / 2001
Aluminum, plastic, and silkscreen
108 × 50 × 50 in.
(270 × 127 × 127 cm)
Courtesy of the artist and Matthew Marks Gallery, New York

Susan Giles p. 150
(American, b. 1967)
Lives in Chicago

Panzoomtilt,* 2004
Video installation
Dimensions variable
Courtesy of Kavi Gupta Gallery, Chicago

Felix Gonzalez-Torres p. 189
(American, 1957–1996)

Untitled (Portrait of Ross in L.A.), 1991
Multicolored candies, individually wrapped in cellophane
Dimensions variable
The Art Institute of Chicago, on extended loan from the Howard and Donna Stone Collection, Chicago

Taft Green p. 130
(American, b. 1972)
Lives in Los Angeles

Reaction Facets: international airport, 2004
Wood, acrylic, and hardware
74 × 80 in. dia.
(188 × 203.2 cm)
Courtesy of the artist and Richard Telles Fine Art, Los Angeles

Johan Grimonprez p. 239
(Belgian, b. 1962)
Lives in Ghent, Belgium, and New York

Dial H-I-S-T-O-R-Y, 1997
DVD on plasma screen
68 minutes
Edition of 35
Courtesy of the artist and Yvon Lambert, Paris and New York

Angelina Gualdoni p. 107
(American, b. 1975)
Lives in Chicago

The Reflecting Skin,* 2004
Oil and acrylic on canvas
60 × 72 in.
(152.4 × 182.9 cm)
Courtesy of Kavi Gupta Gallery, Chicago

Subodh Gupta p. 149
(Indian, b. 1964)
Lives in New Delhi

This Side is the Other Side, 2003
Bronzed Vespa scooter and chrome cans
41 × 28 × 67 in.
(105 × 70 × 170 cm)
Courtesy of the artist and Jack Shainman Gallery, New York

John Hinde Studio p. 50
All works:
1968–1975/2002
Digital prints from original chromogenic development prints
Each: 20 × 40 in.
(50.8 × 101.6 cm)
Edition of 25
Courtesy of Daiter Contemporary, Chicago

A Corner of the Beach-comber Bar (Butlin's Bognor Regis)

The South Seas Bar (Butlin's Clacton)

Heated Outdoor Pool (Butlin's Skegness)

The Skating Rink and Monorail (Butlin's Skegness)

*The Playroom, Infant's
Centre* (Butlin's
Skegness)

*Lounge Bar and Indoor
Heated Pool (Ground
Level)* (Butlin's Ayr)

A Quiet Lounge
(Butlin's Ayr)

The Old Time Ballroom
(Butlin's Ayr)

Children's Play Area
(Butlin's Bognor Regis)

Thomas Hirschhorn
p. 212
(Swiss, b. 1957)
Lives in Paris

Chalet Lost History,
2002
Mixed-media
installation
Dimensions variable
Courtesy of the artist
and Chantal Crousel
Gallery, Paris

Jim Hodges p. 258
(American, b. 1957)
Lives in New York

don't be afraid, 2004
Color print on wall
Dimensions variable
Courtesy of the artist;
CRG Gallery, New York;
and Stephen Friedman
Gallery, London

Jacob Holdt p. 249
(Danish, b. 1947)
Lives in Copenhagen,
Denmark

American Pictures,
1981–1991
Chromogenic
development prints
27 prints: 11 × 14 in.
to 20 × 16 in.
(27.9 × 35.6 cm
to 50.8 × 40.6 cm)
Courtesy of the artist

**Judith Hopf,
Natascha Sadr
Haghighian, and
Florian Zeyfang**
p. 202
(German, b. 1969,
1967, and 1965)
Live in Berlin

*Proprio Aperto,** 1998
Video projection
and buttermilk
20 minutes
Courtesy of the artists
and Johann König
Gallery, Berlin

Marine Hugonnier
pp. 12, 174
(French, b. 1969)
Lives in London

Ariana, 2003
Super 16mm,
transferred to DVD
18 minutes
Courtesy of the artist
and MW Projects,
London

The Last Tour, 2004
Super 16mm,
transferred to DVD
14 minutes, 17 seconds
Edition of 6
Courtesy of Galerie
Judin, Zurich

Daniel Jewesbury
p. 101
(British, b. 1972)
Lives in County Down,
Northern Ireland

*Mirage,** 2000
Video installation
45 minutes
Courtesy of the artist

**Ilya and Emilia
Kabakov** p. 215
(Russian, b. 1933
and 1945)
Live in Long Island,
New York

*The Artist's Despair or
the Conspiracy of the
Untalented,** 1994
Enamel on canvas,
broken glass, axe,
paper, barriers, table,
and text on paper
Installed dimensions
variable
Collection of Robert
and Melissa Soros,
New York

Anish Kapoor p. 47
(British, b. 1954)
Lives in London

*My Body Your Body,**
1993
Fiberglass and pigment
70⅞ × 40⅜ × 59 in.
(180 × 102.6 × 149.9 cm)
Courtesy of Gladstone
Gallery, New York

Ian Kiaer p. 154
(British, b. 1971)
Lives in London

*Hakp-o dang (black),**
2001
Table, canvas, wood,
and cardboard
Canvas: 19 × 24 in.
(49 × 60.5 cm);
Table height: 10⁹⁄₁₆ in.
(26.8 cm)
Courtesy of Kenneth L.
Freed Collection,
Boston, and Alison
Jacques Gallery,
London

**Rem Koolhaas,
Robert Somol, and
Jeffrey Inaba** p. 119
(Dutch, b. 1944;
American, b. 1961
and 1962)
Live in Rotterdam; New
York; and Los Angeles,
respectively

*Roman Operating
System, Project on the
City (R/OS),** 2004
Multimedia installation
Courtesy of the artists

Jeff Koons pp. 89, 93
(American, b. 1955)
Lives in New York

*Rabbit,** 1986
Stainless steel
41 × 19 × 12 in.
(104.1 × 48.3 × 30.5 cm)
Collection Museum
of Contemporary Art,
Chicago, partial gift of
Stefan T. Edlis and H.
Gael Neeson

*Kiepenkerl,** 1987
Cast stainless steel
71 × 26 × 37 in.
(180.3 × 66 × 94 cm)
Collection of Camille O.
Hoffmann, Naperville, Ill.

Bear and Policeman,
1988
Pigment on wood
83 × 43 × 36 in.
(215 × 110 × 83 cm)
Collection
Kunstmuseum
Wolfsburg

Dinh Q. Lê p. 42
(Vietnamese, b. 1968)
Lives in Ho Chi
Minh City
All works 2004
Chromogenic
development prints
30 × 40 in.
(76.2 × 101.6 cm)
Courtesy of the artist
and Shoshana Wayne
Gallery, Los Angeles

Come Back to My Lai

Not Over Us

We Promised

Sharon Lockhart p. 221
(American, b. 1964)
Lives in Los Angeles
All works courtesy
of Gladstone Gallery,
New York; Blum & Poe
Gallery, Los Angeles;
and Neugerriem-
schneider, Berlin

*Apeú-Salvador: Families /
The Monteiro Family /
Manoel Nazareno
Souza Monteiro, Valciria
Ferreira Monteiro, Maria
da Conceição Ferreira
Monteiro, Alex
Nazareno Ferreira
Monteiro, Valquiria
Ferreira, Monteiro,
Margarida Ferreira
Costa, Laudicéia
Ferreira Monteiro /
Apeú-Salvador, Pará,
Brazil / Survey of Kinship
Relations in a
Fishing Community /
Anthropologist: Isabel
Soares de Souza*, 1999
3 gelatin silver prints,
each: 17⅞ × 22¾ in.
(45.4 × 57.8 cm)
Edition of 6 + 2 AP

*Apeú-Salvador: Families /
The Oliveira Family /
Naíze Barbosa Ferreira,
Mário Ferreira, Nadilson
Barbosa Tavares, Maria
José Ferreira de Oliveira,
José Barbosa de Oliveira,
Danielson Barbosa
Ferreira / Apeú-Salvador,
Pará, Brazil / Survey of
Kinship Relations in a
Fishing Community /
Anthropologist: Isabel
Soares de Souza*, 1999
3 gelatin silver prints,
each: 17⅞ × 22¾ in.
(45.4 × 57.8 cm)
Edition of 6 + 2 AP

*Apeú-Salvador: Families /
The Reis Family / Maria
do Livramento Soares
dos Reis, Marco Antônio
Soares dos Reis, Maria
Lucileide Soares dos Reis,
Marco José Soares dos
Reis / Apeú-Salvador,
Pará, Brazil / Survey of
Kinship Relations in a
Fishing Community /
Anthropologist: Isabel
Soares de Souza*, 1999
3 gelatin silver prints,
each: 18 × 22¾ in.
(45.7 × 57.8 cm)
Edition of 6 + 2 AP

*Apeú-Salvador: Families /
The Soares Family /
Lucimar Barbosa Soares /
Apeú-Salvador, Pará,
Brazil / Survey of
Kinship Relations in a
Fishing Community /
Anthropologist: Isabel
Soares de Souza*, 1999
3 gelatin silver prints,
each: 22¾ × 17¾ in.
(57.8 × 45.1 cm)
Edition of 6 + 2 AP

*Apeú-Salvador: Families /
The Oliveira Family /
Domingos Barbosa de
Oliveira, Maria Garciléia
de Oliveira, Iolanda
Barbosa, Maria Nazaré
de Oliveira / Apeú-
Salvador, Pará, Brazil /
Survey of Kinship
Relations in a Fishing
Community /
Anthropologist: Isabel
Soares de Souza*, 1999
3 gelatin silver prints,
each: 17⅞ × 22¾ in.
(45.4 × 57.8 cm)
Edition of 6 + 2 AP

*Interview Locations /
Family Photographs /
Interview Location:
Survey of the Aripuanã
River Region, Tucunaré
Community, Parańa de
Capimtuba River, Brazil /
Interview Subjects:
Raimunda Ferreira,
Manoel Batista Vieira /
Photograph from the
Collection of Raimunda
Ferreira and Manoel
Batista Vieira /
Anthropologist: Ligia
Simonian*, 1999
2 gelatin silver prints
Panel 1: 18 × 22⅞ in.
(45.7 × 58.1 cm)
Panel 2: 6⅞ × 8⅞ in.
(17.5 × 22.5 cm)
Edition of 6 + 2 AP

*Interview Locations /
Family Photographs /
Interview Location:
Survey of the Aripuanã
River Region, São
Miguel Community,
Boca do Juma River,
Brazil
Interview Subject:
Francisco
Colares/Anthropologist:
Ligia Simonian*, 1999
Gelatin silver print
22¾ × 17¾ in.
(57.8 × 45.1 cm)
Edition of 6 + 2 AP

*Interview Locations /
Family Photographs /
Photographs from the
Collection of Onória Reis /
Interview Location:
Survey of the Aripuanã
River Region, Miramar
Community, Boca do
Juma River, Brazil /
Interview Subjects:
Onória Reis, Manoel
Ademar Almeida Goes /
Anthropologist: Ligia
Simonian*, 1999
3 gelatin silver prints
Panel 1: 8¾ × 6¾ in.
(22.2 × 17.2 cm)
Panel 2: 8¾ × 6⅜ in.
(22.2 × 16.2 cm)
Panel 3: 18 × 22⅞ in.
(45.7 × 58.1 cm)
Edition of 6 + 2 AP

Interview Locations /
Family Photographs /
Interview Location:
Survey of the Aripuanã
River Region, Santa
Helena Community,
Boca do Juma River,
Brazil / Interview
Subject: Maria Francisca
de Jesús / Anthropologist:
Ligia Simonian,1999
Gelatin silver print
22⅞ × 17⅞ in.
(58.1 × 45.4 cm)
Edition of 6 + 2 AP

Interview Locations /
Family Photographs /
Interview Location:
Survey of the Aripuanã
River Region, Santa
Maria do Capitari
Community, Aripuanã
River, Brazil / Interview
Subjects: Joana de Melo
Rodrigues, José Antônio
Rodrigues / Interview
Subject: Maria Helena
Soares Ferreira /
Anthropologist: Ligia
Simonian, 1999
2 gelatin silver prints,
each: 18 × 23 in.
(45.7 × 58.4 cm)
Edition of 6 + 2 AP

Interview Locations /
Family Photographs /
Interview Location: /
Survey of the Aripuanã
River Region, Piãtuba
Community, Aripuanã
River, Brazil / Interview
Subjects: Monciano
Alves Lima, Maria
Ribeiro Ladislau, Maria
Socorro Moreira /
Interview Subjects:
Raimundo Ladislau,
Raimundo Moreira da
Silva / Anthropologist:
Ligia Simonian, 1999
2 gelatin silver prints,
each: 18 × 22¾ in.
(45.7 × 57.8 cm)
Edition of 6 + 2 AP

Interview Location: /
Survey of the Aripuanã
River Region, Expedition
Boat, Tio D'Amico, at
Boa Vista Community /
Aripuanã River, Brazil /
Interview Subject: Álvaro
Quadros / Boa Vista
Community, Aripuanã
River, Brazil / Interview
Subjects: Maria
Menezes, Maria P.
Ladislau da Rocha /
Interview Subjects:
Raimunda Miranda,
Antônio Miranda Alves,
Alcione Moreira de
Andrade /
Anthropologist: Ligia
Simonian, 1999
3 gelatin silver prints,
each: 18 × 22⅞ in.
(45.7 × 57.8 cm)
Edition of 6 + 2 AP

Interview Locations /
Family Photographs /
Interview Location:
Survey of the Aripuanã
River Region, Alto
Monte Community,
Aripuanã River, Brazil /
Interview Subjects:
Cesário Lima, Doralice
Miranda de Souza /
Photos from the
Collection of Cesário
Lima and Doralice
Miranda de Souza /
Anthropologist: Ligia
Simonian, 1999
3 gelatin silver prints
Panel 1: 9 × 5¾ in.
(22.9 × 14.6 cm)
Panel 2: 9 × 6¼ in.
(22.9 × 15.9 cm)
Panel 3: 18 × 22⅞ in.
(45.7 × 57.8 cm)
Edition of 6 + 2 AP

Matthias Müller
p. 106
(German, b. 1961)
Lives in Bielefeld,
Germany

Vacancy, 1998
Video transferred
to DVD
14 minutes
Courtesy of the artist,
Thomas Erben Gallery,
Stellan Holm Gallery,
Timothy Taylor Gallery,
Galerie Volker Diehl,
and Distrito Cu4tro

N L Architects p. 226
(Pieter Bannenberg,
Walter Van Dijk, Kamiel
Klaasse, and Mark
Linnemann; Dutch,
b. 1959, 1962, 1967,
and 1962)
Live in Amsterdam
Color prints on wall
Dimensions variable
Courtesy of N L Archi-
tects, Amsterdam

Cruise City, City Cruise,
2003

Plug-In City, 2004

Melik Ohanian p. 167
(French, b. 1969)
Lives in Paris

SLOWMOTION –
From SLAVE to
VALSE,* 2003
150 electric circuits and
control panel
295⁵⁄₁₆ × 217 in.
(750 × 550 cm)
Courtesy of the artist
and CCA Kitakyushu,
Japan

Roman Ondak p. 161
(Slovakian, b. 1966)
Lives in Bratislava,
Slovakia

Common Trip, 2000
Drawings and objects
made by people to
whom I described the
most remembered
places I have ever
visited
Drawings on paper,
and paper and
cardboard objects
Installed dimensions
variable
Courtesy of the artist;
and gb agency, Paris

Catherine Opie p. 112
(American, b. 1961)
Lives in Los Angeles

Untitled # 1–4
(Chicago) from
American Cities,* 2004
Iris prints on paper
4 prints, each:
16 × 41 in.
(40.6 × 104.1 cm)
Courtesy of Regen
Projects, Los Angeles

Dennis O'Rourke
p. 216
(Australian, b. 1945)
Lives in Canberra,
Australia

Cannibal Tours, 1988
35mm film transferred
to DVD
72 minutes
Courtesy of Direct
Cinema, Ltd.

Gabriel Orozco
pp. 210, 222
(Mexican, b. 1962)
Lives in Mexico City
and New York
All works courtesy of
Marian Goodman
Gallery, New York

*Turista Maluco
(Crazy Tourist)*, 1991
Chromogenic
development print
16 × 20 in.
(40.6 × 50.8 cm)

Sandals Tale, 1996
Chromogenic
development prints
16 prints, each:
12 7/16 × 18 5/8 in.
(31.6 × 47.3 cm)
Edition of 2

Martin Parr p. 141
(British, b. 1952)
Lives in London

*The Last Resort,**
1983–86
Chromogenic
development prints
10 prints,
each: 20 × 24 in.
(50.8 × 61 cm)
Edition of 25
Courtesy of Daiter
Contemporary, Chicago

Philippe Parreno
p. 164
(French, b. 1964)
Lives in Paris
All works courtesy of
Friedrich Petzel Gallery,
New York, and Galerie
Air de Paris

*Fade to Black #2
(Welcome to Reality
Park),** 2003
Phosphorescent
ink silkscreen print
on paper
72 13/16 × 141 3/4 in.
(185 × 360 cm)
Edition of 6

*The Ice Man, Tokyo
1995,** 2003
Phosphorescent
ink silkscreen print
on paper
72 13/16 × 47 1/4 in.
(185 × 120 cm)
Edition of 6

*Sound Pan, Paris 2002,**
2003
Phosphorescent
ink silkscreen print
on paper
72 13/16 × 47 1/4 in.
(185 × 120 cm)
Edition of 6

*Space World,
Kitakyushu 2003,** 2003
Phosphorescent
ink silkscreen print
on paper
72 13/16 × 47 1/4 in.
(185 × 120 cm)
Edition of 6

Paola Pivi p. 29
(Italian, b. 1971)
Lives in London

Untitled (donkey), 2003
Ink-jet print on PVC
397 13/16 × 479 11/16 in.
(1020 × 1230 cm)
Courtesy Galleria
Massimo De Carlo,
Milan

Cedric Price p. 170
(British, 1934–2003)

*Midsection Internal
View for Fun Palace,**
1961–65
Diazotype on masonite
29 7/8 × 47 11/16 in.
(76 × 121.5 cm)
Collection Centre
Canadiene
d'Architecture/
Canadian Center for
Architecture, Montreal

*Interview with Hans
Ulrich Obrist,** 2003
DVD on monitor,
transferred from
mini DV
20 minutes
Courtesy of Hans
Ulrich Obrist, Paris

Florian Pumhösl
p. 109
(Austrian, b. 1971)
Lives in Vienna

*Oceanic,** 2004
Heliographies on paper
3 prints, each:
11 × 15 3/4 in.
(28 × 40 cm)
Edition 5 of 5
Courtesy of Galerie
Krobath Wimmer,
Vienna

**Andrea Robbins and
Max Becher** p. 99
(American, b. 1963;
German, b. 1964)
Live in New York
All works courtesy of
Sonnabend Gallery,
New York

Cologne Karnival No. 1,
1994
Chromogenic
development print
10 1/2 × 12 1/2 in.
(26.7 × 31.8 cm)

Cologne Karnival No. 3,
1994
Chromogenic
development print
10 1/2 × 12 1/2 in.
(26.7 × 31.8 cm)

Cologne Karnival No. 7,
1994
Chromogenic
development print
10 1/2 × 12 1/2 in.
(26.7 × 31.8 cm)

*German Indians:
Campfire*, 1996
Chromogenic
development print
20 × 24 in.
(50.8 × 61 cm)

German Indians:
Blonde, 1998
Chromogenic
development print
20 × 16 in.
(50.8 × 40.6 cm)

German Indians: Chief,
1998
Chromogenic
development print
20 × 16 in.
(50.8 × 40.6 cm)

German Indians:
Chief's Wife, 1998
Chromogenic
development print
24 × 18 in.
(61 × 45.7 cm)

German Indians:
Meeting, 1998
Chromogenic
development print
20 × 16 in.
(50.8 × 40.6 cm)

German Indians:
Three Men, 1998
Chromogenic
development print
20 × 24 in.
(50.8 × 61 cm)

Ugo Rondinone
p. 207
(Swiss, b. 1963)

MOONRISE. west.
december, 2004
Cast polyurethane
38 15/16 × 26 3/8 × 9 7/16 in.
(99 × 67 × 24 cm)
Edition of 3
Courtesy of
Matthew Marks Gallery,
New York

MOONRISE. west. july,
2004
Cast polyurethane
42 15/16 × 24 13/16 ×
24 13/16 in.
(109 × 63 × 63 cm)
Edition of 3
Private collection

Bojan Sarcevic p. 273
(Serbian, b. 1974)
Lives in Paris and
Berlin

Untitled (Bangkok),*
2002
DVD on plasma screen
8 minutes
Courtesy of BQ,
Cologne

Thomas Schütte
p. 255
(German, b. 1954)
Lives in Düsseldorf,
Germany

Ganz Grosse Geister (Big
Spirits XL),* 2004
Enamel on cast
aluminum
3 figures, each:
16 ft. (4.9 m)
Courtesy of Marian
Goodman Gallery,
New York

Bruno Serralongue
p. 199
(French, b. 1968)
Lives in Paris

Asia Hall, Expo 2000,
2000
Silver dye-bleach print
on aluminum
50 13/16 × 63 7/16 in.
(129 × 161 cm)
Courtesy of the artist
and Galerie Air de Paris

Escalier Central, Expo
2000, 2000
Silver dye-bleach print
on aluminum
50 13/16 × 63 7/16 in.
(129 × 161 cm)
Courtesy of Michéle
and Thierry Colin,
Reims, France

Pavillon du XXIème
siècle, Expo 2000, 2000
Silver dye-bleach print
on aluminum
50 13/16 × 63 7/16 in.
(129 × 161 cm)
Courtesy of the artist
and Galerie Air de Paris

Shirana Shahbazi
p. 187
(Iranian and German,
b. 1974)
Lives in Zurich
All works chromogenic
development prints
Dimensions variable
Courtesy of Galerie Bob
Van Orsouw, Zurich,
and Salon 94, New
York

From the series
Goftare Nik, 2000–03

From the series
Painted Desert, 2004

From the series
Real Love/Shanghai,
2004

Robert Smithson
pp. 104, 111
(American, 1938–1973)

Hotel Palenque,* 1969
31 chromogenic
development slides and
audio CD
Dimensions variable
Solomon R.
Guggenheim Museum,
New York
Purchased with funds
contributed by the
International Director's
Council and Executive
Committee Members:
Edythe Broad, Henry
Buhl, Elaine Terner
Cooper, Linda Fischbach,
Ronnie Heyman, Dakis
Joannou, Cindy Johnson,
Barbara Lane, Linda
Macklowe, Brian
McIver, Peter Norton,
Willem Peppler, Denise
Rich, Rachel Rudin,
David Teiger, Ginny
Williams, and Elliot Wolk,
1999.5268

The Spiral Jetty, 1970
16mm film transferred
to DVD
35 minutes
Collection Museum of
Contemporary Art,
Chicago, gift of Muriel
K. Newman

William Staples
p. 254
(American, b. 1966)
Lives in Chicago

Balcony, 2004
Oil on canvas
32 × 32 in.
(81.3 × 91.4 cm)
Courtesy of the artist,
Chicago

Lake, 2004
Oil on canvas
24 × 24 in.
(61 × 61 cm)
Courtesy of the artist,
Chicago

Simon Starling p. 30
(British, b. 1967)
Lives in Glasgow,
Scotland

Tabernas Desert Run,
2004
Watercolor and fuel
cell–powered bicycle in
Plexiglas vitrine
86⅝ × 66¹⁵⁄₁₆ × 24⁷⁄₁₆ in.
(220 × 170 × 62 cm)
Courtesy of The
Modern Institute,
Glasgow

Rudolf Stingel p. 261
(Italian, b. 1956)
Lives in New York

Untitled, 1991
Carpet
Dimensions variable
Courtesy of the artist

Thomas Struth p. 87
(German, b. 1954)
Lives in Düsseldorf,
Germany

*Kunsthistorisches
Museum III, Vienna,*
1989
Chromogenic
development print
58¼ × 74¾ in.
(148 × 189.9 cm)
Collection of Robert
and Sylvie Fitzpatrick,
Chicago

*National Museum of
Art, Tokyo,* 1999
Chromogenic
development print
70⅝ × 109 in.
(179.4 × 276.9 cm)
Courtesy of The Art
Institute of Chicago,
partial gift of Pamela J.
and Michael N. Alper
2003.93

Hiroshi Sugimoto
p. 97
(Japanese, b. 1948)
Lives in Tokyo

The Last Supper, 1999
Gelatin silver prints
Five panels, each:
30 × 40 in.
(76.2 × 101.6 cm)
Courtesy Bill Stone
Foundation

**Pascale Marthine
Tayou** p. 54
(Cameroonian, b. 1967)
Lives in Yaoundé,
Cameroon, and Ghent,
Belgium

Traditions, 2002
Lambda print mounted
on aluminum
74¾ × 49¼ in.
(190 × 125 cm)
Courtesy of GALLERIA
CONTINUA, San
Gimignano, Italy

**Alexander
Timtschenko** p. 73
(German, b. 1965)
Lives in Munich,
Germany

*Caesars, Caesars,
Caesars,* 1997
Silver dye-bleach print
49¼ × 99 in.
(125 × 252 cm)
Courtesy of Peter
Ottmann, Munich

New York, Las Vegas,
1997
Silver dye-bleach print
57¾ × 31½ in.
(147 × 80 cm)
Courtesy of the artist

Treasure Island, 1997
Silver dye-bleach print
31½ × 47¼ in.
(80 × 120 cm)
Courtesy of Galeria
Helga de Alvear,
Madrid

Wild, Wild, West, 1997
Silver dye-bleach print
49¼ × 79¹⁵⁄₁₆ in.
(125 × 203 cm)
Courtesy of the artist

Tannhauser, 1998
Silver dye-bleach print
49 × 92½ in.
(125 × 235 cm)
Courtesy of the artist

Excalibur II, 1999
Silver dye-bleach print
54¾ × 31½ in.
(139 × 80 cm)
Courtesy of Jakob von
Bullion, Berlin

Paris, 1999
Silver dye-bleach print
79¹⁵⁄₁₆ × 49¼ in.
(203 × 125 cm)
Courtesy of Serge
Hosseinzade Dolkani,
Munich

Paris I, 1999
Silver dye-bleach print
49¼ × 61 in.
(125 × 155 cm)
Courtesy of Serge
Hosseinzade Dolkani,
Munich

Venice III, 1999
Silver dye-bleach print
31½ × 65 in.
(80 × 165 cm)
Courtesy of Serge
Hosseinzade Dolkani,
Munich

Venice IV, 1999
Silver dye-bleach print
49¼ × 61 in.
(125 × 155 cm)
Courtesy of Günter
Lorenz, Munich

Wild, Wild, West I, 1999
Silver dye-bleach print
94½ × 49¼ in.
(240 × 125 cm)
Courtesy of Galeria
Helga de Alvear,
Madrid

Rirkrit Tiravanija
p. 143
(Thai, b. 1961)
Lives in New York
and Berlin

*Untitled (From Barajas
to Paracuellos de
Jarama to Torrejón de
Ardoz to San Fernando
or Coslada to Reina
Sofía)*, 1994
Portable table, chairs,
bicycle, video camera,
tripod, and plates
Dimensions variable
Courtesy of
Klosterfelde, Hamburg

Kyoichi Tsuzuki p. 84
(Japanese, b. 1956)
Lives in Tokyo
All works are courtesy
of the artist

*Awashima Jinjya
Wakayama*, 1993
Chromogenic
development print
38⅝ × 38⅝ in.
(98 × 98 cm)

Daikannon Temple,
1993
Chromogenic
development print
59 × 59 in.
(150 × 150 cm)

Gama Park, 1993
Chromogenic
development print
19¹¹⁄₁₆ × 19¹¹⁄₁₆ in.
(50 × 50 cm)

*The Louvre Sculpture
Museum*, 1993
Chromogenic
development print
38⅝ × 38⅝ in.
(98 × 98 cm)

Fruit Bus Stop, 1994
Chromogenic
development print
59 × 59 in.
(150 × 150 cm)

*Gamagori Fantasy R & L
(set)*, 1994
Chromogenic
development print
19¹¹⁄₁₆ × 19¹¹⁄₁₆ in.
(50 × 50 cm)

Hanibe Gankutsu In,
1994
Chromogenic
development print
38⅝ × 38⅝ in.
(98 × 98 cm)

*Hokkaido Erotic
Museum*, 1994
Chromogenic
development print
19¹¹⁄₁₆ × 19¹¹⁄₁₆ in.
(50 × 50 cm)

Thoei Movie Villege,
1995
Chromogenic
development print
19¹¹⁄₁₆ × 29½ in.
(50 × 75 cm)

Toba Erotic Museum,
1995
Chromogenic
development print
59 × 59 in.
(150 × 150 cm)

Snap Sonota, 1996
Chromogenic
development print
19¹¹⁄₁₆ × 39⅜ in.
(50 × 100 cm)

Suginoi Palace, 1996
Chromogenic
development print
38⅝ × 58⁵⁄₁₆ in.
(98 × 148 cm)

Sun Messe Nichonan,
1996
Chromogenic
development print
19¹¹⁄₁₆ × 31½ in.
(50 × 80 cm)

Piotr Uklanski
pp. 172, 251
(Polish, b. 1968)
Lives in New York

*Untitled (Parco
nazionale dell'
Abruzzo)*,* 2000
Chromogenic
development print
under Plexiglas
59¹⁄₁₆ × 80¹¹⁄₁₆ in.
(150 × 205 cm)
Courtesy of Gavin
Brown's enterprise,
New York

Untitled (Vesuvius),
2000
Chromogenic
development print
under Plexiglas
66¹⁵⁄₁₆ × 95¹¹⁄₁₆ in.
(170 × 243 cm)
Collection Ernesto
Esposito, courtesy of
Gavin Brown's
enterprise, New York

Untitled (John Paul II),*
2004
Color print on wall
Dimensions variable
Courtesy of Galleria
Massimo De Carlo,
Milan

Brian Ulrich p. 229
(American, b. 1971)
Lives in Chicago

Cleveland, OH,* 2003
Digital ink-jet print
30 × 40 in.
(76.2 × 101.6 cm)
Courtesy of the artist
and Peter Miller
Gallery, Chicago

Zhan Wang p. 115
(Chinese, b. 1962)
Lives in Beijing

Urban Landscape, 2003
Stainless-steel garden
rocks, pots, pans, and
eating utensils; mirror;
and dry ice machine
24 × 24 ft. (7.3 × 7.3 m)
Courtesy of the artist
and Courtyard Gallery,
Beijing

Andy Warhol
pp. 63, 78
(American, 1928–1987)

*Double Mona
Lisa*,* 1963
Silkscreen ink and
acrylic on canvas
28⅛ × 37⅛ in.
(71.4 × 94.3 cm)
The Menil Collection,
Houston

Empire (excerpt), 1964
16mm film
transferred to DVD
50 minutes
The Andy Warhol
Museum, Pittsburgh

Bibliography

Adorno, Theodor W. *Prisms*. Translated by Samuel Weber et al. Cambridge, Mass.: The MIT Press, 1982.

Aristides, Aelius. *The Complete Works*. Translated by Charles A. Behr. Vol. 2, *Orations: XVII–LIII*. Leiden, Netherlands: Brill Academic Publishers, 1981.

Barnes, Lucinda. "Robert Smithson." In *Robert Smithson / Tony Tasset: Site / Nonsite*. Exh. cat. P. 5. Chicago: Museum of Contemporary Art, 1995.

Barthes, Roland. *The Eiffel Tower and Other Mythologies*. Translated by Richard Howard. Berkeley, Calif.: University of California Press, 1979.

Baudelaire, Charles. "The Painter of Modern Life," in *Baudelaire: Selected Writings on Art and Artists*. Translated by P. E. Charvet. Middlesex, U.K.: Penguin, 1972. Reprint, Cambridge, U.K.: Cambridge University Press, 1981. Quoted in Warner, Eric and Graham Hough, ed. *Strangeness and Beauty: An Anthology of Aesthetic Criticism 1840–1910*. Vol. 1. Cambridge, Mass.: Cambridge University Press, 1983. Pp. 211–220.

Becker, Carol. "Pilgrimage to My Lai: Social Memory and the Making of Art." *Art Journal* 62, no. 4 (winter 2003), pp. 51–68.

Bell, Claudia and John Lyall. *The Accelerated Sublime: Landscape, Tourism, and Identity*. Westport, Conn.: Praeger Publishers, 2002.

Benjamin, Walter. "The Storyteller: Reflections on the Works of Nikolai Leskov." In *Illuminations: Essays and Reflections*. New York: Harcourt Brace & World, 1968. Quoted in Bonami, Francesco, et al., eds. *Manifesta 3 — European Biennial of Contemporary Art*. Exh. cat. Ljubljana, Slovenia: Cankarjev dom, 2000. Pp. 82–83.

Birringer, Johannes. *Media and Performance: Along the Border*. Baltimore, Md.: The Johns Hopkins University Press, 1998.

Bonami, Francesco. "The Road Around (or, A Long Good-bye)." In *Echoes: Contemporary Art at the Age of Endless Conclusions*. New York: The Monacelli Press, Inc., 1996.

Boorstin, Daniel J. *The Image: A Guide to Pseudo-Events In America*. New York: Random House, 1961.

Bouvier, Nicolas. *The Japanese Chronicles*. Translated by Anne Dickerson. San Francisco, Calif.: Mercury House, 1992.

Bruner, Edward M. "Experience and Its Expressions." In Turner and Bruner, *The Anthropology of Experience*, pp. 3–30.

Carpenter, Edmund. "The Tribal Terror of Self-Awareness." In *Principles of Visual Anthropology*, 2nd ed., edited by Paul Hockings. Berlin: Mouton de Gruyter, 1995. Pp. 481–91.

Chambers, Erve, ed. *Tourism and Culture: An Applied Perspective*. Albany, N.Y.: State University of New York Press, 1997.

Chatwin, Bruce. *The Songlines*. New York: Penguin Books, 1987.

———. *What Am I Doing Here*. New York: Penguin Books, 1989.

Clifford, James. *Routes: Travel and Translation in the Late Twentieth Century*. Cambridge, Mass.: Harvard University Press, 1997.

Conley, Kevin. "How High Can You Go?" *The New Yorker* (August 30, 2004), pp. 48–55.

Cornell, Joseph. *Joseph Cornell's Theater of the Mind: Selected Diaries, Letters, and Files*. Edited by Mary Ann Caws. London: Thames and Hudson, 1993. Quoted in *Traveling: Towards the Border*. Exh. cat. Tokyo: The National Museum of Modern Art, 2003.

Crouch, David and Nina Lübbren, eds. *Visual Culture and Tourism*. London: Berg Publishers, 2003.

Csikszentmihalyi, Mihaly. *Creativity: Flow and the Psychology of Discovery and Invention*. New York: Harper Collins Publishers, 1996.

———. "Leisure and Socialization." *Social Forces* 60, no. 2 (1981): p. 333. Quoted in Lisa Roberts. *From Knowledge to Narrative: Educators and the Changing Museum*. Washington, D.C.: Smithsonian Institution Press, 1997.

Debord, Guy. *The Society of the Spectacle*. Translated by Ken Knabb. http://www.bopsecrets.org/SI/debord/.

de Botton, Alain. *The Art of Travel*. New York: Pantheon Books, 2002.

Diller, Elizabeth and Ricardo Scofidio. "Suit Case Studies: The Production of a National Past." In *Back to the Front: Tourisms of War*. Edited by Diller, Elizabeth and Ricardo Scofidio. Exh. cat. New York: Princeton Architectural Press, 1994. Pp. 32–106.

Eco, Umberto. *Travels in Hyperreality*. New York: Harvest/Harcourt Brace Jovanovich, 1990.

Eliade, Mircea. *Myth and Reality*. Translated by Willard R. Trask. New York: First Harper Colophon edition, 1975.

Fogle, Douglas. "The Occidental Tourist." *Parkett*, no. 68 (2003), pp. 20–24.

Foucault, Michel. "Space, Knowledge, Power." In *The Foucault Reader*. Edited by Paul Rabinow. New York: Pantheon Books, 1984. Pp. 239–56.

Frow, John. "Tourism and the Semiotics of Nostalgia." In *October* 57 (Summer 1991): 123–51.

Gamboni, Dario. *The Destruction of Art: Iconoclasm and Vandalism since the French Revolution*. London: Reaktion Books, 1997.

Gentleman, Amelia, "Smile, please." *The Guardian*, October 19, 2004. http://www.guardian.co.uk/print/o,3858,5042223-103680,00.html/.

Gleber, Anke. *The Art of Taking a Walk: Flanerie, Literature, and Film in Weimar Culture*. Princeton, N.J.: Princeton University Press, 1999.

Golden Spike National Historic Site. Directions to Robert Smithson's *The Spiral Jetty*. http://www.nps.gov/gosp/tour/jetty_directions.html/.

Gottdiener, Mark. *Life in the Air: Surviving the New Culture of Air Travel*. Lanham, Md.: Rowman & Littlefield Publishers, Inc., 2001.

Graburn, Nelson H. H. "Tourism: The Sacred Journey." In Smith, *Hosts and Guests*, pp. 21–36.

————. "The Museum and the Visitor Experience." In *Museum Education Anthology: Perspectives on Informal Learning. A Decade of Roundtable Reports*, edited by Susan K. Nicols. Washington: Museum Education Roundtable, 1984. Pp. 177–182.

Groys, Boris. "The City in the Age of Touristic Reproduction," *Utopia* no. 2 (October 11, 2004), http://artefact.mi2.hr/_a02/lang_en/write_groys_en.htm.

Hacking, Ian. *Mad Travelers: Reflections on the Reality of Transient Mental Illnesses*. London: Free Association Books, 1998.

Hammerskjöld, Dag. *Markings*. London: Barrie & Rockliff with Pall Mall Press, 1963.

Hannerz, Ulf. *Transnational Connections: Culture, People, Places*. London: Routledge, 1996.

Herrera, Phillip, A New Age for Museums, *Town and Country*, May 2004.

Herzog, Werner. *Of Walking in Ice*. Translated by Martje Herzog and Alan Greenberg. New York: Tanam Press, 1980.

Hitchcock, Robert. "Cultural, Economic, and Environmental Impacts of Tourism." In Chambers, *Tourism and Culture*, pp. 93–128.

Hockings, Paul, ed. *Principles of Visual Anthropology*. 2nd ed. Berlin: Mouton de Gruyter, 1995.

Holdt, Jacob. *American Pictures: A Personal Journey through the American Underclass*. Copenhagen, Denmark: American Pictures Foundation, 1985.

Iyer, Pico. *Video Night in Kathmandu: And Other Reports from the Not-So-Far East*. New York: Vintage Books, 1989.

Jack, Ian. "The 12.10 to Leeds." *Granta*, no. 73 (spring 2001), pp. 67–105.

Jokinen, Eeva and Soile Veijola. "The Disoriented Tourist: The Figuration of the Tourist in Contemporary Cultural Critique." In Rojek and Urry, *Touring Cultures*, pp. 23–51.

Kaplan, Robert D. *The Ends of the Earth: From Togo to Turkmenistan, From Iran to Cambodia—A Journey to the Frontiers of Anarchy*. New York: Random House, Inc., 1997.

Kelly, Mary. "Re-viewing Modernist Criticism." In *Art After Modernism: Rethinking Representation*, edited by Brian Wallis. New York: The New Museum of Contemporary Art, 1984. Pp. 87–103.

Kimmelman, Michael, "Looking Long and Hard." *The New York Times,* October 14, 2004, arts section, sec. B.

Kirshenblatt-Gimblett, Barbara. *Destination Culture: Tourism, Museums, and Heritage.* Berkeley, Calif.: University of California Press, 1998.

Koolhaas, Rem, Bruce Mau, and Hans Werlemann. *S, M, L, XL.* New York: Monacelli Press, 1998.

Kristeva, Julia. "By What Right Are You a Foreigner?" In *Trade Routes: History and Geography, Second Johannesburg Biennale.* Edited by Matthew DeBord. Exh. cat. Johannesburg: Thorald's Africana Books. Pp. 39–42.

Lê, Dinh Q. and Moira Roth. "Cuoc Trao Doi Giua/Of Memory and History: An Exchange between Dinh Q. Lê and Moira Roth, June 1999–April 2003." In *From Vietnam to Hollywood: Dinh Q. Lê.* Exh. cat. Seattle, Wash.: Marquand Books, 2003.

Leed, Eric J. *The Mind of the Traveler: From Gilgamesh to Global Tourism.* New York: Harper Collins Publishers, 1991.

Lett, James. Epilogue for "Touristic Studies in Anthropological Perspective" by Theron Nuñez. In Smith, *Hosts and Guests,* pp. 275–79.

Lévi-Strauss, Claude. *Tristes Tropiques: An Anthropological Study of Primitive Societies in Brazil.* Translated by John Russel. New York: Atheneum, 1969.

Lewis, Bernard. *From Babel to Dragomans: Interpreting the Middle East.* New York: Oxford University Press, 2004.

Lippard, Lucy R. *On the Beaten Track: Tourism, Art, and Place.* New York: The New Press, 1999.

Löfgren, Orvar. *On Holiday: A History of Vacationing.* Berkeley, Calif.: University of California Press, 1999.

MacCannell, Dean. *The Tourist: A New Theory of the Leisure Class,* 2nd ed. Berkeley, Calif.: The University of California Press, 1999.

Marin, Louis. "Disneyland: A Degenerate Utopia." *Glyph,* no. 1 (1997), pp. 50–66.

Mattie, Erik. *World's Fairs.* New York: Princeton Architectural Press, 1998. © 1998 V+K Publishing, The Netherlands.

McCullough, Malcolm. *Digital Ground: Architecture, Pervasive Computing, and Environmental Knowing.* Cambridge, Mass.: The MIT Press, 2004.

Mitchell, Timothy. "Orientalism and the Exhibitionary Order." In *The Visual Culture Reader,* 2nd ed., edited by Nicholas Mirzoeff. London: Routledge, 2002. Pp. 495–505.

Munder, Heike, Raphael Gygax, and Adam Budak, eds. *Bewitched, Bothered, and Bewildered: Spatial Emotion in Contemporary Art and Architecture.* Zurich: JRP Editions, 2003.

Nash, Dennison. "Tourism as a Form of Imperialism." In Smith, *Hosts and Guests,* pp. 37–52.

Obrist, Hans Ulrich. *Interviews.* Edited by Thomas Boutoux. Vol. 1. Milan and Florence: Edizioni Charta and Fondazione Pitti Immagine Discovery, 2003.

Oguibe, Olu. "Forsaken Geographies: Cyberspace and the New World Other." In *Trade Routes: History and Geography, Second Johannesburg Biennale.* Edited by Matthew DeBord. Exh. cat. Johannesburg: Thorald's Africana Books. Pp. 46–51.

Osborne, Peter. *The Politics of Time: Modernity and Avant-Garde.* London: Verso, 1995.

Osborne, Peter D. *Travelling Light: Photography, Travel, and Visual Culture.* Manchester, UK: Manchester University Press, 2000.

Perry, Robert Edwin. "The Pole Is Mine." In *The Mammoth Book of Explorers,* 2nd ed., edited by John Keay. New York: Carroll & Graf Publishers, 2002. Pp. 444–45.

Pelton, Robert Young. *The World's Most Dangerous Places.* 4th ed. New York: Harper Collins Publishers, 2000.

Principle Survey of Refugees from the *World Refugee Survey 2004* by the U.S. Committee for Refugees and Immigrants. http://www.refugees.org/wrs04/pdf/principal_sources.pdf/.

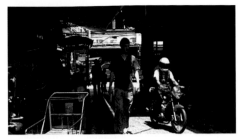

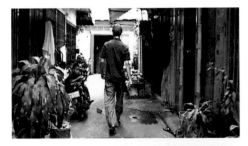

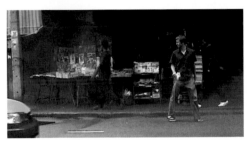

Pollock, Griselda. "Holocaust Tourism: Being There, Looking Back and the Ethics of Spatial Memory." In Crouch and Lübbren, *Visual Culture and Tourism*, pp. 175–189.

Ritzer, George and Allan Liska. "'McDisneyization' and 'Post-Tourism': Complementary Perspectives on Contemporary Tourism." In Rojek and Urry, *Touring Cultures*, pp. 96–109.

Roberts, Lisa C. *From Knowledge to Narrative: Educators and the Changing Museum.* Washington, D.C.: Smithsonian Institution Press, 1997.

Rojek, Chris. "Indexing, Dragging, and the Social Construction of Tourist Sights." In Rojek and Urry, *Touring Cultures*, pp. 52–74.

Rojek, Chris and John Urry, eds. *Touring Cultures: Transformations of Travel and Theory.* London: Routledge, 1997.

Said, Edward. *Orientalism.* New York: Vintage Books Edition, 1979.

Sante, Luc. "Tourists and Torturers." *New York Times*, May 11, 2004, p. A23.

Sassen, Saskia. "A Global City." In *Global Chicago*. Edited by Charles Madigan. Chicago: University of Illinois Press, 2004. Pp. 15–34

———. "Whose City Is It? Globalisation and The Formation of New Claims." In *Trade Routes: History and Geography, Second Johannesburg Biennale.* Edited by Matthew DeBord. Exh. cat. Johannesburg: Thorald's Africana Books. Pp. 56–62.

Saul, John Ralston. *Voltaire's Bastards: The Dictatorship of Reason in the West.* New York: Vintage Books, 1993.

Schama, Simon. *Landscape and Memory.* New York: Random House, Inc., 1996.

Scheuerman, William E. "Globalization." In *The Stanford Encyclopedia of Philosophy (Fall 2002 Edition)*, edited by Edward N. Zalta. http://plato.stanford.edu/archives/fall2002/entries/globalization/.

Segalen, Victor. *Essay on Exoticism: An Aesthetics of Diversity.* Translated and edited by Yaël Rachel Schlick. Durham, N.C.: Duke University Press, 2002.

Shusterman, Richard. "Come Back to Pleasure." In *Let's Entertain.* Exh. cat. Minneapolis: Walker Art Center, 2000. Pp. 33–47.

Smith, Valene L., ed. *Hosts and Guests: The Anthropology of Tourism.* 2nd ed. Philadelphia, Pa.: University of Pennsylvania Press, 1989.

Sontag, Susan. *On Photography.* New York: The Noonday Press, 1989.

Spector, Nancy. *Felix Gonzalez-Torres.* Exh. cat. New York: The Solomon R. Guggenheim Foundation, 1995.

Stafford, Barbara Maria. *Voyage into Substance: Art, Science, Nature, and the Illustrated Travel Account, 1760–1840.* Cambridge, Mass.: The MIT Press, 1984.

Turner, Frederick. "Reflexivity as Evolution in Thoreau's *Walden*." In Turner and Bruner, *The Anthropology of Experience.* Pp. 73–94.

Turner, Victor W. "Dewey, Dilthey, and Drama: An Essay in the Anthropology of Experience." In Turner and Bruner, *The Anthropology of Experience.* Pp. 33–44.

Turner, Victor W. and Edward M. Bruner. *The Anthropology of Experience.* Urbana, Ill.: University of Illinois Press, 1986.

Urry, John. *The Tourist Gaze.* 2nd ed. London: SAGE Publications Ltd., 2002.

Valéry, Paul. Excerpts from *Cahiers, 1905–1935*. Reprinted in Cassiman, Bart, et al., eds. *The Sublime Void: On the Memory of the Imagination*, Exh. cat. Antwerp: Koninklijk Museum voor Schone Kunsten, 1993. Pp. 122–24.

Wigley, Mark. "Insecurity by Design." In Munder, Heike, et al. eds. *Bewitched, Bothered, Bewildered: Spatial Emotion in Contemporary Art and Architecture.* Pp. 45–54.

Reproduction credits

Page 182, 183, 244
Courtesy Matthew
Marks Gallery, New
York

Page 189
©The Felix Gonzalez-
Torres Foundation.
Courtesy of Andrea
Rosen Gallery, New
York. Photograph
©1999, The Art Insti-
tute of Chicago, Photo-
graph by Robert Lifson.

Page 192
© 2004 Artists Rights
Society (ARS), New
York/VG Bild-Kunst,
Bonn. Courtesy
Matthew Marks Gallery,
New York. Photo by
Thomas Ruff.

Pages 193, 194
© 2004 Artists Rights
Society (ARS), New
York/VG Bild-Kunst,
Bonn. Courtesy
Matthew Marks Gallery,
New York.

Page 198 (bottom)
from p.79 of "A Week at
the Fair". Chicago, IL:
Rand McNally & Co.,
1893

Pages 199, 200
Courtesy Air de Paris

Page 207
Courtesy Galerie Eva
Presenhuber, Zurich

Page 208
© Olafur Eliasson
Photo © Tate, London
2004

Page 213
© Florian Kleinefenn.
Courtesy Galerie Chan-
tal Crousel

Pages 216, 217
Courtesy of www.
directcinema.com

Pages 220, 221
Courtesy Gladstone
Gallery

Page 233
Photograph by Michael
Moran

Text credits

Page 27 (top)
From *What Am I Doing
Here* by Bruce Chatwin,
copyright © 1989 by
the Estate of Bruce
Chatwin. Used by per-
mission of Viking Pen-
guin, a division of Pen-
guin Group (USA) Inc.

Page 27 (top)
Extract from *What Am I
doing Here* by Bruce
Chatwin published by
Jonathan Cape. Used
by permission of The
Random House Group
Limited.

Pages 29 (middle),
140 (top), 160
(middle), 252
From *The Songlines* by
Bruce Chatwin, copy-
right © 1987 by Bruce
Chatwin. Used by per-
mission of Viking Pen-
guin, a division of Pen-
guin Group (USA) Inc.

Pages 29 (middle), 140
(top), 160 (middle), 252
Extract from *The Song-
lines* by Bruce Chatwin
published by Jonathan
Cape. Used by permis-
sion of The Random
House Group Limited.

Pages 30 (top), 31
(bottom), 82
copyright ©1988 by
Pico Iyer. Used by per-
mission of Alfred A.
Knopf, a division of
Random House, Inc.

Page 34
From *From Babel to
Dragomans: Interpreting
the Middle East* by
Bernard Lewis, copy-
right © 2004 by Ox-
ford University Press,
Inc. Used by permis-
sion of Oxford Univer-
sity Press, Inc.

Pages 48 (middle), 49
(bottom), 81 (top), 83,
86, 126, 142 (bottom),
211 (top)
Reprinted by permis-
sion of Sage Publica-
tions Ltd. from John
Urry, *The Tourist Gaze*,
© John Urry, 2002.

Page 54 (bottom)
Triste Tropiques by
Claude Levi Strauss.
Copyright © Librerie
Plon, 1955. English
translation copyright
© Jonathan Cape Ltd.,
1973. Reprinted by per-
mission of George
Borchardt, Inc., for the
author.

Pages 57 (bottom), 64
(middle)
Gleber, Anke; *The Art of
Taking a Walk* ©1999
Princeton University
Press. Reprinted by
permission of Prince-
ton University Press.

Page 60
Copyright © P.E.
Charvet, 1972. Repro-
duced by permission of
Penguin Books Ltd.

Page 94
*From Knowledge to Nar-
rative: Educators and the
Changing Museum* by
Lisa Roberts. Copyright
1977

Page 95
Excerpts from *Travels
in Hyperreality* by
Umberto Eco, copy-
right © 1983, 1976,
1973 by Gruppo Editori-
ale Fabbri-Bompiana,
Sonzogno, Etas S.p.A.,
English translation by
William Weaver, copy-
right © 1986 by Har-
court, Inc., reprinted by
permission of Har-
court, Inc.

Page 165
First published in the
exhibition catalogue
*Let's Entertain: Life's
Guilty Pleasures* (Walker
Art Center, Minneapo-
lis, Minnesota, 2000).
Reprinted and ex-
cerpted with permis-
sion.

Page 181
Excerpts from "The
Image World" from
On Photography by
Susan Sontag. Copy-
right © 1977 by Susan
Sontag. Reprinted by
permission of Farrar,
Straus and Giroux, LLC.

Page 229
Weber, Samuel and
Henry Sussman. Glyph
I. pp. 54 © 1977.
Reprinted with permis-
sion of the Johns Hop-
kins University Press.

Page 255
© 1991 Columbia
University Press and
© 1991 Pearsons
Education, U.K.

Acknowledgements

An exhibition of this magnitude could not have been realized without the important contributions of many key individuals. We would first and foremost like to extend our deepest appreciation to all of the artists, architects, and lenders who generously allowed their work to be included in the exhibition and catalogue. These exceptional works have stimulated, challenged, and informed the various avenues of thought within this exhibition.

We also extend our thanks to the artists whose works are reproduced here but are not within the exhibition. We are extremely grateful to the authors cited in this catalogue who have graciously allowed the usage of their texts and whose words and ideas inspired the concept for the exhibition.

The coordination of bringing over 150 artworks to the MCA required the expert assistance of numerous individuals. We would especially like to thank the people at the museums and artists' studios, galleries, and representatives listed on page 279.

Turning over the entire museum to one exhibition is a project of great enormity and demands extraordinary collective efforts from the entire staff, and we would like to extend special appreciation to Bob Fitzpatrick and Greg Cameron for supporting this ambitious project. Our gratitude goes to Julie Havel, Warren Davis, and Jennifer Thielen in the Development Department for securing funding; Wendy Woon, the education staff, and volunteer guides for enthusiastically conveying the themes of the exhibition to our visitors; Jennifer Draffen, Meridith Gray, and Jennifer Harris for expertly managing contracts, shipping, and copyright matters; Don Meckley and preparators, Scott Short, Steve Hokanson, and Brad Martin, for putting forth great skill and extra effort to install many challenging works; Dennis O'Shea, as always, knowledgeably handled the technical aspects of film, video, sound, and lighting in the exhibition; thanks also to Angelique Williams and the marketing staff, Karla Loring and Kennon Brown in Media Relations, and the rest of the MCA staff who assiduously worked each day to ensure the success of the exhibition. This innovative catalogue

is the result of the tremendous creativity of the Design and Publications department. In particular we wish to extend our thanks to Hal Kugeler, Kari Dahlgren, Diana Fabian, and Kamilah Foreman.

We relied greatly on the unfailing support of our curatorial colleagues Elizabeth Smith, Staci Boris, Lynne Warren, and Dominic Molon and extend deep gratitude to current and past curatorial interns — Lindsey Delahanty, Haydee Franco, Jenny Gheith, Margo Handwerker, Brynn Hatton, Ruba Katrib, Kelly Kardaras, Dorothy Malkin, Ed Schad, Laura Smith, and Miriam Voss — for their diligent assistance with all aspects of the exhibition and significant contributions to the contents of the catalogue.

We also thank the following friends and colleagues who have entertained numerous consultations and conversations about the catalogue and exhibition: Lina Bertucci, Kerry Brougher, Giulio Ciavoiello, Andre Fiebig, Massimiliano Gioni, Hans Ulrich Obrist, James Rondeau, Nancy Spector, Tabatha Tucker, and Timothy Widholm.

Francesco Bonami, *Manilow Senior Curator*

Julie Rodrigues Widholm, *Assistant Curator*

Tricia Van Eck, *Curatorial Coordinator and Curator of Artists' Books*

UNIVERSAL EXPERIENCE *Art, Life, and the Tourist's Eye*

Acconci Studio: Sarina Basta

Anish Kapoor Studio: Zoe Morley

Blu Dot, Minneapolis: Maurice Blanks,
John Christakos, and Charles Lazor

Cai Guo-Qiang Studio, New York: Hong-kai Wang

Jeppe Hein Studio:
Stephan Babendererde and Aboli Lion

Jim Hodges Studio: Tim Hailand

Studio Diller+Scofidio+Renfro, New York:
Denise Fasanello

Thomas Hirschhorn Studio, Paris:
Pierre Labat and Sophie Pulicani

303 Gallery, New York: Simone Montemurno,
Mari Spirito, and Lisa Spellman

Alison Jacques Gallery, London:
Alison Jacques and Colin Bond

Barbara Gladstone Gallery, New York: Rosalie Benitez,
Barbara Gladstone, Ryan Goolsby, and Michiah Hussey

BQ Gallery, Cologne:
Joern Boetnagel and Yvonne Quirmbach

Casey Kaplan Gallery:
Chana Budgazad and Casey Kaplan

Chantal Crousel Gallery:
Chantal Crousel and Niklas Svennung

Continua Gallery, San Gimignano, Italy: Alice Fontanelli

Courtyard Gallery, Beijing: Meg Maggio

Daiter Contemporary Chicago:
Stephen Daiter and Michael Welch

Emmanuel Perrotin, Paris: Nathalie Brambilla

Friedrich Petzel Gallery, New York:
Jessie Washburne-Harris and Friedrich Petzel

Gagosian Gallery, New York:
Andy Avini and Larry Gagosian

Galeria Helga de Alvear: Helga de Alvear
and Carlos Urroz

Galerie Air de Paris: Helene Retailleau

Galerie Eva Presenhuber, Zurich: Glenn Frel,
Eva Presenhuber, and Markus Rischgasser

Galerie Judin, Zurich: Juerg Judin

Galerie Krobath Wimmer, Vienna: Isolde Christandl,
Helge Krobath, and Barbara Wimmer

Galleria Massimo De Carlo, Milan:
Ludovica Barbieri and Massimo De Carlo

Gavin Brown's enterprise: Gavin Brown, Corrina
Durland, and Laura Mitterand

Jack Shainman Gallery, New York:
Jack Shainman and Claude Simard

Johann König Gallery, Berlin: Kirsa Geiser
and Johann König

Kavi Gupta Gallery, Chicago: Kavi Gupta
and Kristen Vandeventer

Kerlin Gallery, Dublin: David Fitzgerald
and Darragh Hogan

Kurimanzutto Gallery, Mexico City:
Monica Manzutto and Manola Samaniego

Marian Goodman Gallery: Catherine Belloy, Marian
Goodman, Linda Pelligrini, and Rose Lord

Matthew Marks Gallery, New York: Renee Burillo,
Stephanie Dorsey, Matthew Marks, and Kristin Poor

Murray Guy Gallery, New York: Janice Guy

MW Projects, London: Alec Steadman

Regen Projects: Pilar Wiley and Shaun Caley Regen

Regina Gallery, Moscow: Vladimir Ovcharenko

Richard Telles Fine Art, Los Angeles: Richard Telles

Sonnabend Gallery, New York:
Antonio Homom, Xan Price, and Queenie Wong

Storms Galerie, Munich: Norbert Schulz

Tanya Bonakdar Gallery, New York:
Tanya Bonakdar and Erin Manns

The Modern Institute, Glasgow: Claire Jackson

Thomas Erben Gallery:
Thomas Erben and Stephen Uhlhorn

Yvon Lambert, New York: Vanessa Bergonzali,
Yvon Lambert, and Muriel Quancard

Canadian Center for Architecture, Montreal:
Howard Shubert

Soloman R. Guggenheim Museum: Kim Bush

The Art Institute of Chicago: Amy Berman
and Eva Panek

Artists Rights Society: Eliana Glicklich and Caitlin Miller

Felix Gonzalez-Torres Foundation: Michelle Reyes

Visual Artists and Galleries Association:
Andrea Mihalovic-Lee

Chris Boot

Yoshiko Isshiki

Natsuko Odate

Anya Shen

Robert Smithson Estate

The longest journey is
the journey inwards . . .

Dag Hammarskjold *Markings*